cheat 3ds Max 2014

Get spectacular results fast

Michael McCarthy

First published 2014 by Focal Press 70 Blanchard Road, Suite 402, Burlington, MA 01803

and by Focal Press 2 Park Square, Milton Park, Abingdon, Oxon OX14 4RN

Focal Press is an imprint of the Taylor & Francis Group, an informa business

© 2014 Taylor & Francis OR author/s

The right of Michael McCarthy to be identified as author of this work has been asserted by him in accordance with sections 77 and 78 of the Copyright, Designs and Patents Act 1988.

All rights reserved. No part of this book may be reprinted or reproduced or utilised in any form or by any electronic, mechanical, or other means, now known or hereafter invented, including photocopying and recording, or in any information storage or retrieval system, without permission in writing from the publishers.

Notices

Knowledge and best practice in this field are constantly changing. As new research and experience broaden our understanding, changes in research methods, professional practices, or medical treatment may become necessary.

Practitioners and researchers must always rely on their own experience and knowledge in evaluating and using any information, methods, compounds, or experiments described herein. In using such information or methods they should be mindful of their own safety and the safety of others, including parties for whom they have a professional responsibility.

Product or corporate names may be trademarks or registered trademarks, and are used only for identification and explanation without intent to infringe.

Library of Congress Cataloging in Publication Data

McCarthy, Michael, 1977-

How to cheat in 3ds max 2014: get spectacular results fast / Michael McCarthy.

pages cm -- (How to cheat--)

Includes index.

ISBN 978-0-415-84274-7 (paperback) -- ISBN 978-0-203-75844-1 (ebook) 1. 3ds max (Computer file) 2. 3D studio. 3. Computer animation. 4. Computer graphics. I. Bousquet, Michele, 1962- How to cheat in 3ds max 2011. II. Title.

TR897.7.B6839 2013 006.6'96--dc23 2013025533

ISBN:978-0-415-84274-7 (pbk) ISBN: 978-0-203-75844-1 (ebk)

Printed in the United States of America RR Donnelley - Jefferson City, MO

Typeset in Myriad Pro, Amasis, Flexysansbold by Michele Bousquet

SUSTAINABLE FORESTRY Certified Chain of Custody
At Least 20% Certified Forest Contents At Least 20% Certified Forest Content www.sfiprogram.org SFI-01042

Logo applies to text stock only

Contents

7	Customization and UI 3
	Enhanced menu 4
	X marks the spot6
	Make the new old again 8
	Hotbox quad10
	Custom workspace12
7	Basics 15
	A selection of selections16
	Making a Scene
	Zoom, pan, display20
	Organizing objects22
	Transforms and coordinates24
	Organizing objects: a matter of choice26
	Roger's top 10 reasons why you can't select your object
3	Modeling31
	Modeling tools32
	Reference images
	Spline to low poly36
	Virtual studio38
	15-minute building40
	Modeling around maps 42
	Secrets of the spline44
	Curvy curtain46
	How to make a mess with modeling48
	BYO weapon50
	Modeling for the masses

Character Modeling	. 55
Character references	56
Character modeling process	58
Chop shop	60
Nip and Tuck	62
Polygon building	64
Subdivision	66
Poly modeling in practice	68
Making animatable models	70
Materials	. 73
Material Editor basics	74
Mapping coordinates	76
Preparing textures	78
Concavity	80
Faking subsurface scattering	82
People, trees, and cars	84
Multiple maps	86
Procedurally speaking	88
Gradual mix	90
Unwrapping the mapping	92
Normal mapping	94
Mapping a character	96
Basic mental ray materials	98
Custom mental ray materials	100

6	Lighting & Shadows103	9	Animation 145
	1-2-3 Lighting104		Animation 101
	Troubleshooting shadows106		Spinning your gears148
	Exterior lighting108		Animated pivot point
	Bright sunshiny day		Following a path
	Mental ray lighting112		Look a-here
	Good lighting made better114		Jumping beans156
	Daylight savings time		Linktopia158
	Where's the shadow?118		Linking to multiple objects160
	Shadow and wireframe		Chains
	presentation120		Super-duper tools164
7	Reflections123	10	Character Animation 167
	Reflecting on reflections124		Character animation workflow168
	Bling126		CAT 101
	Reflections in the dark128		Biped 101
	Reflections in the dark128 Where's my reflection?130		Biped 101 172 Skeleton fitting 174
0	Where's my reflection?		
8	Where's my reflection?		Skeleton fitting174
8	Where's my reflection?		Skeleton fitting. 174 Skinning. 176
8	Where's my reflection?		Skeleton fitting.174Skinning.176Walking in your footsteps178The alternative skeleton.180
8	Where's my reflection?		Skeleton fitting.174Skinning.176Walking in your footsteps.178The alternative skeleton.180Biped foot control.182
8	Where's my reflection?		Skeleton fitting.174Skinning.176Walking in your footsteps178The alternative skeleton.180Biped foot control.182CAT gizmos.184
8	Where's my reflection?		Skeleton fitting.174Skinning.176Walking in your footsteps.178The alternative skeleton.180Biped foot control.182

11	MAXScript189	Parameter Wiring 231
	A world of MAXScripts	Wiring 101232
	Voronoi stone wall192	Follow me234
	Gizmo control194	Telling time236
	CAT gizmos for custom rigs196	Spinning wheels238
	Getting a little tense198	Feeling exposed240
	PF Spliner200	To code or not to code242
12	Rendering203	Special Effects245
	Rendering basics	Logo polishing246
	Mental ray rendering206	MassFX destruction248
	What is mental ray, anyway?208	Raindrops250
	Nitrous viewport210	Morphing252
	Quicksilver rendering212	Cracks in a surface254
	Render passes with state sets 214	What's in the box?256
	Managing your scene216	Particle flow basics258
	Tipping the attenuation scales218	Swirly particles
	Plugins	mParticles262
13		Data flow operators
	V-Ray222	
	Phoenix FD224	Appendix267
	Ornatrix226	дреник207
	Zookeeper228	Index273

Foreword from the author

I am very excited to be taking over the *How to Cheat in 3ds Max* series. It has had a long and distinguished legacy with the extremely talented and prolific Michele Bousquet. For this reason, I was thrilled when Michele and Focal approached me with the opportunity to update and continue this book series because I feel that it provides an intelligent and interesting perspective on how 3ds Max can be utilized to achieve the fastest and best results.

Following in Michele's BIG footsteps is a challenge, but I hope I bring some new and interesting things to the book and series as a whole. In my production work I am continually running into tips, tricks, and interesting ways to do things in 3ds Max and I love to share these with the CG community.

New topics I have created for this book may be more on the intermediate side and do require a certain basic knowledge of 3ds Max and 3D in general. That being said, many of Michele's great and useful topics on the basics have been preserved and updated in this revision to provide the reader the absolute best in fundamental, cutting-edge and outside-the-box 3ds Max techniques.

In this new edition, I hope the CG community will be able to build on the solid foundation that Michele has laid down and climb even a little deeper into what 3ds Max can do

Michael McCarthy

A word from Michele

As the author of the previous three *How to Cheat in 3ds Max* books, I am happy that Michael McCarthy picked up where I left off and brought this book to life once more.

I still remember the day in 1998 when I first met Mike. He came to my office for a personalized training session on 3ds Max, and over a discussion of the best topology for animals (he was trying to model a penguin) we became instant friends.

Over the years, a lot of students have asked me how they can get to the point where they can teach and write books about 3ds Max. Michael asked me this question too, and I gave him the usual list: improve your skills, then get your work out there by contributing to forums, posting tutorials online, and going to conferences. Mike did all these things and more, leveraging his native skill of digging into features and plugins to become one of the best-known trainers on 3ds Max, and eventually earning the title of Autodesk Master.

Along the way, Mike and I collaborated on a number of projects from a Character Studio training DVD to documentation for plugins. For this latest book in the *How to Cheat in 3ds Max* series, it seemed a fitting time to pass it to Mike. I'm pleased that he's added so much rich, new content to the book, much of it based on his extensive experience teaching both beginner and experienced students.

There was a time when I referred to Mike as my "star student," but that time has long ago passed. I happily leave this book in his capable hands.

Michele Bousquet

How to cheat, and why

The truth about cheating

The word "cheat" has an interesting history. Its original meaning described the passing of an inheritance to someone other than one's heirs. This definition has come up through the ages to mean getting something dishonestly, or getting things by trickery or good luck. This book is an example of the original definition whereby I will impart the knowledge I have gathered through the years unto you, the reader.

In this book, you'll learn shortcuts to use 3ds Max to its full potential without having to learn it all from scratch, and thus make your own good luck as an artist. There are some very thick and intimidating books out there that cover every possible tool in 3ds Max but this is not one of them. If you want to get the job done in the least possible time, then this is the book for you.

The "cheats" in this book were all gleaned from real-world jobs and projects, where the client wanted something done in three days, not three months or even three weeks. I learned most of this through trial and error, and eventually developed my own bag of tricks. With this book, I've opened the bag and spilled out the contents.

Workthroughs and examples

Each workthrough in this book is designed as a double-page spread. This allows you to prop the book up next to your monitor as you work with the files on the web. Many of the examples pertain to real-world companies, and show techniques used for a recent job.

At the end of most chapter is an Interlude with a discussion of a relevant topic. Think of it as advice from the shopworn.

What's on the website?

On the book's companion website are starter scenes and maps for many of the cheats in this book.

www.howtocheatin.com/3dsmax

Feel free to try out the techniques on the included files, or use your own scenes instead. I've also included final scenes and animation so you can see the end result. The names of files that pertain to the cheat appear under the download icon on the right page of the spread.

When you load a scene file for the first time, you'll get a message telling you that 3ds Max can't find the maps. Just browse to the maps folder for that chapter and add the path, and all the maps for that chapter should load without further messages.

There are images and scenes in the book that couldn't be included on the website due to copyright constraints. In most cases, you can visit the website of the company that provided the imagery and see plenty of their work there.

Acknowledgments

I want to thank two of my star students for contributing their wonderful models to the book. Tetyana Rykova, for her Fluffy the cat character and Ralph Sutter for his Gunslinger and Quadruped character. You can have a look at their other works at:

Tetyana Rykova

http://tetyanarykova.com

Ralph Sutter

http://ralphsutter3d.com

A big thanks to Jason Donati, Paul Neale, and Michele Bousquet for providing insightful interludes from a professional artist's perspective. An extra special thanks to Michele for all her help with the book and through the years. She has always been an amazing help and inspiration to me.

I also want to thank John Rand and Borislav Petrov (Bobo) their help with some of the scripting topics. It's people like these guys that make the 3ds Max community a great place to be!

I'd also like to thank the Mark Gerhard for his keen technical editing and folks at Focal Press for giving me the opportunity to update this book and make these tips available to 3ds Max users once again.

Finally I want to thank my wonderful and amazing wife Candice and our new baby boy Declan. You two are the lights of my life.

Michael McCarthy

How to use this book

I'd be surprised if anyone read this book by starting at the beginning and going through to the end. This is the kind of book you should be able to just dip into and extract the information you need.

Still, I'd like to make a couple of recommendations. The Customization and Basics chapters deal with the fundamentals of using 3ds Max, so if you're new to the program, you should start there. In general, you can't do anything else until you do a bit of modeling, so I recommend that you look through the Modeling chapter before tackling some of the more advanced topics like Character Animation and Parameter Wiring.

Although the book is designed for users of 3ds Max 2014, most topics apply to 3ds Max 2013 and many apply to earlier versions as well. The MAX files on the website are in 3ds Max 2014 format, but all the bitmaps will work with any version.

The techniques in each chapter build up as you progress through the workthroughs. Frequently I'll use a technique that's been discussed in more detail earlier in the same chapter, so it might be worth going through the pages in each chapter in order, even if you don't do every cheat or read every chapter in the book. If a cheat mentions a topic you're not familiar with, check the Index or the 3ds Max help for more information.

The download icon, when it appears on a tutorial page, indicates that the file(s) listed below the icon are available on the website. These files are the same ones used to create the images for that topic. You can use these files immediately to try out the cheat, or use your own instead.

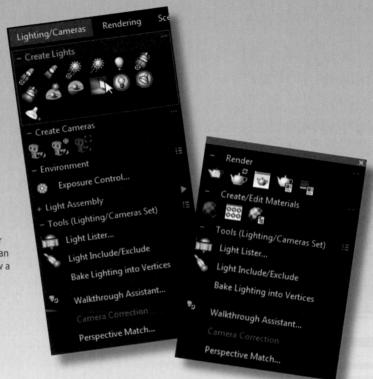

Customizing your user interface (UI) can make your workflow a lot faster.

1

Customization and UI

3DS MAX HAS EVOLVED over the years to include a variety of features for customizing the user interface, all with the goal of improving your workflow and making it faster and easier for you to create great scenes. In this chapter, I'll tell you about some of the most popular timesavers.

Customization and UI

Enhanced menu

DS MAX 2014 SHIPS with a brand new menu system that can improve your workflow. This new feature is tucked away under the Workspaces dropdown.

The new Enhanced Menu is faster to navigate and has flexible functionality like docking, tear-offs, and different ways to view menu options. Sub-menus can be expanded or minimized by default.

The new functionality of Enhanced Menus is great for adding your own custom menu with all the tools you use most often and minimizing the ones that you rarely use. You can even set menu sections to show as icons, text, or text and icons to maximize your workspace and improve item recognition in menus.

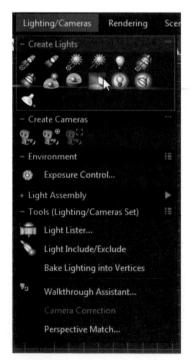

The new layout groups the tools in more task-based way. For example, the Lighting/Cameras menu has tools like Exposure Control and the Light Lister as well as options to create lights and cameras.

If you find yourself going to the same menus over and over, tear them off to put them close at hand instead of at the top of the screen. You can also dock different menus together to build your own quick tool pallet.

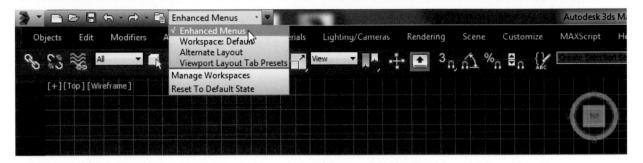

To enable the Enhanced Menu, choose Enhanced Menus from the Workspaces dropdown. This will switch to a Workspace that has the new Enhanced Menu and new layout.

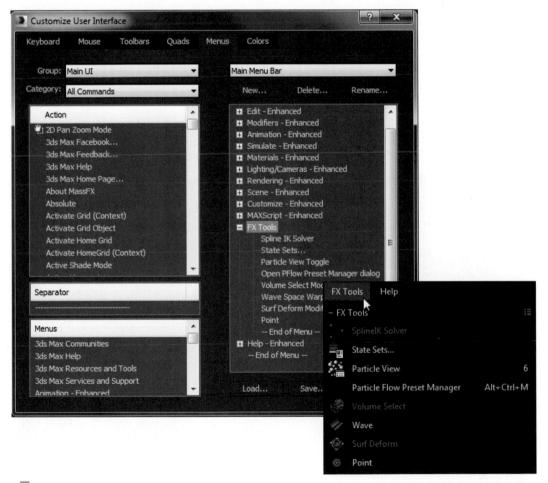

In the Menus tab of the Customize User Interface dialog, you can build your own custom menu and add it to the the main Menu bar of 3ds Max. This will give you quick access to your favorite tools and the ability to dock this new menu with others like Rendering or Animation in the UI.

Customization and UI

X marks the spot

SIDE EFFECT of the new Enhanced Menus is a great feature called the 3ds Max Search Bar. This new tool allows you to quickly search through commands and execute them in the viewport under your mouse.

In addition, 3ds Max 2014 has a new method of cycling the viewports akin to the Windows workflow of cycling through applications with Alt-Tab.

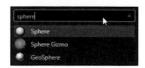

As you hover the cursor over any viewport, tap the X key to bring up the new Search Bar feature in 2014. Here you can type in actionable commands. Try typing in Sphere and three options will pop up: Sphere, Sphere Gizmo, and GeoSphere.

You can choose the first option by pressing Enter or by picking one of the additional options with a mouse click. Once you press Enter you will be prompted to create a Sphere object in the viewport and brought to the Create panel in the 3ds Max UI.

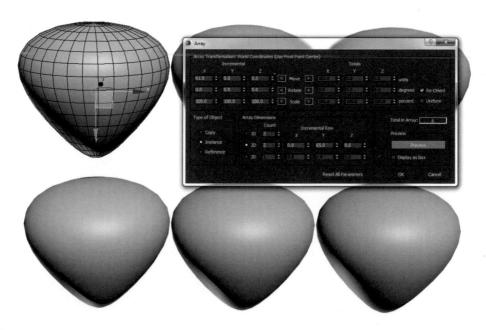

You can also run commands like Align, Array, and Light Lister. Tap the X key and start typing Array with your sphere selected. The Array dialog will pop up once you press Enter.

taper Taper Taper

With the Sphere selected hit the X key again and type Taper. Select the Taper modifier to apply it to your sphere. The Modify panel will be activated so you can adjust the Taper parameters.

[Front] [Wireframe]

Another quick workflow improvement in 3ds Max 2014 is the addition of viewport cycling when you're in a maximized view. Previously you would need to use a hotkey or minimize and then maximize your view again to cycle viewports. Now you can use Windows + Shift to bring up a viewport switching interface. Hit the Shift key to cycle through and choose your view.

HOT TIP

You can set up a variety of 3ds Max actions like Play, or set your coordinate system to Local, using the X key actions.

Customization and UI

Make the new old again

E OLD-TIME USERS of 3ds Max already have significant muscle memory with regard to the order and layout of our menus. If you're one of us, you might prefer the way menus were set up in previous versions of 3ds Max instead of the new task-based order.

However, it would be nice to have the benefits of the new features while taking advantage of the speed and flexibility of the Enhanced Menus.

Here is a quick way to get the best of both worlds and set your Enhanced Menus back to the older menu layout.

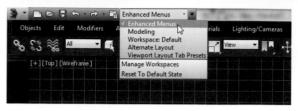

Switch to the Enhanced Menu Workspace layout to enable the new Enhanced Menu.

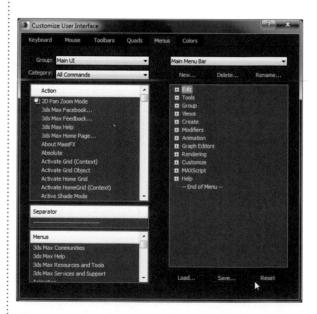

Go to Customize User Interface and under the Menu Tab click Reset. This will reset your menus to the original default layout but still use the enhanced menu.

Create a new Workspace called Enhanced Menu Original in Manage Workspaces.

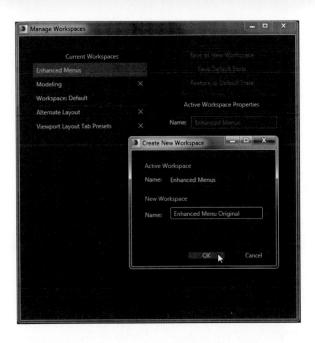

Customize the menu items to have certain ones open by default, display icons, or text only.

Customization and UI

Hotbox quad

HEN WORKING back and forth between 3ds
Max and Maya, I find myself missing Maya's Hotbox feature. This is heads-up display that gives you access to all the application menus right under your mouse when you hit the spacebar.

In 3ds Max you can emulate this Maya feature by adding a custom quad menu. You can add pre-defined 3ds Max menus to a custom quad menu so that when you right-click, you get a set of menus. Then you can assign the spacebar hotkey to bring up that quad menu.

Even if you've never used Maya, this method of putting your frequently used tools at your fingertips can speed up your workflow dramatically.

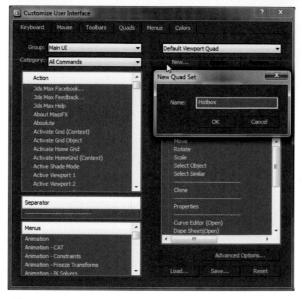

Go to the Customize menu and choose Customize User Interface. In the Quads tab add a new quad menu named Hotbox. Set the shortcut key to Space, and check the Show All Quads option.

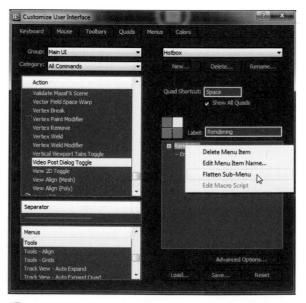

If you want your menu options to fill the quad rather than having to use a sub-menu, right-click and choose Flatten Sub-Menu.

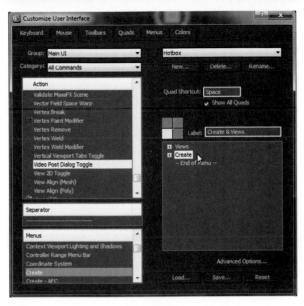

Drag menus from the left-hand Menu section to the Quad section marked in yellow on the right. You can even add back in the File menu if you prefer to use it instead of the newer Jewel icon.

Now you can save out your new Hotbox quad menu and quickly access your tools directly under your mouse with the tap of the spacebar.

HOT TIP

You can make custom menus in the Menus tab of the Custom User Interface dialog to remove tools that you never use, and add in other tools and scripts that you use all the time.

With this and other UI modifications it may be necessary to close and relaunch 3ds Max.

Customization and UI

Custom workspace

Y DEFAULT, 3ds Max exposes all the tools necessary for modeling, texturing, lighting, rigging, animation, and other tasks. However, you don't always need or want all these tools displayed.. Workspaces allow you to create a custom interface for each different task.

For example, if you work primarily with modeling, you don't need particle simulation or rigging tools to be displayed. Instead, you'll want the Graphite Modeling Tools handy at all times. You might also want to use a Viewport Tab Preset to customize your viewport layout for modeling.

Here I'll walk through the steps of setting up a modeling workspace. You can use these concepts to set up a custom workspace for any 3ds Max workflow.

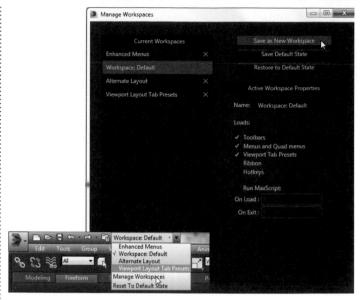

From the Workspace dropdown at the top of the screen, choose Manage Workspaces. Choose Save as New Workspace. Name the new workspace Modeling and check the Ribbon and Hotkeys options in Active Workspace Properties.

Customize your menu by having only modeling tools present. In Customize User Interface under the Menu tab remove all of the menu items from the Main Menu Bar. Now add back menu items only for modeling tasks like Parametric Deformers, Spline objects, and Poly tools. You can even tear off dockable, floating menus that will persist and load with the workspace.

You don't need the Track Bar or other animation tools for modeling, but you do want Graphite Modeling Tools available all the time. Customize your panels by docking the Graphite Modeling Tools to the right, and by turning off the Track Bar UI from Customize>Show UI.

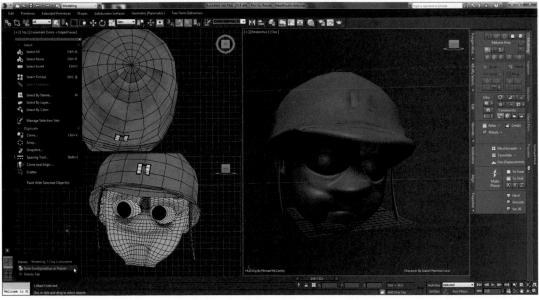

Viewport Tab Presets allow you to quickly set up views especially for the task at hand. For modeling, a good layout is a three-view tab with a large Perspective view with Clay shading, and two smaller views displaying Consistent Colors with Edge Faces on. After setting up such a viewport display, you can right-click the Viewport Tab and save it as a preset.

HOT TIP

You may want to create your own new menus instead of using the 3ds Max default ones. This can avoid confusion and $editing\,the\,3ds$ Max default menus by mistake. By doing this you can also remove commands you rarely use in those menus.

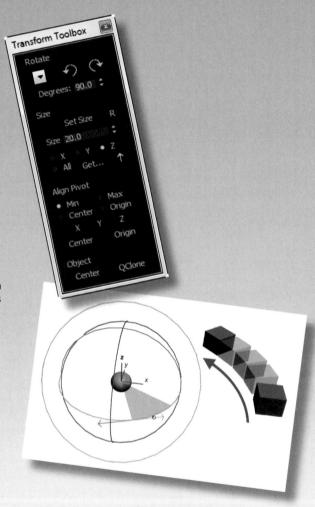

Using 3ds Max is an adventure that begins with a few important steps.

2 Basics

THE TECHNIQUES DESCRIBED in this book assume a basic grasp of 3ds Max. But with so many options to choose from, it's easy to get lost in all the tools, buttons, and menus.

Not all features are created equal. This chapter goes over the fundamentals of 3ds Max with an eye toward the most important tools and how you can use them to create beautiful scenes as quickly as possible.

2

A selection of selections

HE ABILITY TO SELECT objects at will is an important skill for working quickly with 3ds Max. Just about every operation you perform will start with the selection of one or more objects or sub-objects.

Conversely, there's nothing more frustrating than knowing exactly what you need to select, but not knowing how to select it or get at it.

Every possible type of selection can be done with the tools at hand. It's just a matter of knowing them so you can mix and match when needed.

When you rest the cursor over an object's wireframe for a moment, the object's name appears as a tooltip. This is one reason why it's important to name your objects intelligently.

To select multiple objects, hold down Ctrl while clicking. To unselect an object, hold down Alt while clicking. Note that this workflow differs from earlier versions of 3ds Max, where holding down Ctrl while clicking an already selected object used to unselect it.

To select multiple objects or select by name, click the Select by Name button on the toolbar or press the H shortcut key. On this dialog, you can display specific sets of objects such as just geometry or lights.

The Scene Explorer (Tools menu > Scene Explorer) is similar to the Select by Name dialog, but you can leave it open as a floater while you work. You can also open multiple Scene Explorers showing different sets of objects.

Click an object's wireframe to select it. In a wireframe view, you will need to click an actual line. The axis tripod appears, the object wireframe changes color, and the object name appears on the panel at the right of the screen.

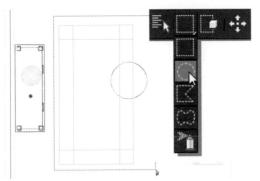

You can also select multiple objects by drawing a bounding region around them. Start by clicking in a blank area of the viewport, and then drag in any direction. The shape of the region is determined by the Selection Region currently chosen on the toolbar.

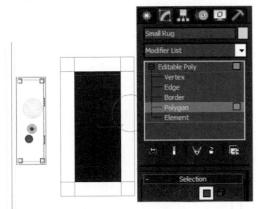

When the object is at a sub-object level you can only select sub-objects that correspond to that level for that object. To select other objects, you will need to return to the base level of the object by exiting the sub-object level.

If objects are on top of one another in the view you're working with, you can hold the cursor still and click multiple times to cycle through the objects. Watch for the object name to appear on the panel.

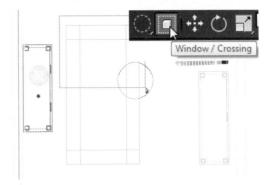

The Window/Crossing toggle on the toolbar determines how the bounding region works. When Window is turned on, only objects that are completely within the bounding region are selected. When Crossing is on, all objects touched by the bounding area are selected.

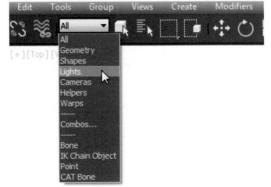

The Selection Filter can limit your selections to specific object types such as lights and cameras. Be sure to reset the selection to All or Geometry to select objects again.

HOT TIP

Pressing the Spacebar locks or unlocks the current selection. If you think you might have accidentally locked the selection by pressing the space barinadvertently, lookforthe lock icon on the status bar to see if it's turned on. Just press the Spacebar to turn it off again.

Making a Scene

HERE IS A MYTH that you should spend most of your time modeling, and then cram all the lighting, texturing, and animation into whatever time remains in the schedule. This so-called wisdom stems from the early 1990's when computer graphics were new, modeling was a rare skill, and any rendering at all was impressive.

Nowadays, clients expect decent materials, lighting, and animation, if not outright realism. To achieve this goal, the best approach is to take time at the front end to gather reference materials such as photos, drawings, videos, and textures. Each hour spent on preparation can reduce scene creation time by five or even ten times, in addition to providing a strong direction for modeling, materials, and lighting. In addition to this you should always plan your scene around your camera shots, models, textures and lighting setups. Having a proper storyboard before you start is important to this process.

Before you load 3ds Max, gather up a few pictures with lighting, materials, and compositions that approximate your vision of the final rendering. You won't be copying these images, but having them handy for reference will be invaluable as you create the scene.

Gather up or create your textures and reference images. See the Modeling chapter to find out how to create reference images and textures from photographs and the Materials and Mapping chapter for creating tileable textures.

If animation is part of your scene, get a rough animation in place before working with lights and rendering. Test renderings and previews will give you a quick approximation of the final result. See the Animation chapter.

Sketch out the scene with all major elements. This step can be as elaborate as a color storyboard or as simple as a quick line drawing on a slip of paper. Even if you're using a detailed architectural plan, consider items that aren't noted such as trees, cars, and people.

In 3ds Max, block out the scene with primitives as placeholders for the final objects. This will enable you to place a camera and see which objects need to be the most detailed. You can also place a few representative lights to get an idea of how they'll work with the scene.

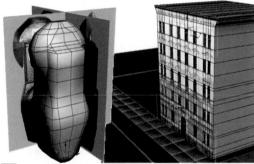

Now you can start modeling. Use the reference images and textures liberally to guide the process. The best tool for modeling is the Editable Poly. See the Modeling chapter for tips on speedy modeling using your maps.

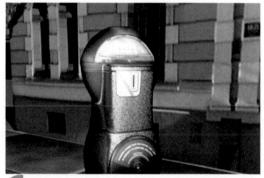

Materials and mapping are next. Avoid spending a lot of time tweaking colors and reflections as materials will change appearance when lighting is added or changed. See the Materials and Mapping chapter for tips on quick mapping.

HOT TIP

Photographs edited in Photoshop can often provide all the reference material you need.

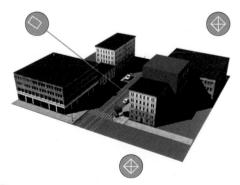

Place lights in the scene to simulate "real" lighting, such as near an indoor lamp or in the sky to simulate the sun. Shadows are a key element in adding dimension. See the Lighting and Shadows chapters for more details.

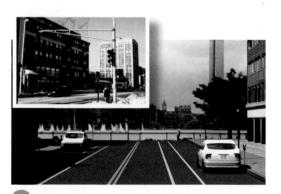

Test renderings show you how the scene is shaping up. Compare your rendering with sample photos and pick out details that will improve realism. See the Reflections and Rendering chapters for tips on increasing realism.

Zoom, pan, display

VER THE COURSE of your work with 3ds Max, you will need to zoom, pan, and rotate the scene many times to get the job done. You'll also need to switch your viewport displays between wireframe and shaded to see what's going on with the model. Learning how to use the tools available will save you a great deal of time in the long run.

A mouse with a middle wheel can speed up your work in 3ds Max by many times, allowing you to zoom, pan, and rotate the scene quickly and easily.

viewport label or press the \lor hotkey to choose from a menu.

The zoom controls are at the lower right of the screen. The Zoom Extents buttons are useful for getting objects back into view. The Maximize Viewport Toggle switches between smaller views larger views.

[+] [Orthographic] [Smooth + Highlights]

If you have a middle mouse wheel, hold down Alt and the wheel at the same time, and drag to rotate the view.

You can also use the View Cube to rotate the viewport or change to a different view. Click a view on the cube itself, or click a rotation arrow to rotate the view

Use F3 to toggle wireframe and shaded displays in any viewport, and F4 to toggle edge display when in shaded or Realistic mode.

If your mouse has a middle wheel, you can zoom in and out by rolling the wheel, or pan by pressing the wheel and dragging. This method of viewport navigation means you don't have to keep clicking different viewport navigation buttons to move around your scene.

HOT TIP

Pressing Ctrl +
Zoom Extents
All zooms all
viewports except
the Perspective
view. This is useful
for keeping a
Perspective view
exactly as it is
for rendering
while zooming
the remaining
viewports.

If you like the view in a viewport and want to keep it to return to later, you can use Viewports menu > Save Active [current view]. Use Restore Active [current view] to get it back.

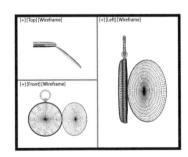

If you prefer a different viewport arrangement, click the arrow button on the tab bar to the left of the viewports, or use Views > Viewport Configuration > Layout tab.

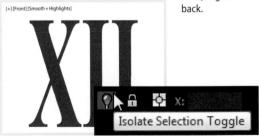

To quickly isolate one or more objects in viewports, select the objects and click the Isolation Toggle button on the status bar. You can also choose Tools > Isolate Selection, or press Alt+Q.

Organizing objects

VEN A TRUE ARTISTE needs to get organized once in a while. Object names, layers, and selection sets are all part of keeping your scene tidy so your work will be as fast as possible.

Keeping the scene organized is especially important when you need to pass it on to someone else. On the receiving end, there's nothing worse than getting a scene full of Box01 and Box02 with no layers or selection sets in sight.

Be kind to your fellow artists (and to yourself!) and take a few moments to get your scene in order. You'll be glad you did.

The Object Properties dialog is "command central" for your objects. Choose Edit > Object Properties, or right-click and choose Object Properties from the quad menu.

Naming your objects intelligently is the first step toward good scene management. The quickest way to do this is to type in the name on the Modify panel.

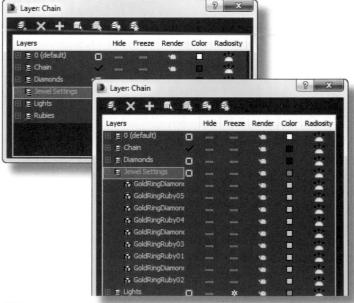

Organizing your objects into layers can also help keep things under control. In 3ds Max, layers refer to sets of objects, not physical layers. In other words, layer order has no effect on the appearance of a rendering. In the Layer dialog, you can also hide, freeze, and select objects. To open the Layer Manager, click the Layer Manager button on the toolbar or choose Tools > Manage Layers.

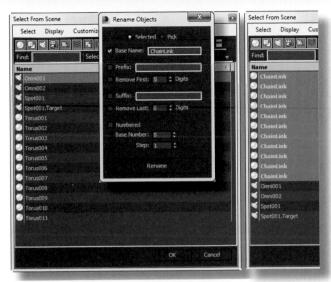

If you have numerous similar objects that need to be renamed, you can use Tools > Rename Objects to automate the process. Enter the number of digits (letters) to remove, and enter a new prefix to replace the letters removed. Here, a selection of toruses (Torus01, Torus02, etc.) is renamed while keeping the numbering intact.

You can temporarily hide objects to unclutter your viewports, or freeze them to make them impossible to select by accident. Right-click the screen and choose a Hide or Freeze tool from the quad menu.

A Selection Set is a name given to a selection of objects, providing quick selection of object sets from a dropdown menu on the toolbar.

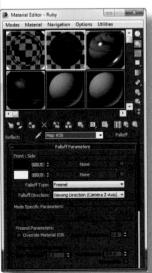

Be sure to name your materials, too. If you have a lot of complex materials, consider naming your maps as well. You'll be glad you did.

Use Group > Group to group objects into one single selectable entity. While this is a common practice for architectural scenes, grouping makes animation difficult to control, so I don't recommend it.

Transforms and coordinates

HE MOVE, ROTATE, AND SCALE buttons on the toolbar are called transforms. The Select and Move transform is your primary tool for lining up objects in a scene.

Coordinate systems work hand-in-hand with transforms. A coordinate system determines what 3ds Max considers to be the X, Y, and Z directions at any given moment. While you can choose a variety of coordinate systems from the dropdown menu on the toolbar, the ones you'll use most often are View, World, and Local.

The default coordinate system for orthographic viewports (straight-on views) is the View coordinate system. In the Top, Front, and Left views, X always points to the right and Y always points up in whichever viewport is active at the moment.

A different coordinate system can be assigned to each transform. When you want to change the coordinate system, be sure to choose the transform first. If you want a single coordinate system to apply to all transforms, choose Customize > Preferences, click the General tab, and turn on Constant in the Ref. Coord. System group.

The Pick coordinate system uses a specific object's pivot point as the center for transforms on all objects in the scene. After you pick the object to use as the center, choose the Use Transform Coordinate Center button from the flyout. This type of coordinate system is most useful for rotating one object around another.

The default coordinate system for the Perspective view is called World. Here, Z always points in the up direction. The coordinate system is still listed as View on the toolbar because having the World system in the Perspective view is part of the View coordinate system's definition.

The Local coordinate system is aligned with the selected object's pivot point. Each object you create is automatically assigned its own XYZ pivot point. If the object has been rotated, the Local coordinate system allows you to easily move the object in the direction in which it's rotated.

The pivot center button next to the coordinate system dropdown menu determines whether the object will be transformed around itself (Use Pivot Point Center), the center of the selection (Use Selection Center), or some other object (Use Transform Coordinate Center).

50 55 60 65 70 X: 79.072 \$ Y: -0.0 \$ Z: 51.955 \$

To transform an object by a specific amount, you can enter a value on the status bar, or right-click the transform button to bring up a type-in entry dialog.

The Transform Toolbox (Edit menu > Transform Toolbox) gives you instant access to all the transform tools, plus some great options for controlling the way transforms work in viewports.

HOT TIP

Avoid using the scale transform on an object whenever possible. Instead, adjust the object's parameters if it's a primitive. For an Editable Poly or Editable Mesh, scale the object at the Vertex or Polygon sub-object level. Changing an object's dimensions with parameters or sub-object scaling has no negative effects on the object.

The F12 hotkey brings up the Transform Type-In dialog for the currently selected transform.

INTERLUDE

Organizing objects: a matter of choice

WITH A CHOICE OF SO MANY TOOLS in 3ds Max for organizing objects, you have many options for managing your scene. Layers, for example, are not necessarily better or worse than selection sets. It's a matter of what works best for your purposes.

A selection set is simply a selection of objects that you give a name to. It's the easiest one to use: select, enter a name on the toolbar, done. In the early days of 3ds Max, before layers were introduced, this was the primary tool artists used to organize objects.

Grouping has been available for just as long. This type of tool is common in 2D graphics and layout programs such as Illustrator and InDesign. While it works very well in 2D for just about anything, grouping has specific, limited uses in 3D.

For objects that won't be animated, grouping is fine. Architectural artists, for example, find it useful to group together all the furniture so they can move it around easily. This works because the furniture isn't going to be animated to fly around the scene (or so one would presume). The camera might be animated, but that won't have any effect on grouped objects just sitting there.

If the object is going to be animated, grouping becomes something that we in the 3D industry call A Bad Idea. If you animate the group to make it fly around, the animation keys are on the group itself as an object. If you later ungroup the objects, you will lose the animation keys. And if you open the group and animate individual objects within the group, and then ungroup the object, you get what we in the industry call A Big Mess. So for static objects, group away. For animated objects, use Dummy objects to keep it all together (covered in the Animation chapter).

Layers are the most used and adopted method of organizing your scene in 3ds Max. Architectural designers love layers because they're are a mainstay of AutoCAD, a technical design program used by most of the known universe, and many architectural artists got their start with AutoCAD. If you can get in the habit of it, I recommend organizing your objects into layers once you start to build your scene up past a few basic objects.

Containers were added to 3ds Max a few versions back for the purpose of sharing specific parts of a model across multiple users, as with a game development team sharing parts of a game environment. You can save parts of your scene into their own scene files, then assemble them into one master scene using XRefs or Containers. Containers haven't caught on outside this usage, though.

If you model something made up of several separate objects, such as a chair made up of numerous bits of metal and wood, you can use the Attach tool (available with Editable Poly and Editable Mesh objects) to put them all together into one object. Each object will retain its own material and become an Element sub-object, which makes it easy to select the piece and move it around or assign it a different material.

In short, no one method for scene organization does it all. Try them out and use what works best for a particular set of objects, a specific scene, or you personally.

PLAYTIME

Roger's top 10 reasons why you can't select your object

MY GOOD FRIEND Roger Cusson is, like me, a long-time instructor on 3ds Max. One day we got to talking about the challenges of teaching such a large and complex program, and we agreed that the biggest barrier new students have is confusion about selecting objects.

Roger proposed that since we go over these pitfalls in every class, he should publish a list of Roger's Top 10 Reasons Why You Can't Select Your Object. The list never actually got published until the first edition of this book. Here is the list, printed for the first time in the first edition of this book and back by popular demand, including a cutout reminder list that you can tape to your laptop or monitor for easy reference.

- The current selection is locked, preventing you from making a new selection. You can tell if this is the problem by checking the Selection Lock Toggle on the status bar to see if the button is turned on. Click the button to turn it off, or press the space bar.
- You are attempting to select an object in a wireframe view by clicking in its volume area rather than on the wireframe. Click the wireframe, or change to a shaded viewport and click the volume.
- The object is frozen. Right-click anywhere in the viewport and choose Unfreeze All, or use the unfreeze options on the Display panel.
- A creation button, such as Box or Sphere on the Create panel, is still clicked, and a selection tool (such as Select Object) is not currently selected. Right-click a couple of times to turn off the creation tool, or click a selection tool.
- You are still at the sub-object level for one object. At a sub-object level, you can select only sub-objects of that object. Return to the base level of the object by turning off the sub-object level.
- The Window/Crossing toggle on the toolbar is set to Window, and you are making a Crossing selection. Click the button to toggle to Crossing.

- You are clicking the back side of a one-sided object such as a Plane. Rotate the view and click the other side.
- You are currently using a tool that 's expecting a selection for that specific tool. For example, if you click Select and Link then click Select by Name, you will pick an object to link to rather than simply selecting an object. Click Select Object to turn off the other tool and enable selection.
- The Selection Filter is limiting your selection. Set the Selection Filter to All.
- You are trying to use Shift or Alt instead of Ctrl to add to the selection. Use Ctrl to add to the selection, and Alt to remove from the selection.

Roger's Top 10 Reasons Why You Can't Select Your Object

- Unlock the selection (space har, or turn off Selection Lock Toggle).
- Click the wireframe, not the volume.
- Unfreeze the object (right-click for quad menu, choose Unfreeze All).
- Turn off the creation tool you're currently using, or click Select Object.
- Get out of sub-object mode.
- Make sure Window/Crossing is set to the mode you want.
- One-sided object? Click the other side.
- Turn off the tool that's expecting a selection, or click Select Object.
- Reset the Selection Filter to All or Geometry.
- Use Ctrl to add to the selection, not Shift.

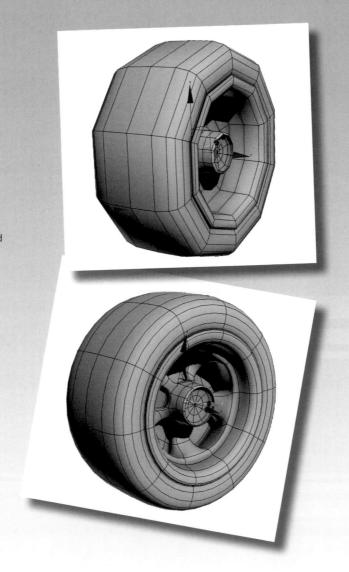

Modeling quickly and intelligently requires good reference images and a little ingenuity.

3 Modeling

MODELS ARE the main building blocks of scenes. When creating a model, it's important to model just enough detail to make a good rendering. It's easy to get bogged down in small details that take a long time to model and won't even be noticeable in the final rendering.

Mapping, the process of putting textures on a model, is akin to modeling. In this chapter you'll learn simple mapping techniques that can reduce modeling time to minutes instead of hours.

3 Modeling

Modeling tools

NOWING the primary modeling tools in 3ds Max will make your work go much faster. Make sure you can find all these tools in the user interface, and take it from there.

Primitive objects are the starting point for most of your objects. Between Standard and Extended Primitives, there are more than 20 primitives to choose from. The box is the most commmonly used base object for both simple and complex models.

In some cases, a spline (curved or straight line) is the most straightforward way to create an object. The Sweep and Lathe modifiers, among others, will turn a spline into a 3D object.

A primitive can be turned into an Editable Mesh or Editable Poly for direct access to vertices and polygons. You can access the tools at the Vertex or Polygon sub-object level by expanding the base object and choosing a sub-object level, or you can click directly on a tool from the Graphite ModelingTools toolbar.

To clone an object, hold down Shift as you move the object. A Copy is independent of the original. An Instance maintains a connection between the two so any changes to one clone changes the other. References are a combination of the two, which is useful under specific circumstances.

Reference images

HE IMPORTANCE of using reference images for modeling cannot be overstated. An hour spent creating or cleaning up useful reference images can easily save you a dozen hours of modeling and tweaking.

The best tool for cleaning up reference images is Photoshop. By learning the Transform tools, you'll open up a whole new world of useful images that can even double as textures.

I've found the following tools most useful for image cleanup:

- Quick Selection
- Transform
- Distort
- Warp
- Guides

Take photographs or make drawings of the object you want to model. With a symmetrical object such as this fire alarm, a front and side view are sufficient. Take photos at as much of a straight-on view as you can get. You can also take a back and top picture if you like.

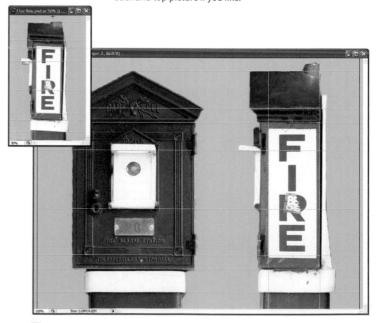

Use horizontal guides on the front view to line up the side view parts. You'll need to use the Distort and Warp tools liberally to remove the perspective from the side view. Utilize any obvious rectangular elements, such as the FIRE decal, to determine the correct vertical alignment.

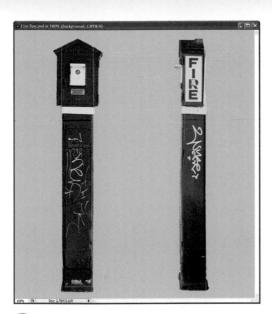

Use guides to help you rotate the items straight.
Using a contrasting background color, erase the photo background with the Quick Selection and Eraser tools. Resist the temptation to waste a lot of time delicately erasing pixels at the edges. The edges don't have to be perfectly clean to use the images for reference in 3ds Max.

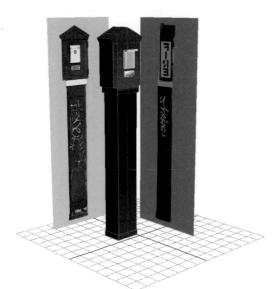

Save the image and use it as a guide for your model's proportions in 3ds Max. The details on how to do this are covered in this chapter.

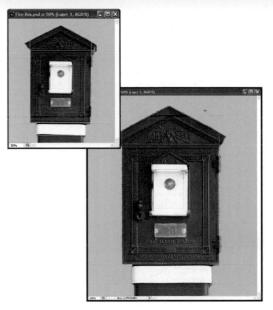

In this case, the base of the fire alarm in the front view is straight, but the top is crooked. Straighten out the image using the Rotate, Distort, and Warp tools as necessary. Remove any perspective artifacts from the image. Here, I erased the bit of the underside of the "roof" that was visible at the upper right corner of the object.

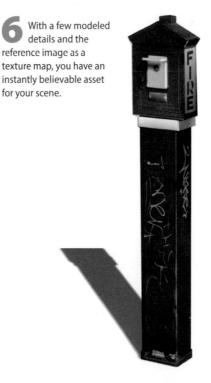

FireAlarm.tga FireAlarm.max

HOT TIP

Outdoor photographs taken on an overcast day have fewer shadows and more even lighting than those taken in bright sunlight.

Spline to low poly

HEN ARTISTS model with splines they tend to output a final fairly high-poly or smooth-looking result. Starting with a spline to create a low-poly mesh for further editing or details is a very effective workflow.

Spline modeling through operations like a Lathe, Extrude, or Surface is a fast way to rough out a basic shape of an object. Once you have that basic form you can adjust the number of steps the spline has in order to create a low-poly mesh output instead of high-poly final result.

Treate a spline profile of a wheel and tire in the front view. You create the right side and then Mirror it in sub-object Spline mode.

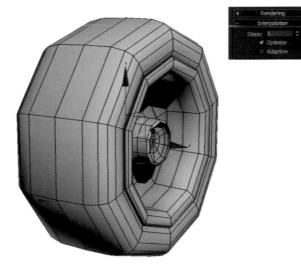

Adjust the Lathe Segments down to 10 to reduce the number of polygons generated around the Lathe. Now select the Line in the modifiers stack and in the Interpolation rollout set the Steps to 1. That will bring down the number of polygons generated along the spline.

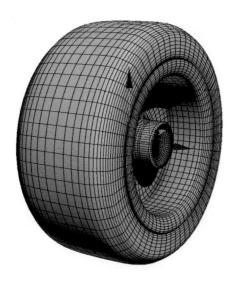

Add a Lathe modifier and adjust the Axis Direction to X. Also in sub-object Axis mode position the Axis to the center of the wheel's hub.

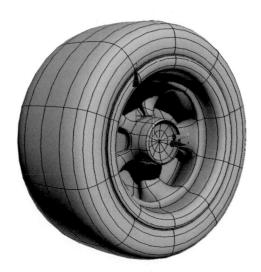

Now can add more detail with poly modeling techniques. Add an Edit Poly modifier on top of your Lathe and in sub-object Polygon mode select every other polygon radiating out from the center hub. Bevel these in a few times to create the mags. Add a TurboSmooth Modifier to smooth out the entire wheel.

WheelStart.max WheelFinal.max

HOT TIP

Using multiple Edit Poly Modifiers can allow you to layer your modeling edits. Toggle them on or off to add or remove modeling details.

Virtual studio

VIRTUAL STUDIO is a scene setup that provides the three-dimensional reference required to model a specific object. It's one of the prime tools used by expert modelers to get the job done quickly. I recomend this method over basic viewport backgrounds.

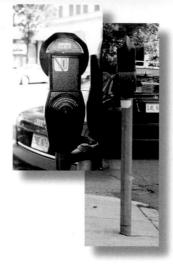

Get two views of the object you want to model. In Photoshop, paint out the backgrounds and remove any obvious perspective from the images as described in the Reference Images cheat.

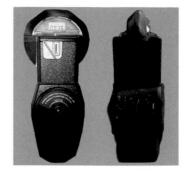

Create a perfectly square image that contains both maps. This will save your being concerned with the image aspect ratio when you use it in 3ds Max.

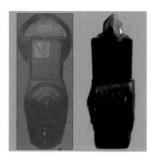

Make a box and position it in the Front viewport to align with the image. Press Alt+X to make the box see-through, and match its size roughly to the outer bounds of the front reference image.

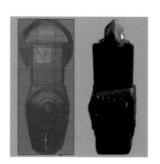

Press F4 to turn on the Edged Faces display, and increase the number of box segments to allow enough detail for the object. Convert the object to an Editable Poly by right-clicking the modifier stack and choosing Convert to Editable Poly.

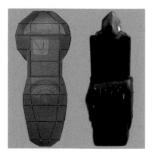

Now you can directly access the box's vertices (points) and edges (lines between points) to shape the object. At the object's Vertex sub-object level, move and scale vertices to shape the object to fit the image. Be sure to select vertices using a bounding area so you get the ones in the back as well.

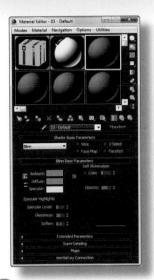

In 3ds Max, create a material with the reference image as a Diffuse map. Set the Self-Illumination value to 100 to make the image show clearly in viewports regardless of the lighting.

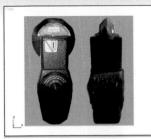

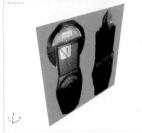

Create a plane in the Front viewport with square dimensions and one segment along each side. Apply the material to the plane, and turn on Show Map in Viewport. Press ☐ to toggle the viewport to a shaded view. Because the map is square, you don't have to be concerned about its aspect ratio.

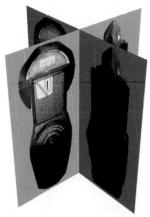

Clone and rotate the plane by holding down Shift while rotating it by 90 degrees. The resulting arrangement, called a virtual studio, provides a framework for creating a 3D model.

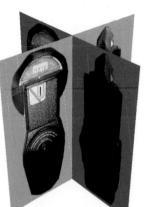

HOT TIP

MeterRef.jpg MeterMap.jpg MeterPole.jpg Meter.max

To speed up the modeling process, model one side of the object and use the Symmetry modifier to mirror it to the other side.

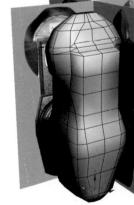

With the help of the virtual studio, finish shaping the object as necessary. If necessary, add more edges with the Cut tool, or with the Connect tool as described in the 15-Minute Building cheat.

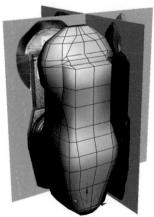

With the use of a TurboSmooth modifier, the result is a correctly proportioned object that looks great when rendered, especially if you use the reference images as a basis for its textures.

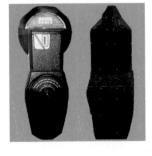

In the Left viewport, move vertices to match the side image.

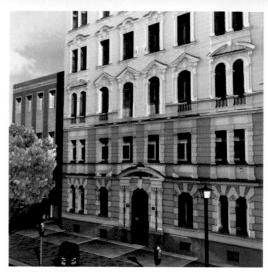

HEN YOU NEED TO POPULATE a scene with buildings, you can do it with a long, arduous process, or you can do it the quick and easy way. Which would you prefer?

The Preserve UVs feature of the Editable Poly object makes it possible to visually shape the building right to the map without leaving the Front viewport.

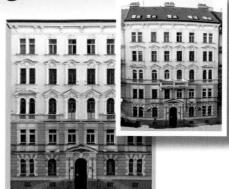

Get a photograph of a building with a nearly straighton perspective. In Photoshop, correct the perspective distortion and clean it up. In this image, I've removed the flag, signage, and balcony from the facade. Note the background color, which is similar to the building color.

Count the number of horizontal segments you'll need to extrude windows and other details. Here, I counted one for the top and bottom of each window with an extra segment for each arched window. There's one segment near the top that will be used to shape the roof, for a total of 16.

Access the Vertex sub-object level. In the Edit Geometry rollout, turn on Preserve UVs. This will keep the map in place while you move vertices. Move each row of vertices to line up with its corresponding horizontal.

Using the windows as a guide, count how many vertical segments will be needed. Select the horizontal edges and use Connect again to add the segments.

In 3ds Max, create a box and map the building image onto it. Assign a UVW Map modifier and use Align to View, Fit, and Bitmap Fit to map the image with the correct aspect ratio. The box won't have the right aspect ratio, but you need to get the image right before you can fix this.

Adjust the box size with parameters only, with the Show End Result On/Off Toggle turned on. If you use scaling rather than parameters, the map won't stay still while you change the box size. Collapse the modifier stack and convert the box to an Editable Poly.

WhtBldgMap.jpg WhtBldg.max

Access the Edge sub-object level and select the vertical edges at the sides of the building. You'll need to make sure Window/Crossing is set to Crossing, and then draw a bounding area across the box horizontally.

Click Connect Settings and choose the appropriate number of segments. The horizontal segments appear on the box. If you can't see them, press F4 to turn on Edged Faces in the viewport.

To force vertices to move along existing edges, turn on the Edge option in the Constraints section of the Edit Geometry rollout.

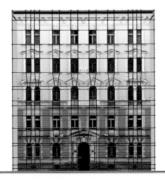

With Preserve UVs on, move the new columns of vertices to line up with windows. Note the adjustment of vertices around arched windows and the sides of the building.

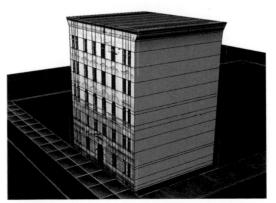

If the texture wobbles as you move vertices, fix it by reapplying the UVW Map modifier. At the Polygon sub-object level, select the window polygons and extrude them inward. Voila! A 15-minute building.

Modeling around maps

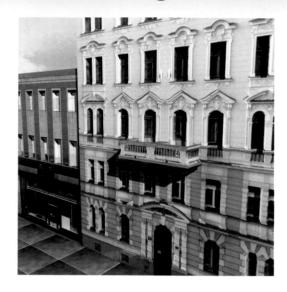

In Photoshop, cut out the balcony and paste it to its own layer. On the facade, carefully paint out the balcony by taking a guess as to what the building looks like in that area. This step was already done in the 15-Minute Building cheat.

HADOW CASTING DETAILS make an important addition to your 15-minute building. A sign hanging off the facade, a balcony, flags, and other doodads multiply the 3D illusion.

The most convincing items use maps you've created from a photo. However, these items are often odd-shaped, and it can be tough to get the object and map to match. By using the Preserve UVs feature, you can use a map placed right on the object as a guide and get the modeling done right-quick.

For the 15-minute building in the previous cheat, the original image shows an ornate balcony. Adding the balcony to the scene as a 3D object adds depth to the rendering without a lot of work.

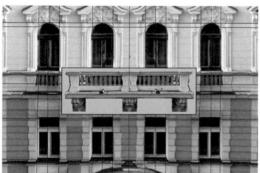

Make a material with the balcony front map and put it on the box. Adjust the size of the box so the map looks right. That means you need to adjust the box until the map is correct, without any regard for whether the box is the right size.

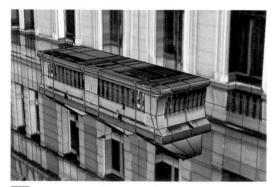

Modeling right over the mapping, rather than modeling and applying the mapping later, makes the process much simpler. Here, I've shortened the sides of the balcony to show only half of the map.

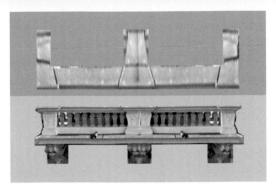

Separate the balcony picture into the front and top views, and save each one as a map. Not much of the balcony top is visible, so I've stretched the image to make its proportions match the balcony front.

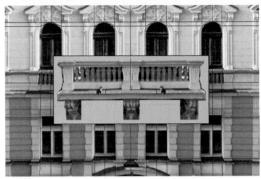

In 3ds Max, create a primitive object a bit larger than the final object. A box works best for the balcony, as it does for most modeling tasks. Create the box in the Top viewport.

WhtBldgMap.jpg BalconyMap.jpg Balcony.max

Make a judgement on the number of segments you'll need to model the object. Here we want sufficient segments for the supports and top detail. Collapse the box to an Editable Poly.

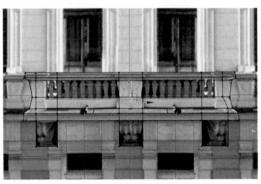

Go to the Vertex sub-object level, turn on Preserve UVs in the Edit Geometry rollout, and move vertices around to fit the map. You might need to delete polygons or use Extrude or Weld to make the right object shape.

HOT TIP

When creating maps from photos, fill in the background with a main color from the map. That way, if the map "bleeds" a little off the sides of the object in 3ds Max, the effect won't be so noticeable.

For the balcony top, select the top polygons and apply a UVW Map modifier to give that area its own Planar mapping, and collapse the stack. Apply a material with the balcony top map to the polygons, and extrude them down.

Add a shadow-casting light, and you have an interesting detail that gives a lot of depth with minimal effort.

3 Modeling

PLAYTIME

Secrets of the spline

SPLINES MIGHT SEEM LIKE a lesser cousin of polygons, but in practice they have many uses. Some types of modeling, such as vehicle and aircraft design, require these smooth curves to define the shape of the object.

Splines have a long history. Back in the shipbuilding days of yore, naval architects created their hull designs by bending a strip of wood over and around a series of weights, creating a smooth curve. The piece of wood was called a *spline*. In computer graphics, this idea was borrowed to create what is now called the spline.

Some modelers avoid splines, saying they take too long to adjust. But if you learn to draw them right the first time (or at least close to right), you'll have the freedom to use splines for the jobs that call for them.

I won't lie and say that drawing splines is intuitive. When I first started using splines, I cursed them more often than anyone. But then I figured out a few key things about them, and now I can draw them nearly perfectly the first time, every time.

The factors that determine the shape of the spline are the placement of the vertices and the curves going in and out of them. You can get a large curve out of just two well-placed vertices. The fewer you use, the easier it will be to adjust the curves.

Start by drawing as few vertices as possible and see what you can get out of that. When drawing a spline, a single click makes a corner vertex, where the spline will go straight in and out of the vertex. To get a little curve on it, drag the vertex while placing it.

The two key points to get into your head are:

You do *not* have to drag all the way to the next vertex before releasing the mouse button. Once the curve looks good for all the vertices drawn so far, release the mouse and move it to the next spot.

You don't even have to drag in the direction of the next vertex. Learn to ignore the line between the last vertex and the current cursor position, as this does not determine the shape of the line. After you drag to make the curve shape, you can release and move the cursor and place the next vertex anywhere you want.

After you've drawn your nearly perfect spline, you can move vertices around

HOT TIP

If you can't move the vertex handles after you've created the spline, press the minus key (-) to shrink the transform so you can get at the handles.

and adjust their handles (if they're the Bezier type). To change a vertex type, rightclick the vertex and choose the new type from the quad menu. If you make a big mess of things, change all the vertex types to Smooth and take it from there.

It takes practice to get good at drawing splines, but really no more than an hour or two. That's all it takes to unravel the secrets of the spline. Just imagine how good you'll feel when you can create them quickly with no muss or fuss.

Curvy curtain

HE NURBS MODELING method uses curves to define a surface, as opposed to polygons. While NURBS caused a sensation when they were first included in 3ds Max back in the 90's, nowadays they're mainly used for specialty modeling of softly curved surfaces. Here, NURBS make an easy, convincing curtain out of a handful of curves.

When making a surface with draping folds, it's important to draw each curve separately. While you could copy a single curve and scale each copy, the final model would have a stiff, computer-generated appearance. When you draw each curve separately, the inevitable differences between each one will result in subtle variations over the length of the curtain, making it look more realistic.

In the Front viewport, select the curve at the top of the curtain. On the Modify panel, in the General rollout, click Attach. Click each curve in descending order.

On the Modify panel, in the Create Surfaces rollout, click ULoft. Click the top curve, then click each curve in succession to create the curtain surface. Right-click to complete creation of the loft.

The ULoft might be inside-out. Choose the Surface sub-object, and click the Surface itself to select it. In the Surface Common rollout, toggle the Flip Normals checkbox to make sure the curtain is facing the right way.

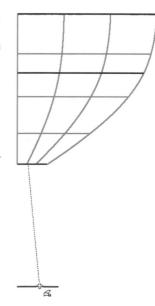

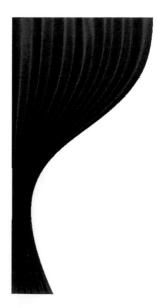

On the Create panel, choose Shapes, and pick NURBS Curve from the dropdown menu. Click Point Curve, and create a wavy curve in the Top viewport to set the shape for the top of the curtain. Right-click to end the curve.

CurtainStart.max CurtainFinal.max

Create more NURBS Point Curves in the Top viewport to set the shapes at different vertical levels along the curtain's length. Make sure each curve has the same number of points and the same pattern of peaks and valleys. You can scale a curve after creating it, or edit points on the Modify panel at the Point sub-object level.

In the Front viewport, move each curve to correspond to its vertical position along the length of the curtain.

In the Top viewport, move the curves so they are on top of one another.

To remove the curvy effect at the curtain's middle, increase the tension on that curve. At the Surface sub-object level, select the surface itself, then select the curve from the list in the ULoft Surface rollout. Increase Tension parameter to 20 or 50. Do the same with the last curve to firm up the curtain at the bottom.

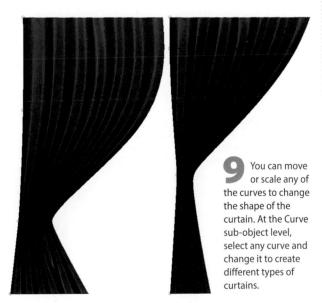

HOT TIP

NURBS stands for Non-Uniform Relational B-Splines. If you're curious about what this means, you can look it up on the Internet. But many artists enjoy long, profitable careers without ever understanding the exact technical details of the NURBS name.

INTERLUDE

How to make a mess with modeling

HEN YOU SET OUT to model an object, your primary concern is to give the model the right overall shape to represent the object. But right behind that concern is the necessity to create a clean model that will be easy to edit, and that will work in a variety of rendering and animation situations.

Consider a toy car model as an example. To create the body of the car, the most obvious approach is to draw a couple of splines to represent the shape, attach them together, and use the Extrude or Bevel modifier to create a 3D object.

While this is all fine and good for getting the basic shape of the car body, consider what happens afterward. The model is not quite smooth enough, so you apply the TurboSmooth modifier, and that's when you experience the disaster. The model collapses into itself and makes a mess. Even if you don't apply TurboSmooth, just try applying a Bend modifier to it to experience a completely different kind of mess.

What went wrong? When you use Extrude or Bevel on a spline, you're taking a gamble with the face structure. To see what I mean, select the object and turn off the Edges Only option on the Display panel. The edges on such an object go every which way, creating long, thin, triangular faces that the TurboSmooth modifier doesn't like.

A better approach is to start with a Plane, convert it to an Editable Poly, and shape the car's

profile by deleting polygons and moving vertices around. Then apply a Shell modifier to give it some thickness, or use Extrude or Bevel at the Polygon level to shape the object. You might need to use the Flip option on some of the polygons to get the object to look right, but it's well worth the trouble. When you apply TurboSmooth to it, the result is beautiful to behold.

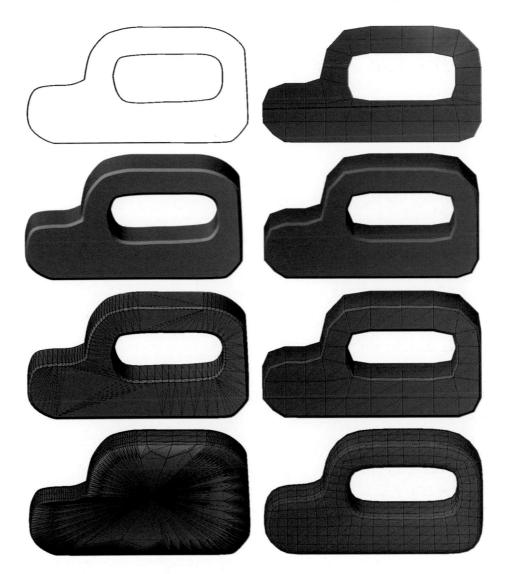

TurboSmooth works well with three-sided and four-sided polygons of a fairly regular shape and size, but not so well with any other kind. Modifiers like Bend and Taper work best with these types, too.

In general, you can use splines all you like with the Sweep and Lathe modifiers, and as Loft paths. Using the Extrude and Bevel modifiers with splines works fine with a boxy object that isn't going to be smoothed. But if you plan to use TurboSmooth with an object, use the Plane modeling method instead.

3 Modeling BYO weapon

HE GAME STARTS
in an hour, and you
want to bring a custom
weapon. What's a modeler to
do?

This speed-modeling technique starts with a plane rather than a box, cutting in half the number of vertices you need to deal with in the first phase of modeling. The Shell modifier makes it 3D. After that, all you need is a bit of shaping and a texture, and you're good to go.

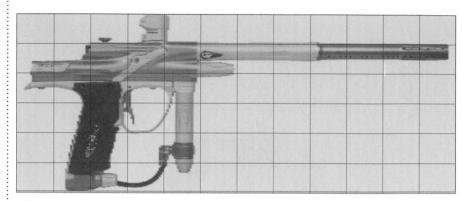

Create a plane the same size as the reference image, with sufficient detail to model the major shapes of the object. Use Alt+X to make the plane see-through so you can see the reference.

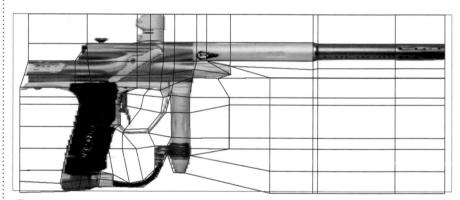

Convert the plane to an Editable Poly. Move the plane's vertices to fit the major parts of the object. As necessary, use Connect to create more edges, weld vertices together, and create new edges between vertices.

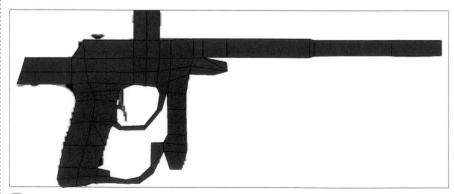

At the polygon sub-object level, delete all the polygons that do not form parts of the object.

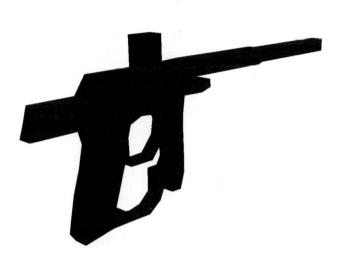

0

Gun.max GunMap.jpg

Apply the Shell modifier to the object to give it some thickness. Collapse the object and convert it to an Editable Poly, and shape the object a bit more where needed.

HOT TIP

When an object has open areas such as the trigger area on the gun, starting with a box would require you to bridge edges after cutting holes. Using a Plane with the Shell modifier eliminates this modeling step.

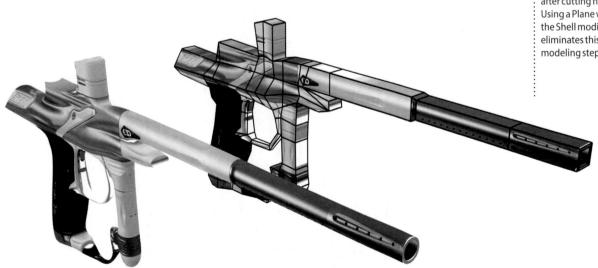

Pull out a few edges and scale down some of the polygons, and you have the basic weapon shape. Apply TurboSmooth, and set the Crease value at the Editable Poly's Edge sub-object level to 1.0 for edges that need to keep their shape. With the reference image as the texture map, you have a weapon that isn't perfect in every detail, but is good enough to get you in the game.

Modeling for the masses

N MY WORK AT TurboSquid I see all kinds of 3D models. TurboSquid.com is the world's largest marketplace for 3D artists to sell their work, and every month about 4500 models are uploaded in every category from Accordions to Zombies.

A few years ago we noticed a shift in customers' demands. When TurboSquid was started in 2000, customers were happy to get any old 3D model no matter what the topology looked like. Then sometime after 2005, the buyers started to get pickier. The complaints came in roundabout ways like, "I merged all these models together in a scene and some of them were way too small," or "I tried to rig this model but it got all crumpled when I animated it."

It became obvious after a while that we needed to put out some kind of standard for our seller artists to follow. But first we needed to nail down what customers were actually asking for, which was a trick in itself. After interviewing and surveying customers in every industry about their workflows, habits, needs, and difficulties, TurboSquid released the CheckMate Pro standard in August 2011. Since then, hundreds of our artists have taken the standard to heart and produced CheckMate-certified 3D models.

Because the standard is designed for professional artists to use in any production workflow, it works for pretty much any client. The standard is published at the TurboSquid website and is free for you to use in your own work. We also have a lot of "best practices" videos on YouTube, and MAXScripts you can run to check your model and see if it meets the standard.

Here are the main points of the CheckMate Pro standard, some of which you'll recognize as good practices mentioned elsewhere in this book.

- Model to real-world scale. Set and use units within 3ds Max, whether it's inches, centimeters, or meters.
- Model with quads (four-sided polygons). Use triangles when you have to, but never use polygons with more than four sides.
- Clean up your models, removing isolated vertices and coincident faces, and fixing flipped normals. In 3ds Max, XView can check for these types of problems.
- Map your models carefully, using unwrapping and other techniques to avoid stretching and other obvious artifacts.

While many of these rules might seem like common sense, you might not have realized how universal they are. Clients working in games, films, TV, and architectural visualization all have similar needs.

I invite you to use the CheckMate Pro standard for your own work. If you follow these rules from the start, they're not hard to incorporate into your 3D models.

Michele Bousquet

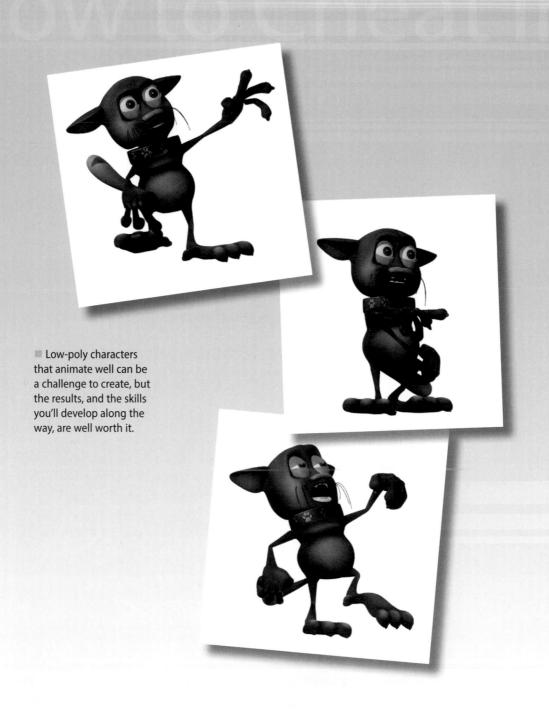

4 Character Modeling

ODELING CHARACTERS is one of the most appealing uses for 3ds Max. We've all seen great animation and stills featuring characters seemingly sculpted from nothing into living, breathing people.

Your main tool for character modeling is persistence. Character modeling takes skills that you might not have coming into the field of computer graphics, but you can develop these skills with practice.

When learning these techniques, a rule of thumb is that your first character will take a week to create and will look absolutely terrible; the second will take half the time and look twice as good; and successive attempts will continue to take exponentially less time and look even better. If you keep at it using the techniques described in this chapter, you'll eventually get where you want to be.

Character references

EFORE YOU START modeling, you'll need good reference images to work with. At the very least, you'll need one image for the front of the model, and another for the side. The images don't have to be highly detailed, but they do need to provide enough information to create the basic shape of the model. If you don't have the skills to photograph or draw the images, get an artistic friend or colleague to help.

For highly detailed areas, such as the face or an intricate piece of jewelry or clothing, you can create a separate set of images and use them after you've completed the bulk of the model. Even with good reference images, after modeling the character you'll need to complete the finishing touches by visually checking the model itself against your vision of what it should be.

Starting with useful reference material is key to creating appealing characters. Time spent up front to make or get these images will pay off many times over in the time you'll save while modeling.

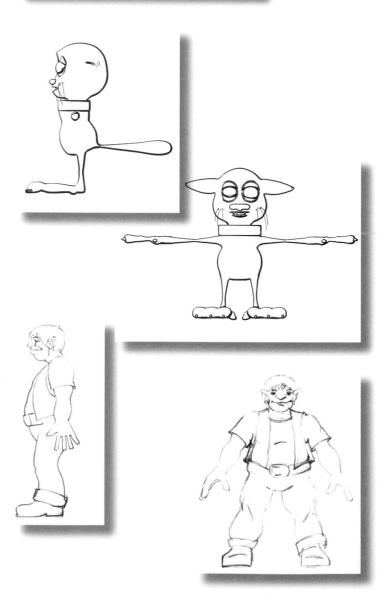

Reference images can be drawings or photos, or combinations of the two. Making the outlines of the character's body clear is more important than color. The front reference image should show the character standing straight with its arms away from its sides, and its legs slightly apart. Facial reference should show use a neutral facial expression, or at least the same expression in both pictures.

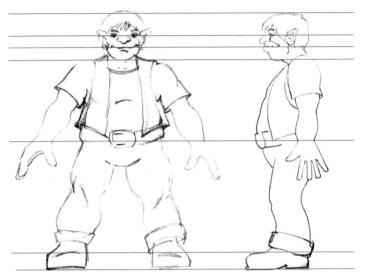

Using Photoshop, resize front and side images so the character is the same height in both images, and major areas of the body or face line up. It can be helpful to put both reference images into the same image and use guides to line up the images.

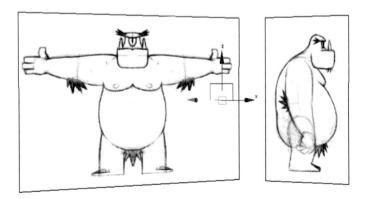

Map the reference images onto two perpendicular planes in 3ds Max, leaving enough room to create the model where the two images intersect.

SethFront.jpg SethSide.jpg OgreFront.jpg OgreSide.jpg CatFront.jpg CatSide.jpg

HOT TIP

For a body side reference image, it can be helpful to erase the arms to make it easier to see the shape of the body from the side.

Character Modeling

Character modeling process

O MODEL ANY CHARACTER, you'll use the same general process in 3ds
Max. As with sculpting, you'll start with
a simple object like a box or cylinder, and mold
and shape the character using a variety of tools.

This is a basic overview of the process; the tools themselves are described in more detail in subsequent topics.

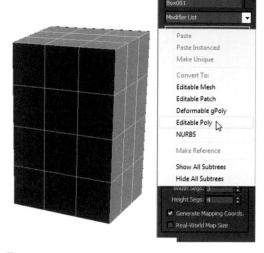

After you've set up your reference images, start with a box. Convert it to an Editable Poly so you can access the Polygon and Vertex tools.

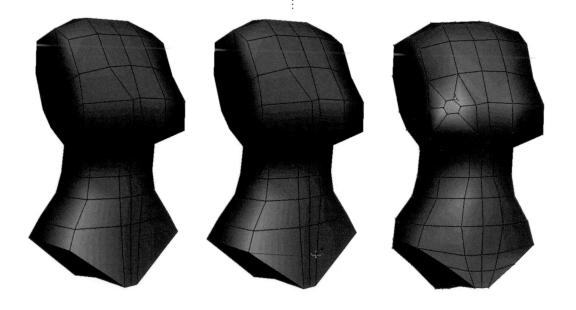

Add more detail and shape to the torso using Cut, Connect, Chamfer, and other cutting and refinishing tools described in the topic Chop Shop. You'll also need to clean up the edge flow with the tools in the Nip and Tuck topic.

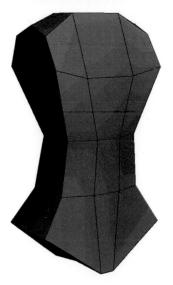

At the Vertex sub-object level, move vertices around to give the torso its general shape to match the front and side reference images.

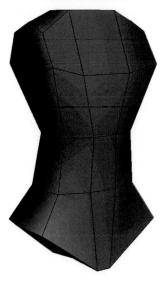

Smooth out the shading to see the torso's shape more accurately. See the Polygon Building topic for details.

HOT TIP

If you've never created a character before, sculpting it in clay first can be very helpful to the process.

Form polygons on the body where the arms and legs will come out. Extrude the limbs, then form the hands and feet.

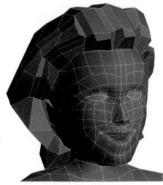

Using a separate set of reference images, model the head and hair.

Character Modeling

Chop shop

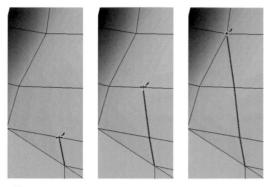

To create more polygons, use the Cut tool at the Edge sub-object level to cut new edges.

UTTING AND RESTRUCTURING your model's polygons is an inevitable part of character modeling. Although Editable Poly and Editable Mesh have numerous sub-object tools, you'll find that you use the same few over and over again. Here you'll find a guide to the most popular and useful tools.

Most of these tools can be found on the Graphite toolbar, where you can easily choose them rather than hunt for them on the command panel.

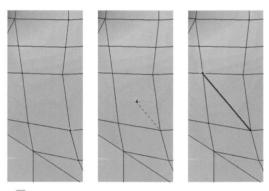

You can draw a new edge in a specific place with the Create tool at the Edge sub-object level.

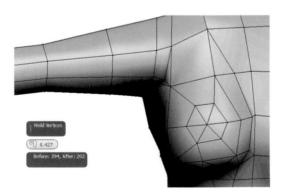

Every once in a while during your chopping session, you should use Weld to clean up coincident vertices. Extra vertices are a common cause of pinching.

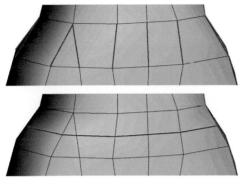

You can also use the Connect tool to create new edge loops around a specific area.

The Chamfer tool creates two edges from one. This tool often requires cleanup afterward with Target Weld.

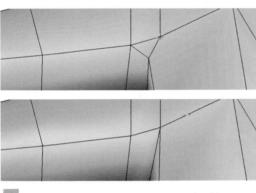

Target Weld at the Vertex sub-object level welds one vertex to another. This is helpful for cleaning up areas with too many small polygons, which can cause pinching.

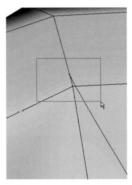

The Collapse tool at the Vertex sub-object level, similar

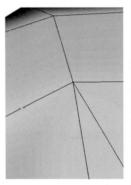

to Target Weld, automatically welds all selected vertices into one.

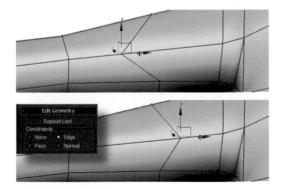

When you move vertices around, use the Edge constraint to keep them moving along the model's surface and not out in space.

Before extruding limbs, use Make Planar at the Polygon sub-object level on the polygons you plan to extrude. This will give you a flat area to extrude cleanly.

HOT TIP

When cutting a new edge between two existing vertices, use Create to draw the edge rather than Cut. Using Create will avoid duplicate vertices that need to be welded later on.

4

Nip and Tuck

N YOUR QUEST for a well-built model with three-sided and four-sided polygons, you will do a lot of plastic surgery on your model. Even if the shape of the model is right, you'll need to clean up edges to make them flow. A model with flowing edges doesn't pucker when you apply TurboSmooth, and will deform smoothly when animated.

Before checking for problem areas, be sure to smooth the model using the technique described in the Polygon Building topic.

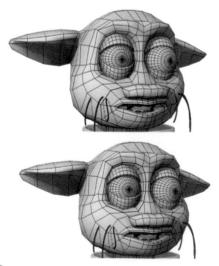

An edge loop is a series of consecutive edges forming a closed loop on the model. Edge loops make for smoother subdivision, and allow the model to deform more cleanly during animation.

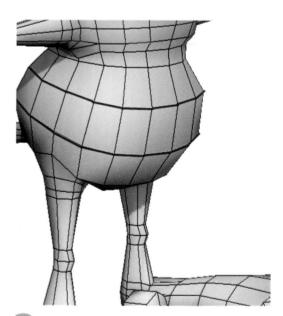

Whenever possible, form edge loops around major body areas. Use cutting and welding as much as necessary to make the loops flow.

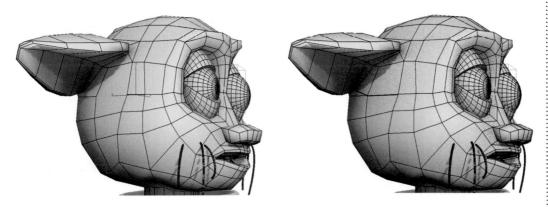

Clean up any edges that end abruptly by cutting or creating new edges.

Use the Symmetry modifier to allow you to model just one side of the model and have it mirror to the other side. After you use the Symmetry modifier for the last time, collapse the stack and some asymmetrical details.

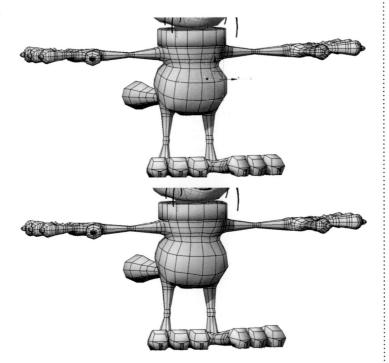

HOT TIP

If your model puckers at any given spot, you might need to weld vertices. **Cutting edges** sometimes creates new, extra vertices on top of existing ones, leading to puckering. Sometimes, the puckering is visible only when you render, or when you apply TurboSmooth.

4

Polygon building

OMETIMES YOU'LL make such a mess of things that you have to delete polygons and make new ones from scratch.

Although you won't need ths skill often, when you do need it, you'll really need it. If you know you can create polygons at will, you won't be afraid to cut and chop in your quest for the perfect construction.

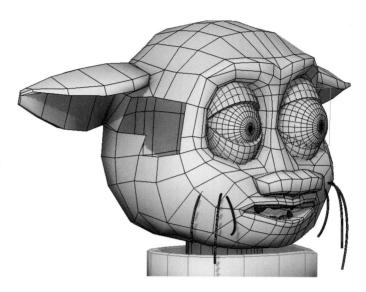

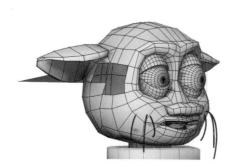

When drawing polygons from scratch, take care to click actual vertices on the model. Otherwise, the vertices will end up out in space.

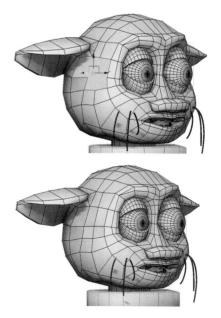

Instead of drawing polygons from scratch, you can select the open hole at the Border sub-object level of an Editable Poly, and use the Cap tool to close it up. You'll need to create new edges through the cap to make three-sided and four-sided polygons.

To delete polygons, simply select them at the Polygon sub-object level and press Delete. To draw a new polygon, click Create at the Polygon sub-object level, then click three or four vertices to outline the polygon, and click once more at the starting vertex to finish. Be sure to click vertices in sequential order and in a counterclockwise direction. Going counterclockwise will make the polygon's normals face the correct direction. If you use a clockwise direction, you'll have to flip the polygon's normals after creating it.

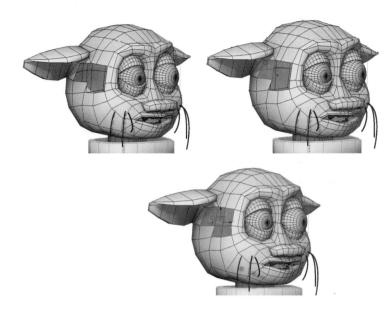

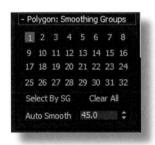

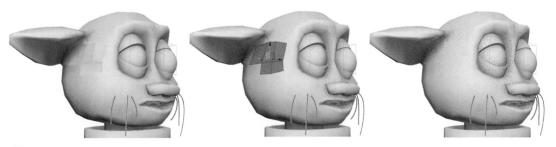

Newly created polygons won't appear smooth as they won't be in the same smoothing group as surrounding polygons. While looking at the Polygon Smoothing Groups rollout at the Polygon sub-object level. select one of the polygons near the new polygons and note which smoothing groups the polygon belongs to. Then select the new polygons, and assign them to that smoothing group.

Character Modeling

4

Subdivision

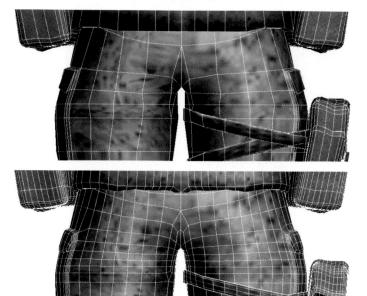

HE TURBOSMOOTH and MeshSmooth modifiers subdivide a model into more polygons, smoothing out the model in the process. MeshSmooth has more parameters, but TurboSmooth uses less memory and updates faster. For this reason, TurboSmooth has become the subdivision modifier of choice for 3ds Max modelers.

When modeling, try to keep all polygons three or four-sided. Such a model animates better, and also works well with the TurboSmooth modifier.

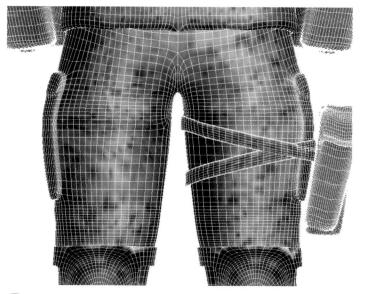

With the TurboSmooth modifier, a value of 1 or 2 for Iterations is usually plenty. To keep viewports updating quickly, you can set the Render Iters parameter to 1 or 2 and leave the Iterations parameter at 0, which will make the model render with the Render Iters value but not show it in viewports.

To make edges keep their shape when TurboSmooth is applied, increase the Crease parameter at the Edge sub-object level to 1.0.

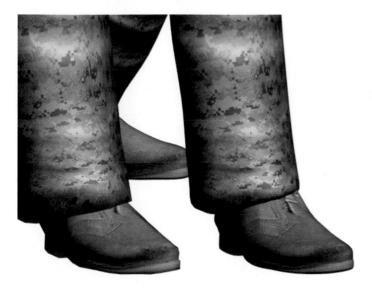

If you want to apply a subdivision modifier like TurboSmooth to a skinned model, always apply it above the Skin modifier on the stack.

HOT TIP

The Subdivide modifier, while originally designed for radiosity renderings, can also be used to create more detail only in areas with larger polygons. Adjust the Size parameter to limit the effect to the largest polygons.

Character Modeling

Poly modeling in practice

OX MODELING a low poly character is one of my favorite things to do. If you have good reference and follow it, your experience will be much better. If you're new to box modeling or just want to play around, a cartoony character like this anthropomorphic cat from one of my star students Tetyana Rykova is great to work with. This little guy was modeled and used in as entry in an 11-Second Club competition animation.

In the side view, move vertices around to line up polygons for the arm holes, one on each side of the body. You might need to use Connect at the Edge sub-object level to cut more edges. Select the armhole polygons, and Bevel or Extrude to get the basic arm shape. Then move vertices to shape the arms.

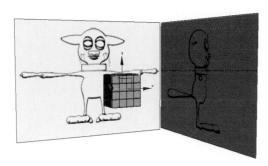

Create or obtain front and side views of the character (called a model sheet in the 3D biz), and use it to create a virtual studio in 3ds Max. Create a box with 1-4 segments along the height, width, and depth.

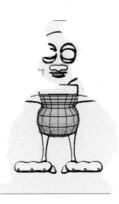

Make the box see-through, and collapse it to an Editable Poly. At the Vertex sub-object level, shape the box to match the character's torso. Move vertices at the corners of the box to make it rounder.

CatFront.jpg CatSide.jpg

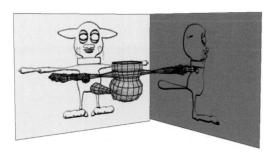

At the end of each arm, use Connect to cut extra edges for fingers. Bevel polygons with the By Polygon option turned on to create separate fingers.

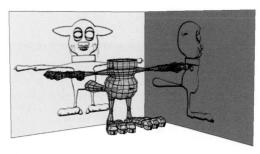

In the same way you did the arms, extrude the legs and feet and shape them at the Vertex sub-object level. Then use Bevel to create the head, and shape it the same way.

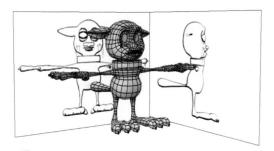

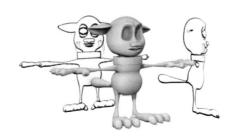

Apply the TurboSmooth modifier for some instant gratification. If TurboSmooth makes the model too squishy, select some of the edges and add additional edge loops in those areas. This will hold the edges in place even when TurboSmooth is applied. Continue working with the model, using the same tools to extrude and shape any additional character elements.

INTERLUDE

Making animatable models

NOT ALL CHARACTER MODELS ARE created equal. A model that looks great in a still rendering is not necessarily going to animate well. This is why, when you're modeling a character, you need to pay attention to how you construct it in addition to how it looks when rendered.

Characters that animate well have these attributes in common:

The model consists of three-sided and four-sided polygons only. These types of polygons are necessary for smooth edge flow, but that's not all. Many game engines work only with three-sided or four-sided polys, and the TurboSmooth modifier itself behaves correctly only with these types of polygons.

Polygons are evenly sized and spaced. Long, thin triangles are bad news in a character model. Remember that when a character's arm or leg bends, the polygons themselves don't bend. You need enough evenly-spaced detail to make smooth bends at the character's joints.

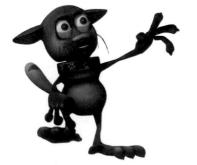

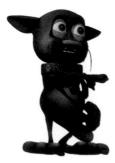

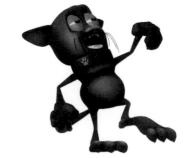

Edges follow natural bend and crease lines. When you sit, there's a natural V-shaped crease where your thighs meet your hips. When you bend your elbow, there's a natural crease where the wide part of your lower arm meets the upper arm. Make edges on your character to follow these natural creases.

Both visible and hidden edges flow smoothly. The Editable Poly is the form of choice for many character modelers because of its toolset, as compared with Editable Mesh. The catch is that a four-sided poly has a hidden edge that, if turned in the wrong direction, can wreck the smooth flow of faces.

Subdivision is used intelligently. If the model has three-sided and four-sided polygons and uses creasing where needed, you can create it with a low number of polygons, skin the model with ease with the Skin modifier, then put the TurboSmooth modifier above the Skin modifier on the stack. The result will be a model that animates easily and accurately, updates quickly on screen, and renders beautifully.

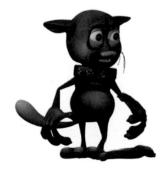

5Materials

HAVING GOOD TEXTURES is half the battle in making realistic materials. The other half is knowing how to create materials with the textures, and how to get them onto objects with the right orientation and size. While a map is 2D and provides color information only, a material has a 3D aspect to it. Shininess, bumpiness, and transparency are all set within the material. You define a material with one or more maps, and then assign the material to a 3D object.

In this chapter, you'll learn how to create materials and apply mapping to suit your scene.

5

Material Editor basics

HE MATERIAL EDITOR is the heart of all materials and mapping. Here is where you specify the maps that will be applied to the object. This topic is a quick guide to the Material Editor tools you'll use the most often.

As of version 2011, 3ds Max has two different material editors: the compact Material Editor (the only version before 2011) and the Slate Material Editor. This topic covers the Slate version, which gives you a graphical representation of the material.

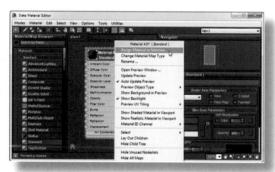

To assign the material to an object in the scene, first select the object, then right-click the Material header and choose Assign Material to Selection from the pop-up menu.

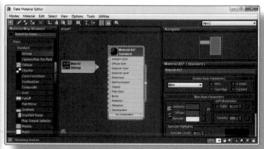

To assign a bitmap as the material color, scroll down the Material/Map browser display to find the Maps listing.

Drag a bitmap node into the Active View, and choose a bitmap with the Select Bitmap Image File dialog.

To show the map on the object in viewports, select the Bitmap node and click the Show Shaded Material in Viewport button on the toolbar. The color on the Bitmap node change to a two-color display to indicate the map is being shown the viewports.

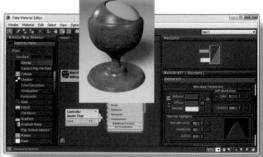

To make the material shinier, scroll down the Parameter Editor to locate the Specular Highlights parameters. Adjust the Specular Level and Glossiness parameters to change the material's shininess. The shininess changes in both the viewport and renderings.

Open the Slate Material Editor by pressing the M key or clicking the Material Editor button on the toolbar. To start a new material, locate the Standard material in the Material/Map Browser under Materials > Standard. Drag the Standard material type to the right side of the Active View to create a Material node and start a new Standard material.

To change the material color, double-click the Material node header to make the material parameters appear in the Parameter Editor. Click the Diffuse color, and change the color in the Color Selector.

HOT TIP

To switch between the Slate and Compact Material Editors, use the Modes menu on either one.

Connect the new bitmap node to the Diffuse Color slot on the Material node. To see the Controller Bezier Float noded right-click, and chosen to Show Additional Parameters and selected Show All. This value represents the Diffuse color amount. A value of 1.0 means the bitmap will be used for the full color.

To make the material bumpy, create a Noise map node and attach it to the Bump node of the material. Another Controller Bezier Float node appears. To make sure you know which one goes with which map, expand the Additional Params and Maps rollouts on the Material node.

Double-click the Noise map node to see its parameters in the Parameter Editor. Click Show Shaded Material in Viewport to see the Noise map on the object, and increase the Tiling parameters. You'll need to render the viewport to see the Diffuse and Bump maps working together.

Mapping coordinates

APPING IS A METHOD of specifying the orientation and size of maps on an object. For mapping, 3ds Max uses a special coordinate system that works with both flat and curved sections of objects. When you apply a material to an object, the object's own mapping coordinates determine the textures' orientation and size.

Every primitive, and just about every other kind of object you can create in 3ds Max, has mapping coordinates assigned to it by default. You can change the default coordinates by applying a UVW Map modifier to the object, where you'll have a selection of mapping types to choose from. In practice, you'll use just two or three of them for the majority of your work.

Every primitive in 3ds Max, and most other objects, have default mapping coordinates applied. As you'd imagine, the default mapping coordinates correspond to the general shape of the primitive.

Box, Spherical, and Shrink-Wrap have specialty uses for certain types of objects. You will rarely use the other types available with the UVW Map modifier.

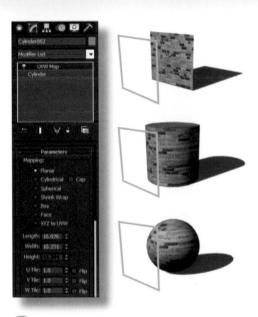

To change the mapping coordinates, apply a UVW Map modifier. The default setting for this modifier, Planar, projects the map onto the surface. This is the mapping type you'll use most often.

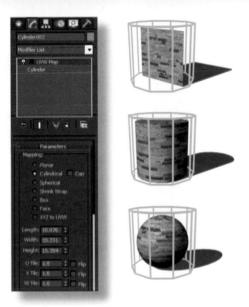

Cylindrical mapping looks good on curved surfaces, but warps at the edges of flat surfaces. This is the mapping type you'll use occasionally, mostly for round surfaces.

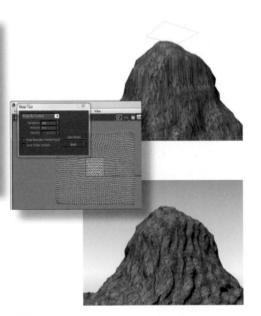

On a lofted object, you can use the Apply Mapping option to apply custom mapping coordinates that follow the loft path. For objects that follow a spline but aren't created with lofting, you can use the Unwrap UVW modifier's Spline Mapping feature.

When mapping coordinates from the UVW Map modifier don't give you exactly what you need, you can use the Unwrap UVW modifier to fine-tune the mapping. See the Unwrapping the Mapping topic for details on this feature.

HOT TIP

3ds Max uses UVW as the letters for its coordinate system to avoid confusion with the XYZ coordinate system used to designate 3D space.

Preparing textures

OOD TEXTURE MAPS are the key to believability in your renderings. Realistic textures can bring a crude model to life, but it doesn't work the other way around. If your textures aren't up to par, your rendering will suffer accordingly.

Rather than paint your own textures, start with photographs as a base and do a bit of cleanup in Photoshop.

A straight-on photograph of an object makes an excellent basis for a texture map. In Photoshop, remove perspective with the Warp and Distort tools and clean up the image.

If the map doesn't match the object exactly, the background color will "bleed" onto the object. Use Photoshop's Smudge tool to push the edges of the image and make it larger.

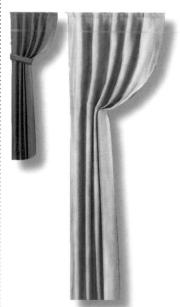

If you need a Bump map, make a grayscale version of your texture map and increase the contrast so you have a range from black to white.

Tiny shadows in crevices can be hard to produce with lighting and shadows alone. Build these shadows into the texture itself for a more realistic rendering.

You can also create textures right in 3ds Max by rendering an orthographic viewport. This is a great way to make animated textures for television and monitor screens.

To make a map tileable, cut it into four equal quadrants and swap each one with its diagonal counterpart. Clean up the visible edges in the middle, and the result is a tileable map. This technique is particularly good for landscape elements that need to be tiled over a large area, like grass, rocks, and sand. Use a lexture like this with the Gradual Mix cheat to make a natural-looking landscape.

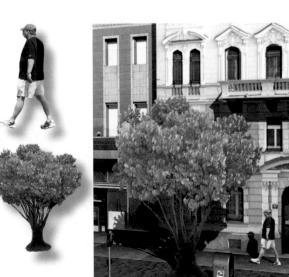

To create interesting shadows without having to model the objects, create a Projector map from a photo. See the Shadows chapter to find out how to use this type of map.

man's Furniture

HOT TIP

To create textures from photographs, you can use the same techniques as those used on reference images in the Modeling chapter.

5

People, trees, and cars

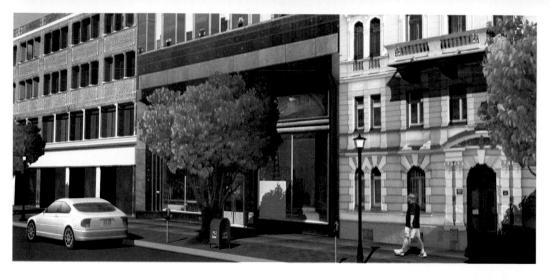

XTRA SCENE ELEMENTS like people, trees, and cars are time-consuming to create as models.

You can save a lot of time by creating these extra elements as textures and mapping each one onto a plane. For a more three-dimensional look, you can also model a simple low-polygon object, and let the textures do most of the work.

In 3ds Max, create a material with the PSD file as the Diffuse map. In the PSD Input Options dialog, choose the Individual Layer option and select the single layer. This ensures that the background area will be transparent. In the Bitmap Parameters rollout, make sure Alpha Source is set to None.

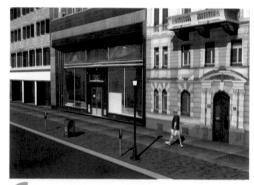

Place a shadow-casting light in the scene with ray Traced Shadows. This will render shadows cast by transparent objects correctly, while a Shadow Map won't.

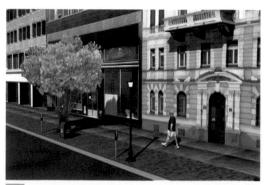

The same can be done with trees. The base of the tree will give away the fact that it's on a plane unless you hide it behind something, such as a mailbox.

Get together a few pictures of elements you want to use in the scene. Action poses work best for people, such as walking or sitting, rather than just standing there. For cars, get side and top photos, and back or front views as needed.

In Photoshop, paste the image onto a transparent layer, and erase the background. The Quick Selection tool can help with large areas, but you'll need to do some custom cleanup around the edges. Save each image as a PSD file.

PeopleTrees.max

In the Compact Material Editor, pick the material from the scene. Expand the Maps rollout, and drag the map from the Diffuse slot to Opacity slot as a Copy. Click the map in the Opacity slot, and set Mono Channel Output to

Alpha. This will enable the renderer to generate shadows for the object. Change the Sample Type to a cube and turn on the Background option to check that the map background is transparent.

Create a plane in the scene and assign the material to it. Turn on Show Standard Map in Viewport to see the image in the scene. Assign a UVW Map modifier to the plane, and use View Align, Fit, and Bitmap Fit to ensure the mapping matches the PSD file's aspect ratio.

HOT TIP

If there are no shadows cast upon the plane in the scene, vou can set the Self-Illumination value in the Blinn **Basic Parameters** rollout to 100 to get the full range of color in the image regardless of the scene lighting. However, self-illumination will also prevent the plane from receiving shadows from other scene elements.

To darken the shadowy area of the tree, use a Mix map and mix the tree with black, with a black-to-white Gradient map to determine the Mix Amount.

A car can also be mapped onto a plane or created as a low-polygon object. Although it won't hold up to close scrutiny, it's fine as an auxiliary element.

Multiple maps

OU WILL OFTEN NEED to map several different textures onto one object. There are many ways to do this, but the one shown here is the quickest.

The key is to assign each material to an appropriate selection of polygons. The result is an automatic Multi/Sub-Object material with exactly the right materials in the right places.

This technique uses the Compact Material Editor, where it's easier to copy materials than in the Slate Material Editor.

In the Compact Material Editor, select a material slot, click the Diffuse color for a new material, and change the color to the general color of the object. Assign the material to the object. Drag the material to another slot to make a copy, and give it a different name. In this second material, assign the texture map you want to use on just one part of the object.

Choose the Bitmap Fit option on the UVW Mapping modifier, and pick the texture map. This will resize the gizmo to the same aspect ratio as the bitmap.

Access the main level of the UVW Mapping modifier, and right-click it. Choose Collapse All to collapse the modifier stack. This embeds the mapping in the selected polygons.

At the Polygon sub-object level, select the polygons to which you want to apply the texture map. Assign the material to the object while still at the Polygon sub-object level. This assigns the material to the selected polygons only. Press F2 to toggle selection display so the selection is outlined in red, rather than displaying the face as solid red. This way you can see the texture you've applied.

With the polygons still selected, apply a UVW Map modifier to the object. Use the View Align and Fit options to line up the gizmo with the approximate size and orientation.

MailStart.max MailFinish.max USPS_Logo.psd USMail.jpg

If the texture needs to be moved or scaled, access the Gizmo sub-object level of the UVW Mapping modifier, and move or scale the gizmo.

If the map is a decal (meaning it's not meant to be tiled), turn off the Tile checkbox for both U and V in the bitmap's Coordinates rollout in the Material Editor.

Select another set of polygons and repeat the process: Assign a material, apply a UVW Map modifier, adjust the gizmo, collapse the stack. Repeat this as many times as needed to map the entire object.

After assigning multiple materials, click an empty sample slot in the Material Editor and use the eyedropper to pick the material from the object. The material is a Multi/Sub-Object material with all sub-materials assigned appropriately.

HOT TIP

To see the bitmap on the object after assigning the material, turn on the Show Shaded Material in Viewport option on the Material Editor toolbar.

5 Materials

Procedurally speaking

ROCEDURAL maps use algorithms (a series of equations) to generate an individual color pattern. You change the pattern not by painting pixels, but by adjusting parameters.

Although 3ds Max comes with many procedural maps, I use the Noise map and Gradient Ramp map more than all the others combined. With the examples here, it's easy to see why.

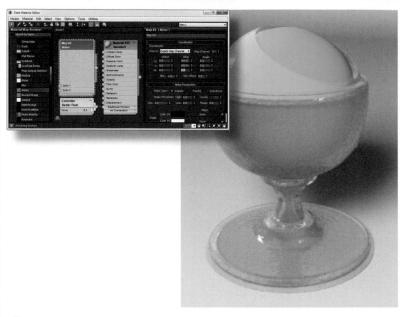

The Noise map makes a random pattern of black and white blobs. This type of map makes a great Bump map to give an object a bit of texture. Change the Source to Explicit Map Channel, increase the Tile values, and turn on Show Standard Map in Viewport to see how the map lies on the object.

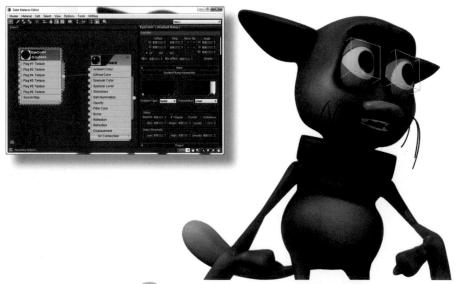

The Gradient Ramp map makes a gradient from a series of colors. The Radial type creates concentric circles, and the Solid Interpolation setting makes great cartoon-style eyeballs.

The Noise map, like many maps, can be nested. In other words, the black or white channels in a Noise map can lead to another Noise map, or any map for that matter. Here, a Noise map is used as a background. The Size parameter is turned down low and the Noise Threshold: Low value is increased to reduce the amount of white. This produces a field of white stars on a black background. Then the black channel holds another Noise map made up of larger blobs of dark blue and purple, creating a rich background for a space scene.

with a small Size setting, increase

HOT TIP

If a Noise pattern is still too large the Tiling values in the map's Coordinates rollout. Procedural maps don't always appear accurately in viewports, so be sure to render the scene to see what the map really looks like.

You can also use a Gradient Ramp to generate rings of varying colors. Here, the Gradient Ramp map in the Diffuse channel is coupled with a Noise map in the Opacity channel to create the semi-transparent rings around a planet.

Gradual mix

LARGE LANDSCAPE might call for gradual changes from one kind of ground cover to another. Examples are grass and dirt on a forest floor and rocks and snow on a mountaintop.

There are a number of ways you could create the texture map for such a landscape, such as mixing two maps and using a Noise map to vary it across the surface. But with that type of setup, it's hard to control where each map appears on the terrain.

Instead, you can use vertex painting to put different maps on specific areas. This technique gives you fine control over the final look of the landscape while retaining natural-looking variations from one map to another.

Create a terrain object with any method and apply a VertexPaint modifier to it. In the VertexPaint dialog, turn on Vertex Color Display - Unshaded. By default, all vertex colors are white. You'll use the VertexPaint tool to paint some of the vertices black.

In the Material Editor, create a Standard material with a Mix map in the Diffuse map slot, and assign it to the terrain. Select a Color 1 map for the black areas and a Color 2 map for the white areas. As you assign each map, display it in the viewport with the Show Show Shaded Material in Viewport option so you can adjust tiling appropriately.

Make sure the color swatch in the Paintbox is black. Click the Paint tool and move the cursor over the object to see the disk-shaped Paintbrush tool. Drag the cursor over the object to paint areas black. Here, I've painted the peaks black and left the valleys white.

For the Mix Amount map, choose a Vertex Color map. This will use the vertex colors to determine the amount by which the two maps are mixed. Since you can see only one map at a time in viewports, you'll need to render the image to see the result. You can also paint some of the black vertices back to white to change the effect.

TerrainStart.max TerrainMix.max

HOT TIP

To see the ground cover bitmap on the object without the vertex colors, turn on the Disable Vertex Color Display option in the VertexPaint dialog.

Unwrapping the mapping

APPING A vertical surface like a mountain presents specific difficulties that can be solved only with the Unwrap UVW modifier.

This powerful tool can be used in a variety of situations. Here it's used to clean up mapping artifacts on a vertical surface.

Learning to visualize how the Edit UVWs dialog relates to the object takes some practice, but it's well worth the time spent. Once you know how to unwrap your UVs, you'll be able to map any object with ease regardless of its size or shape.

Planar mapping works fine for the top of the mountain, but you'll get stripes on the sides due to the map pixels going straight down. To visualize the problem clearly, you can apply a Checker map to the object and see where the checkers stretch.

For extreme vertical areas, you can also reduce the striping further by scaling selected vertices so they use more of the map. Turn on Soft Selection in the lower row of tools below the edit window, and move and scale vertices. Vertices selected in the viewport are automatically selected in the Edit UVWs dialog, and vice versa.

Apply an Unwrap UVW modifier and click Edit, and you'll see why. The vertices in the vertical areas are all bunched up around the center of the mapping coordinates. You'll use the Relax tool to fix this.

Select all the points and choose Tools menu > Relax. Choose the Relax by Centers option with the Keep Boundary Points Fixed option turned on, and click Apply several times until the distribution evens out.

MountStart.max MountUVW.max

If the bitmap is displayed on the object in the viewport, you'll see it change interactively as you move vertices around in the Edit UVWs dialog. The result is a mountaintop with an evenly distributed texture and no obvious stripes due to mapping.

HOT TIP

You can display a bitmap in the Edit UVWs dialog to help you visualize how the map will fall on the object. If a material with a Diffuse bitmap has been assigned to the object, you can pick the bitmap from the dropdown list at the top of the Edit UVWs dialog. You can also choose PickTexture and pick a new one to display in the window.

Normal mapping

ORMAL MAPPING is a type of bump mapping that produces realistic, detailed bumps. Normal mapping is particularly useful for replacing a high-resolution object with a low-resolution version for medium shots and animation.

While bump mapping uses a grayscale image and distorts normals at render time, normal mapping uses a range of colors to indicate normals pointing in all directions, and replaces the normals entirely at render time.

Drawing a normal map from scratch is a complicated business, so 3ds Max provides tools to create them for you. The Render to Texture tool projects the faces of a high-resolution object onto a low-resolution version to produce the normal map.

Normal mapping works best on curved surfaces, where none of the hi-res object's faces are at right angles to one another. With the right kind of hi-res object, you can instantly get a fabulous-looking low-res object without the overhead of hi-res polygons.

In the Render to Texture dialog, in the Mapping Coordinates group, choose Use Automatic Unwrap for the Object setting. Having the Render to Texture operation unwrap the mapping for you usually yields better results than using the existing mapping.

As long as we're rendering a normal bump map, we may as well grab the hi-res object's texture too. Click the Add button again, and choose DiffuseMap. Set the Target Map Slot to Diffuse Color, and set the map size to 2048x2048.

In the Output rollout, click Add and choose NormalsMap, and click Add Elements to add it to the output queue. Make sure the Target Map Slot is set to Bump. Set the map size to 2048x2048, and turn on Output into Normal Bump.

In the Baked Material rollout, choose Output Into Source and Keep Source Materials. This will cause the Render to Texture operation to automatically assign the new maps to the low-res object's material in their appropriate slots.

Create two objects, one with a high resolution and all the contours modeled, and the other a low-resolution version of the same object. Both objects must have mapping coordinates. Apply a material to the low-res object.

Move the low-res object in such a way that the normals of the high-res object will project onto its surface. Here, I've reduced the radius of the low-res ball so it fits inside the hi-res one.

SoccerBall.max

Select the low-res object. Choose Render to Texture from the Rendering menu, or press the shortcut key 0 (zero). The Render to Texture dialog appears.

In the Projection
Mapping group, click
Pick, and pick the hi-res object.
This adds the Projection
modifier to the
low-res object, and puts a cage
around the hi-res object. This
cage sets the direction of the
face projection from the hi-res
to the low-res object.

HOT TIP

A normal is an imaginary vector (arrow) pointing out from a face or polygon. 3ds Max uses normals to determine how to shade surfaces at render time. For example, if a face's normal is pointing right at a light source, that face will render brighter than faces with normals pointing in other directions.

Click Render on the Render to Texture dialog. The unwrapped texture shows in the Rendered Frame Window, and the new maps are assigned to the appropriate slots in the low-res object's material. An Automatically Flatten UVs modifier is added to the low-res object's stack.

Move the low-res object away from the hi-res one, and render any viewport. The low-res object's material has been updated with the new maps, and it appears with the same colors and contours as the hi-res object.

Concavity

N THE MAXSCRIPT chapter we look at a plugin called Tension. This plugin can be used to make some pretty interesting shaders. Along with its ability to display tension with vertex colors it can also display concavity. Using this we can create a fast dirt shader for a creature.

Apply the Tension modifier to a creature with a good amount of geometry folds and detail. Uncheck Do Compression and Do Expansion from the Tension Parameters rollout and be sure Do Convex is checked under Convexity/Concavity. Also uncheck Relative to Ref. Pos. This will turn off the tension calculations because we don't need them now.

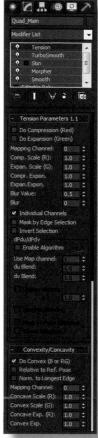

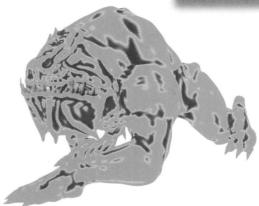

You will need to fine-tune some of the parameters in the Tension modifiers Convexity/Concavity rollout to get a more clamped result. Set the Concave Scale to 10.0 and the Concave Exp to 0.1. This should push the red out more and make it more defined.

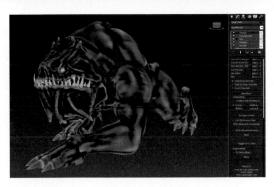

Click Toggle Vert Colors on the Operations rollout to see the character displayed with a green color for the convex areas of the mesh and red for concave.

To use this vertex information in our material we will need to use a Vertex Color map as a mask. Create a Standard material that has 100% Self Illumination so it will be easy to see the blend. Add a Mix map to the Diffuse color slot and pipe in a Vertex Color map to the Mix Amount map. Set your mix colors to green and red and the Vertex Color Sub Channel to Green.

Now we can add a noise map or other grime map to the concave areas. Add a noise map for now and adjust its size to fit the character. Also change the green color to one more fitting the character.

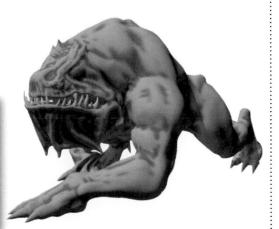

Set the Self Illumination back and tune your maps so that you have an interesting dirt map on the character.

5

Faking subsurface scattering

UBSURFACE SCATTERING is a CG effect that simulates the way light affects thin, convex surfaces such as skin. In life, areas such as the ears begin to glow red as the light gets in and scatters around. Areas that are deep in in a contour don't get as much light and so they don't have that glowing effect. When you can simulate this effect, you can have much more real-looking skin.

While there are tools in 3ds Max for making light affect surfaces in this way, these tools usually cause render times to go through the roof.

So how do we get a subsurface scattering effect without the long render times? In the previous topic, we used the Tension plugin to make a dirt map for your character based on the concavity in the mesh. We can use that same information to get a convincing subsurface scattering effect without the long render times.

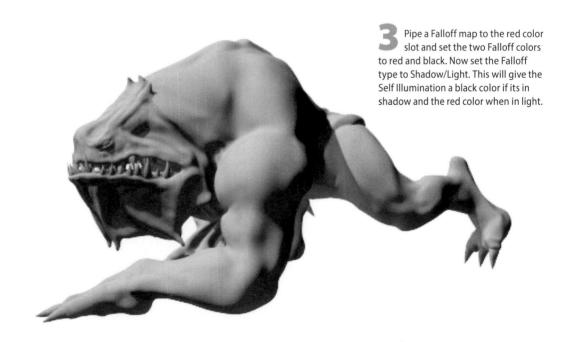

Fake3SStart.max Fake3SEnd.max

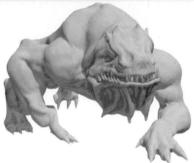

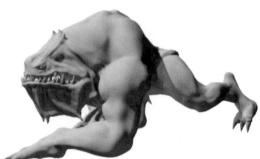

Start with the setup from the last topic and create a Mix map for the Self Illumination map. Use the same Vertex Color map as the Mix Amount and set the colors to red and black. In the root of the Standard material set the Color checkbox for Self Illumination so it uses the map's color instead of just the value. Turn off the Diffuse map so you can easily see what you're doing in preview renders.

The red colors generated by this setup are too bright.
Set the red to be a very deep red and tune it so it looks
like bit of glow under the skin but not too much. The deeper
the red the less of an effect you will get. One thing you
should notice is that we are getting this effect in shadows
too. This is because the effect is driven by the vertex colors
and not the light at all.

Turn your Diffuse map back on and play around with the colors to get a good balance. We are using basic colors and simple shaders here but ideally you would have a unwrapped Diffuse, Dirt, and Self Illumination map. Also remember this is is a fake. It looks cool in many instances and is much faster to work with than real subsurface scattering but for high end skin shading MR Fastskin or Vray is recommended.

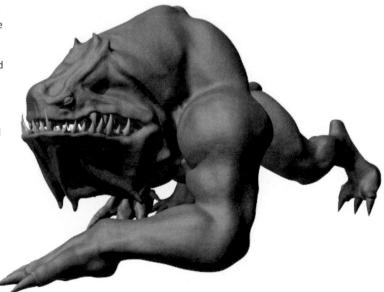

5

Mapping a character

APPING A CHARACTER requires a few special techniques. The use of the Unwrap UVW modifier makes it possible to put all the textures into one image, making a game-ready character that uses as little memory as possible.

Wrapping your head around the Unwrap UVW modifier takes a little practice, but it will open up a new world of texturing to you.

Apply the Unwrap UVW modifier, and click Edit. The mesh displayed in the Edit UVWs dialog represent the object flattened out.

Create selections and seams, and Quick Peel other parts of the body. Flat parts of a character like the bottom of the boot can be planar mapped instead of using Peel.

Once you have all or a significant portion of the object mapped you can apply a material and render our a UVW template to paint in Photoshop. From the Tools menu in the Edit UVW window choose Render UVW Template and render out a template.

Select all the polys and move them out of the mapping space to keep a clear workspace for newly mapped geometry.

Select a body part to start mapping. In this case we'll start with the leg. Select the polygons that make up the leg, making sure you get all the ones around the back.

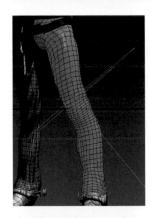

With the polygons still selected, Click on the Point to Point Seam tool.

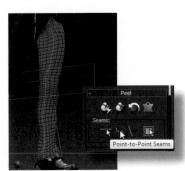

Click Quick Peel and the leg will be unwrapped in the UVW Editor.

In Photoshop paint over the template image to get the texture detail you want on the polygon islands laid out. Once you are pleased with the image bring it back into 3ds Max and apply it.

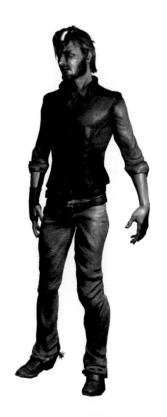

HOT TIP

To make the map easier to see and work with in the Edit UVW dialog, choose Options > Preferences, turn off Tile Bitmap, and use View > Show Grid to turn off the grid display.

Basic mental ray materials

ENTAL RAY comes with a number of preset materials that work "as is" in your scene. Materials that are difficult to create with the Standard type take just minutes when you use the Arch & Design material's presets.

Mental ray materials are available only when mental ray is selected as the renderer. These materials are designated in the Material/Map Browser by a yellow sphere icon.

Note that if you switch back to the default renderer after you assign mental ray materials, you will need to reassign non-mental ray materials to make the scene render properly.

In the Render Setup dialog > Common tab, change the renderer to NVidia mental ray. Open the Slate Material Editor, where the mental ray materials will now be available. Drag an Arch & Design material into the Active View.

Experiment with more templates, and note how they change the Diffuse, Reflectivity, and Transparency settings. Also, look for the Bump and Displacement settings in the Special Purpose Maps rollout. Many templates automatically assign textures to these parameters.

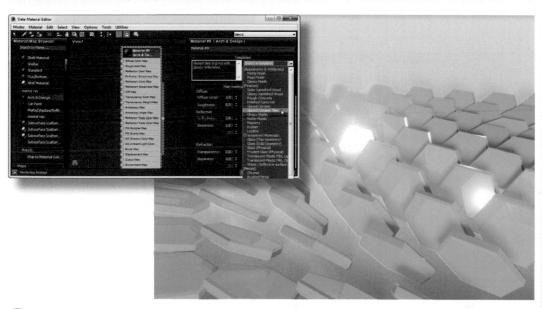

On Double-click the material node to see the material parameters. To get started, choose a template from the Select a Template dropdown and assign the material to an object in the scene. Choosing a template sets the material parameters to appropriate values, but the preset name doesn't stay with the material. Try a new template, change the Diffuse color swatch, apply it to an object, and render. Set the output resolution low to keep the rendering time reasonable.

Where mental ray really shines is with hard-to-get-right materials like glass. Here, I've applied the Glass (Physical) template to the pint glass. At any time, you can change the parameters on any rollout to change the object's color or appearance.

The Water, Reflective Surface template gives you instantly believable water. With just a quick change of the Diffuse color, you can make it match your scene. In the next topic, Custom Mental Ray Materials, you'll learn how to use your own maps with these templates.

HOT TIP

To keep the rendering time to a reasonable length while getting the benefits of mental ray, turn on Enable Final Gather in the Global Illumination tab of the Render Setup dialog, and set the Presetto Draft.

Custom mental ray materials

HILE PRESET MATERIALS can get you through some of your projects, to really make use of mental ray you'll need to use your own bitmaps and textures. To create a 3D version of this 17th-century ornamental carving, I used mental ray to make all those nooks and crannies really pop.

Before you start using mental ray, create Standard materials for the object as usual.

Remove the default map assigned to the Arch & Design material by selecting and deleting it. Connect the Diffuse Color map from the original material to the Diffuse Color map for the Arch & Design material. Render the scene to see how the material is coming along. Here I've assigned the material to the leaves only.

Replace the Reflection Color map with the same map as the Diffuse map. In the case of Masonry, this will put soft reflections on the object. Replace the Bump map with your original material's bump map. For my model, the bumpiness was a bit high for the leaves, so I reduced the Bump value from 1.0 to 0.6.

Get the maps and materials to the point where the rendering looks pretty good with the default renderer, then assign mental ray as the current renderer (Render Setup dialog > Assign Renderer rollout). In the Global Illumination tab, turn on Enable Final Gather and choose the Draft preset. Render the scene to see if it looks any different. Shown here are renderings with the default renderer (top) and mental ray renderer (bottom). Aside from slight differences in shadows, you won't see much of a change until you assign mental ray materials.

In the same Material Editor view, create a new Arch & Design material. This type of material is available only after you have set the renderer to mental ray, and has a number of presets that make it easy to get a particular look for your materials. Click the Templates dropdown menu and choose a template. For my carving, I chose Masonry. Choosing a template changes the material parameters and assigns default maps automatically. You will make your custom material by replacing the default maps.

Carving.max CarvingMR.max

Use the same method to create mental ray materials for all other parts of the model. Use an appropriate preset as a base for each material, and replace the maps with your Standard material maps as necessary. Assign each material to a Polygon sub-object selection to automatically create a Multi/Sub-Object material made up of mental ray materials. Here, I've used the Vertex Paint method to make a messy wall with the Gradual Mix technique.

You can also use the bump map as a Displacement map. This causes the bumps to look as though they are physically modeled, so they show in profile in the rendering. Note the difference in the the circular center of this model, where the ridges stand out and prevent it from looking perfectly round. I also made it look like an old relic by mixing a bit of the Speckle map with the original bump map and by applying a Noise modifier to the model itself.

HOT TIP

If a bump map creates too hard a line between black and white areas in the rendering, increase the Blur value on the bitmap's Coordinates rollout.

Working with lighting and shadows is a skill you'll need to bring realism to your renderings.

6 Lighting & Shadows

LIGHTING AND SHADOWS ADD REALISM to a rendering, but their purpose goes beyond making a scene believable. Shadows anchor stationary objects to the ground and give flying objects their height. They also give important visual cues about scale and location, object solidity, and time of day.

Once you determine the types of shadows you want to have in your scene, you can choose from a variety of methods to create them. Unfortunately, the best-looking shadows usually take the longest to render. In this chapter, you'll also learn some time-saving methods for realistic shadows.

Lighting & Shadows

1-2-3 Lighting

OR GENERAL LIGHTING, a three-point or four-point system with Standard lights provides general illumination without washing out your scene. 3ds Max lights default to the Photometric type, so you'll need to pick Standard from the dropdown menu before getting started.

A light's intensity is set by its Multiplier value in the Intensity/Color/Attenuation rollout. You can also change it in the Light Lister dialog, available from the Tools menu.

Use the top view of this classic lighting setup (shown at left) and angled view (shown on the right) to guide you in placing lights.

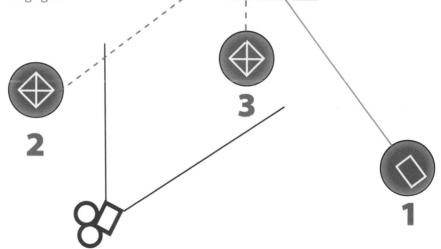

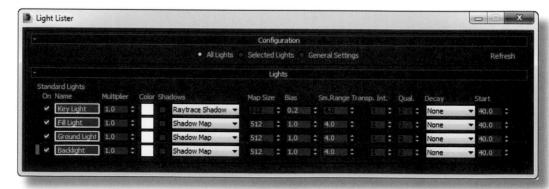

If needed, you can also add an omni light at the back of the scene to light the top of the object. This light, called a kicker or rim light, helps separate key elements from other background objects.

The key light provides the shadow and the bulk of the illumination. Make this light a directional or spot light, and give it the highest intensity of all lights in the scene.

Mailbox.max MailboxLit.max

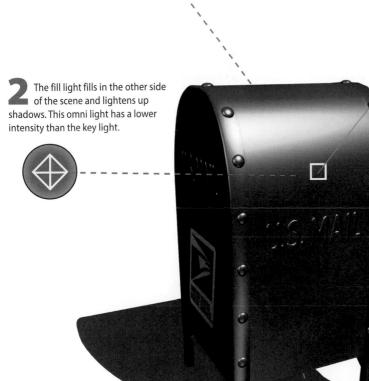

HOT TIP

A light always shines through objects in the scene unless its Shadow checkbox is turned on.

A dim omni light placed under the ground and slightly forward simulates light bouncing off the ground.

Troubleshooting shadows

O YOUR SHADOWS ARE appearing, but they're misbehaving. If you don't know why they're being naughty, you can waste hours trying to make them obey. Check out these common shadow problems and their solutions.

If visible rectangular chunks appear in a Shadow Map shadow, you need more samples. Increase the Sample Range for the shadow to smooth them out.

Sometimes a shadow becomes disconnected from the object that casts it. This effect is most noticeable with thin objects. Reduce the Bias setting for the shadow type to bring the shadow closer to the object.

Spot and Omni lights cast nonparallel shadows (top). Compare with Direct lights, which cast parallel shadows like those from the sun (bottom). Non-parallel shadows make an outdoor scene look small, like a miniature indoor version. The difference is subtle, but the human eye detects it.

HOT TIP

A Shadow Map shadow works by projecting a square map in the direction of the light in the Size you specify. The larger the Size, the more shadow detail is calculated.

You can also preview shadows in a viewport the Nitrous viewport. With the view shading set to Realistic, right and make sure Illuminate with Scene Lights and Shadows are checked.

6

Exterior lighting

IGHTING FOR
AN outdoor scene
requires a direct
shadow-casting light
to simulate the sun, a
medium-strength fill light
to lighten the shadows, and
a dim underground light to
simulate bounced light.

This lighting setup works equally well with the default renderer and with mental ray.

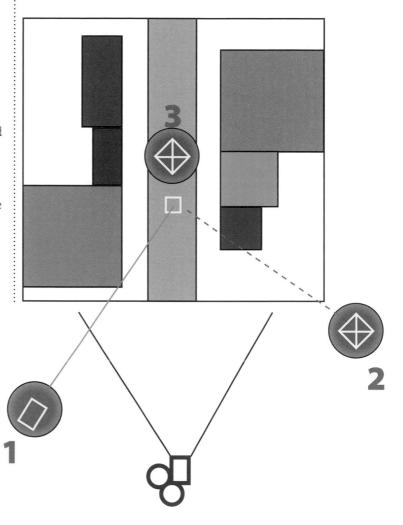

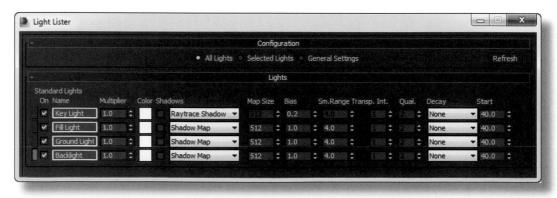

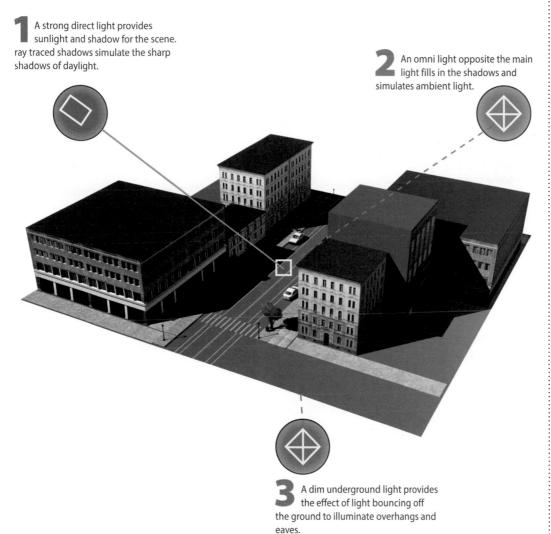

Exterior.max ExteriorLit.max

HOT TIP

While ray Traced Shadows cast sharp shadows, Shadow Map shadows cast soft shadows like those you see on an overcast day.

If you're feeling adventurous and want to try out the mental ray renderer, use a mr Daylight System as the only light and see what kind of results you get.

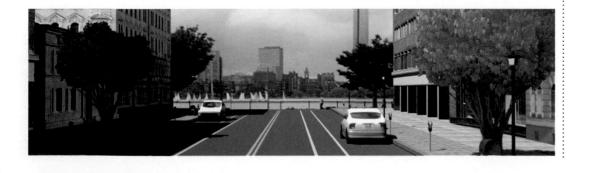

6

Bright sunshiny day

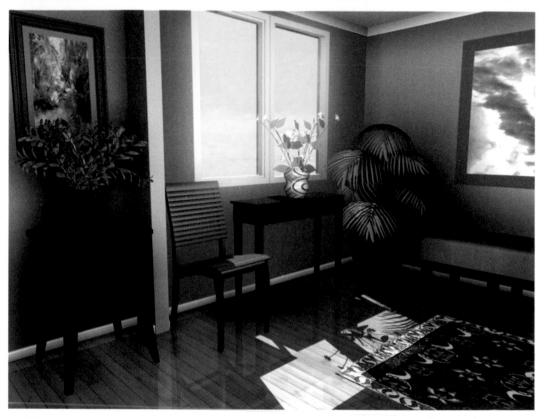

UNLIGHT THROUGH a window makes a pretty presentation for a room. A glow around the windows simulates the real-life effect of light spilling in through the window and washing the outdoor view to white.

This topic shows how to set up this type of lighting for the default renderer. See the Mental Ray Lighting cheat for details on how to adjust it for mental ray.

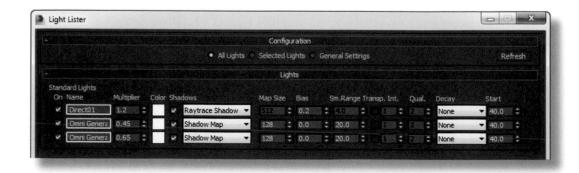

Use a strong Direct light to make sunlight come through the window. Turn on Shadows and set the shadow type to ray Traced Shadows. Turn off the Casts Shadows property for the window panes to allow the light to come through the windows and shine onto the floor.

Two or three Omni lights placed in the central part of the room simulate sunlight bouncing off the walls and floor to illuminate areas that aren't in the direct path of the sunlight. Turn on Shadows and set the shadow type to Shadow Map. A small Size and a large Sample Range create soft shadows on the walls and floor.

0

InteriorDay.max

HOT TIP

Shadow Map shadows from an Omni light get softer when you move the light farther away from the object receiving the shadow (wall or floor).

A glow around the windows adds to the impression of strong sunlight. Change the window pane material's Material ID Channel to a number other than 0, then set up a Glow with Render > Effects > Lens Effects. In the Glow Element rollout, go to the Options tab and set the Material ID value to the same number as the Material ID channel. Adjust the Intensity and Size parameters on the Parameters tab to make a soft glow around the windows in the rendering.

Environment and Effects

6

Mental ray lighting

HE KEY TO GOOD LIGHTING with mental ray is to start with lighting that works well with the default renderer. Then you can switch to the mental ray renderer and adjust your lighting before moving on to adjusting materials. This usually means turning lights off or reducing their intensities rather than adding more lights to the scene.

To change the render to the mental ray renderer, choose Rendering menu > Render Setup > Common Tab > Assign renderer rollout and pick NVIDIA mental ray renderer. Then make sure Enable Final Gather is on in the Global Illumination Tab, and that the Preset is set to Draft. You can also increase Diffuse Bounces to 1 or 2 to brighten up dark areas.

For an interior with windows, you'll always need to change all Shadow Map shadows to the mental ray Shadow Map type to keep soft shadows in the mental ray rendering. Usually, the default settings for this shadow type will give you harsh and blocky shadows, and even strange artifacts such as those on the tapestry on the far wall.

Increasing the Sample Range in the mental ray Shadow Map rollout for both lights, which will spread out each shadow over a wider area. Here, I've increased the Sample Range to 0.2 for both lights. The result is a spray of dark dots on the walls, but we can fix that.

With an exterior scene, the change to mental ray lighting takes just a couple of minutes. You might need to decrease the lights' Multiplier values to get the right intensity or turn them off altogether. Here, I've turned off the underground light and reduced the Multiplier for both the sun and fill lights.

ExteriorMR.max RoomMR.max

HOT TIP

Turn on mr photographic **Exposure Control** when rendering with mental ray. Use the tiny Render Preview window, then changed the EV Value until the little thumbnail lighting looks good. Finish it off by using Image Control to finetune the Shadow/ Midrange and Highlights.

To smooth out the spotty shadows, increase the Samples value for each light to a high number such as 100 or 200. This will take color samples from more pixels in each shadow, effectively smoothing them out. It's a lot easier to make these adjustments at the very start, before you adjust Multiplier levels.

Before making further adjustments to lights, change your materials to mental ray materials, as described in the Custom Mental Ray Materials topic in the Materials chapter.

Good lighting made better

IGHTING EFFECTS can add that extra something to a scene. The techniques shown here are good choices if you need to punch up the scene or give it a bit of interest. However, these techniques are not a substitute for good basic lighting.

As with all good things in 3D, enhancements can take longer to render but can set your image apart from the crowd.

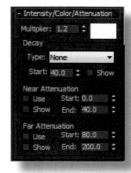

Changing the color swatch in the Intensity/Color/ Attenuation rollout changes the light's color. For outdoor scenes, use pale yellow for sunlight and pale blue for moonlight.

RoomNeg.max RoomAtten.max SpaceFlare.max RoomVolume.max

A negative Multiplier value decreases the lighting where the light shines, creating a dark spot. Use this technique when you want to reduce light in a small area. You can also scale the light itself on one axis to shape the light to the area you want to affect. Here, a spot light has been scaled on one axis to make its hotspot and falloff areas tall and thin.

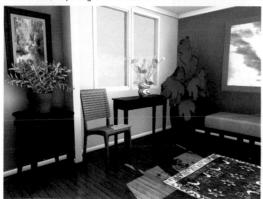

Attenuation causes a light to lessen or decay farther from the light source. Turn on this feature for an individual light with the Use checkbox in the Far Attenuation group. To control the degree of decay, turn on Show and adjust the Start and End values. The image at left has no attenuation, while the image at right has attenuation enabled for the two omni lights that simulate bounced light. The effect takes longer to render but can add a touch of realism to your lighting.

A volume light is suitable for strong sunlight through a window mingling with dust or smoke. To create this effect, choose Rendering > Environment, click Add, pick Volume Light, and pick the light. For the light itself, turn on the two Use checkboxes for the light in the Intensity/ Color/Attenuation rollout and adjust the Near and Far values to prevent the volume light from overpowering the scene. You can also change the Density and Max Light % values in the Environment rollout to change the "thickness" of the effect.

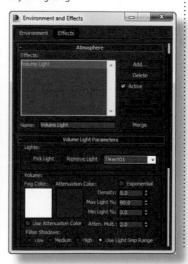

Lighting & Shadows

Daylight savings time

N RESPONSE TO user requests, Autodesk has introduced several lighting systems into the last few releases of 3ds Max.

The advantage is more choices for you. The disadvantage is that older systems are never retired, and the plethora of choices can be confusing.

This guide takes you on a tour of the Daylight lighting system and its uses. The Daylight lighting system, designed for use with mental ray, sets a light to use as a virtual sun and an environment or background for a virtual sky, which not only renders in viewports but affects the coloration of the scene.

The Daylight system features a compass rose and date/time/location settings for real-life light settings, but you can also adjust the light angle manually. The Daylight system is the only place where you can enable the mr sun light, which works like Skylight but is optimized for mental ray. While the mr sun can save time in some situations, standard lighting is still just as useful as it always has been.

It's best to the use the Daylight system with scenes that are created to real-world scale. You can use it with all scenes, but you might need to make heavy use of Multiplier parameters to get the right lighting.

To create a Daylight system, choose Create > Systems > Daylight and drag in any viewport. Drag once to create the compass rose, and then again to set the height of the light. To adjust the light's distance from the scene, choose Date, Time and Location, and change the Orbital Scale value. You can switch to other types of lights and skies on the Modify panel.

If you need a photographic background with the Daylight system, you're best off using the map itself as the background in the Environment and Effects dialog rather than mr physical sky. Select the Daylight, and in the

Modify panel, set the Skylight option to Skylight rather than mr sky. This uses settings in the Skylight Parameters rollout to illuminate the scene, even if you don't have a Skylight in the

scene.

The mr physical sky map is a partner to the Daylight system. It creates a basic simulation of the sky not so much for a pretty rendering but to give the mr sun light some color to work with for reflectivity. When you choose mr sky as the Skylight, the Daylight system automatically creates this map and sets it as the background in the Environment and Effects dialog (provided there isn't already a map there). You can drag the map from the dialog to the Material Editor to see and edit its settings. To see exactly how the sky will look, make sure to choose mrphotographic Exposure Control, and adjust the EV valuet.

The mr physical sky map displays some basic colors that you can adjust in the Material Editor. If the sky is black, try increasing the Multiplier in the mr sun light's mr Sky Parameters rollout. You can also add some indistinct clouds or color to the mr physical sky map by turning off Inherit from mr sky in the Material Editor and assigning a bitmap to the Haze slot. For the bitmap, choose Environ and Spherical Environment, and increase the Output Amount to 5–10 and RGB Level to 2–3.

HOT TIP

The Skylight light can also create realistic diffuse lighting throughout a scene, but it's designed to work with the Default Scanline renderer: you can't get shadows if you use it with mental rav. Skylight was originally designed to work with Light Tracer, an early raytracing tool that has been largely replaced by mental ray.

If you use mr sun with mr physical sky and the mr sun light is visible in the rendering, the sun will appear in the rendering. There's limited use for this feature, but it is very cool.

Where's the shadow?

HADOWS HAVE A HABIT of disappearing from time to time. Described here are the top five reasons your shadows aren't appearing in your scene.

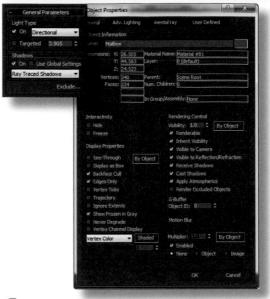

Make sure the Shadows option is turned on for the light, and that each object's Cast Shadows and Receive Shadows properties are turned on (Edit > Object Properties).

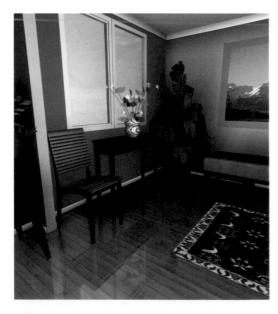

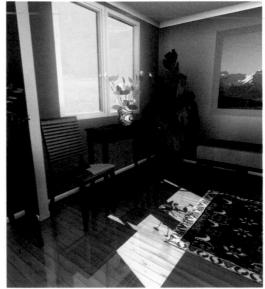

Light that you expect to show through an opening, such as light through a window, might be blocked by an object. Turn off the object's Cast Shadows attribute to let the light shine through.

If the other lights are too bright, shadows can be washed out. The shadow-casting light should be the brightest, and the total of all Multipliers should be below 3.0.

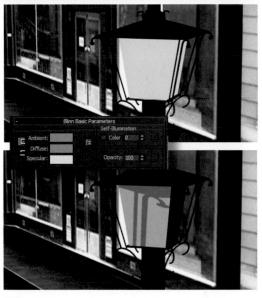

If the object receiving the shadow is completely selfilluminated, no shadow will appear. Turn down the material's Self-Illumination value in the Material Editor.

HOT TIP

If you're having trouble determining what the problem is with your shadows, turn off all the lights, and then turn them on one by one and render the scene. The Light Lister dialog is an excellent tool for this trouble-shooting technique.

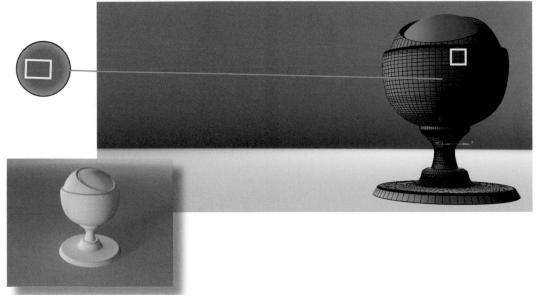

If the light angle is too low in relation to the surface receiving the shadow, the shadow might stretch out or might not even appear at all. Move the light up to increase the angle to the ground.

INTERLUDE

Shadow and wireframe presentation

YOU'VE PROBABLY SEEN images of models presented with a nice shadow beneath them or even a wireframe representation. These types of images have become a staple on the Internet for modelers showcasing their work in portfolios, stock 3D model marketplaces, and online profiles. The techniques for producing these images aren't complicated but require a bit more thought than a simple rendering or screen capture.

For a model with a shadow beneath it, place a plane at the floor level (usually just touching the bottom of the model) and point a shadow-casting light at the model. Then create a Matte/Shadow material and apply it to the object. When you render, only the shadow cast by the object will appear on the plane, and the rest of the plane will be invisible.

Presenting a wireframe requires a little more ingenuity. You could just turn on the Backface Cull option on the Display panel and capture the screen, but in general this gives you a pretty ugly capture. On the creature model shown, for example, there's a lot of crisscrossing of edges on the head and shoulders. This happens with just about any model that has any complexity to it.

Instead, create a copy of the model right on top of itself with Edit > Clone. Create two materials, one a Matte/Shadow material with the Receive Shadows option turned off and the other a black self-illuminated material.

Assign the Matte/Shadow material to the original and the black material to the copy. Select the copy and apply the Lattice modifier to it. This creates geometry along each edge. Choose the Struts Only From Edges option and reduce the Radius to a value that looks good.

The Lattice technique is the most reliable, but it has a limitation: the wireframe will be narrower farther from the camera. For most models this isn't a problem, but if you prefer to have a uniform wire width, you can use the Push modifier instead.

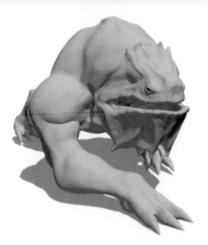

■ Creature model rendered with Matte/ Shadow plane below it (above), followed by straight screen capture with Backface Cull (upper right), and Push copy (lower right). You can also just choose Hidden Line as a viewport shading mode and do a viewport capture by clicking the plus button in the viewport menu, then pick Create Preview > Capture Still Image.

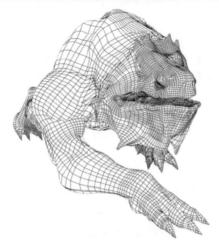

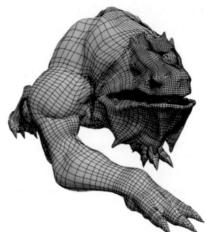

Select the copy, and instead of applying the Lattice modifier, apply a Push modifier. Set the Push Value to a small number such as 0.2. This will push the model's faces out along their normals. Then, for the black material, turn on the Wire option. In the Extended Parameters rollout, set the wire's Size and turn on the Pixels option. The rendered image will have a uniform wire size everywhere in the rendering, regardless of the edges' distances from the camera.

In both cases, the key is the original object inside the copy with its Matte/ Shadow material. This material hides the edges at the back of the model and does a far better job than a screen capture with the Backface Cull option.

Nothing says "shiny" like reflective surfaces in your scene. To get as much bling as you can with the least rendering time, use the techniques in this chapter.

7Reflections

IN LIFE, REFLECTIONS APPEAR on shiny objects. A bit of shine and reflection well placed in a scene adds realism that you can't get any other way.

While nature produces reflections with ease, recreating them in 3ds Max takes some know-how. There just isn't enough rendering time in this world to render every reflection that nature makes, so you need to pick where and how your reflections will appear. Knowing your options and the end result you're looking for are essential to fast work and pretty results.

Reflecting on reflections

EFLECTIONS ADD a needed degree of realism to a scene. However, there's no magic Reflection button in 3ds Max; you need to set reflection types separately for each material used in the scene.

In general, the more accurate you want the reflections to be, the longer the effect will take to render. If an object is close to the camera or is the focal point of the scene, you'll need accurate reflections. For incidental objects, simpler and faster-rendering solutions will do.

Here, reflection techniques are presented roughly in order of fast/decent to slow/accurate.

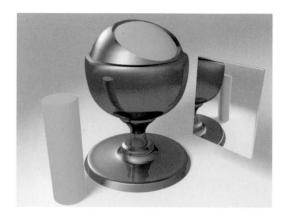

Using a Reflect/Refract map in the Reflection channel causes curved objects to reflect the environment, which means you need to have surrounding geometry and/ or an environment map to reflect. The Reflection percentage determines how strongly the surrounding geometry is reflected. Here, the objects reflect each other as well as the environment.

The quickest and easiest reflective material for curved surfaces is a Standard material with a Bitmap map in the Reflection channel. This type of map puts a bitmap on an imaginary sphere around the scene and reflects the pixels off the object based on the camera angle. In this example, I've used Chromic.jpg, a map that comes with 3ds Max and my favorite all-purpose bitmap for reflection.

By default, the Reflection percentage is set to 100 (represented as 1.0 in the Controller Bezier Float node), which causes the reflection to overpower the material. Reduce the percentage in the Maps rollout to 10 or 20 (or the Controller Bezier Float value to 0.1 or 0.2) and increase the Specular Level and Glossiness settings to make reflections more realistic.

ShaderBallRef.max

HOT TIP

One great advantage of using a reflection bitmap is the ability to blur it easily. Raytrace options usually take quite a long time to render a blurred reflection.

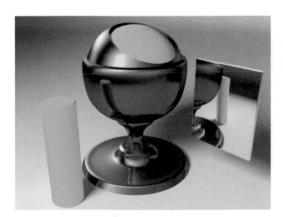

More accurate results can be achieved with a Raytrace map on both curved and flat surfaces, but it takes much longer to render. This map was an older solution to the problem of reflections, which is why it's used in so many scenes from previous versions of 3ds Max. Raytrace maps can usually be replaced with Reflect/Refract and Flat Mirror maps without noticeable loss of scene quality.

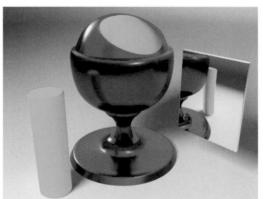

Of course, you get the best results with mental ray materials, which automatically reflect the geometry and environment map if the Reflectivity setting is above 0.0. The reflectivity works for both curved and flat surfaces. However, the added render time is worth it only if the reflective objects are the focal point of the scene. Otherwise, you can use the faster, simpler solutions described in earlier steps.

7

Bling

UCH A BRILLIANT SHINE is easy to produce with the help of the Raytrace material and a black-and-white background map. This type of material renders fast and produces great results without the overhead of Mental Ray.

A few simple steps is all it takes. The resulting jewels will sparkle and shine regardless of the lighting setup you use.

To make the bling sing, a black-and-white background is essential. Open the Environment and Effects dialog with Rendering menu > Environment, and click the Environment Map box to choose a bitmap. Here I've used Chromic,jpg from the standard Maps/Reflection folder. Drag the map from the Environment and Effects dialog to the Slate Material Editor as an Instance so you can edit its parameters. In the bitmap's Coordinates rollout, choose the Environ option and the Spherical Environment type to wrap the image around the scene. For this scene, I also cropped the bitmap to use mostly white areas.

To make the jewel surface, start with a Spindle, available as an Extended Primitive. Collapse it to an Editable Poly and weld the center vertices together.

2 Shape the spindle by welding vertices and chamfering edges as needed. Don't apply TurboSmooth, as the faceted surface will provide the shine.

Bracelet.max

For the gems, create a new Raytrace material to apply to the spindles. Change Luminosity and Transparency to white, and experiment with the index of refraction (Index of Refr.). To enhance the gem's transparency, use a Falloff map in the Reflect channel with Falloff Type set to Fresnel.

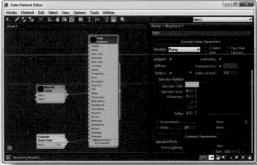

To make a colored gemstone, set Luminosity to black, and change the Diffuse and Transparency colors to the colors of the gem. Change the Specular Color to a lighter version of the gemstone color, and adjust the index of refraction as necessary.

HOT TIP

The Raytrace material is a legacy feature from many releases ago. Before we had Mental Ray, the Raytrace material was used to create most ofouradvanced reflection effects. Although Mental Ray materials have replaced the Raytrace material for most applications, it's still a good map for creating precious gems.

Reflections in the dark

WHEN WORKING WITH reflections on 3D logos there are a few things to remember. First, It's important to have a good three-point lighting setup. Next, the logo needs to have a good amount of detail and bevels to catch the light. Finally, if the logo is highly reflective it needs a good environment to reflect.

When creating logo or motion graphics scenes, problems with reflections crop up because there is environment or decent default lighting setup. An environment and lighting setup needs to be created to make your logos look spectacular. After all, if you put a shiny object in a dark room with nothing in it, all you will get is a black, uninteresting object.

With a logo in a scene that has no lights and no environment, all you get is black. Creating or turning on a key light will start to show the form of the object.

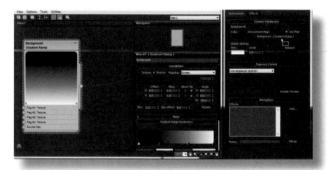

A Gradient Ramp map can be a used to create a flexible and interesting environment for a scene like this. Create a Gradient Ramp map with a few interesting colors to reflect and that matches the color tone of your scene.

Drag the Gradient Ramp map into the Environment slot of the scene so the object will have something interesting to reflect. The coordinates of the map should be set to Screen or Cylindrical Environment.

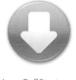

LogoReflStart.max LogoReflEnd.max

Adding a back light or rim light in will catch some of the bevels from the back and start to break the logo's form away from the background. A back light is also a great light to add a bit of accent color.

Finally a few fill or bounced lights can add more details to the sides of the object as well as fill out the body more. However, there is still no environment in the scene which is bringing the coolness factor of the logo way down.

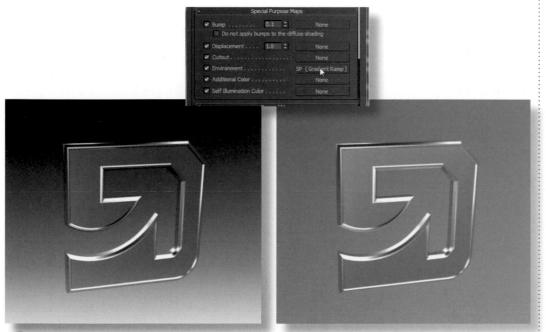

By setting your Gradient Ramp map to Cylindrical Environment in the Coordinates rollout you can usually get more interesting reflections than with it set to Screen. If you do this however, you may not get the desired look out of the background. To have the best of both worlds, make a copy of the Gradient Ramp map and set it to Cylindrical Environment. Place that copy into the Environment Map slot of your Arch & Design material. This will give you an interesting Screen background in the render while using a Cylindrical mapping for the logo's reflections.

INTERLUDE

Where's my reflection?

SO YOU'VE SET UP A STANDARD MATERIAL for a reflective surface using a Reflect/Refract map or Bitmap map in the Reflection slot. You apply the material, render the camera view, and...nothing. No reflection on the surface. What went wrong?

The problem is most likely with the angles between the objects. To understand how this works, we'll do a quick lesson in optics, the science of light.

In life, light bounces off an object and into your eyes or a camera. Light bouncing off the object means you can see it; no light bouncing off the object means you can't.

When a mirror or other reflective surface is present, light bounces off the object, then the mirror, and then into your eyes. That's how you see the reflection in the mirror. The light always bounces in a straight line, and bounces off the reflective surface at exactly the same angle at which it hits it.

In order to see a reflection in a mirror, your eyes have to be at the same angle to the mirror as the object you're looking at. When you stand straight in front of a mirror, the light just bounces straight out and back again into your eyes. If you stand to one side of the mirror, you'll see objects on the other side.

When you're seeing a reflection, distance from the mirror is not a factor in whether the object is reflected; only the angle of reflection is important. If this is confusing, get out a hand mirror and experiment with it. Hold it to the side and see what reflects in the mirror, and compare your eyes' angle to the reflected angle.

And so it is in 3D. In order for the camera to "see" the reflection, the object being reflected on the surface must be at the same angle to the surface as the camera. If it isn't, you won't see a reflection.

Highlights work the same way. A highlight is created by light reflecting off a surface and right into your eyes. Getting highlights on an object is a matter of placing the light in such a way that it bounces off a part of the object and right into the camera lens.

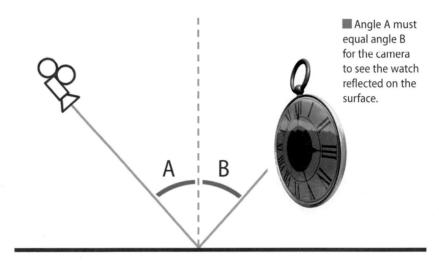

The Place Highlight tool, available from the Align flyout on the toolbar, works very well for both highlight and reflection placement. For a highlight, activate the camera view, select the light, choose Place Highlight, and drag the cursor over the shiny object. The light will move around to place the highlight at the cursor position. Release the cursor where you want the highlight to appear, and the light is placed in such a way that a highlight will be produced when you render.

To place an object to reflect on a surface, select the object that will be reflected, activate the camera view, and choose Place Highlight. Drag the cursor over the reflective surface and release the mouse when you reach the spot where you want the reflection to appear.

If you still don't get a reflection, then something else is wrong. Be sure to use the Reflect/Refract map on curved surfaces only, and the Flat Mirror map on flat surfaces only. You can also try working with a simplified version of the scene. Get the reflections to appear in the less complex scene then build it up gradually to the complex version.

₹8 € € II.

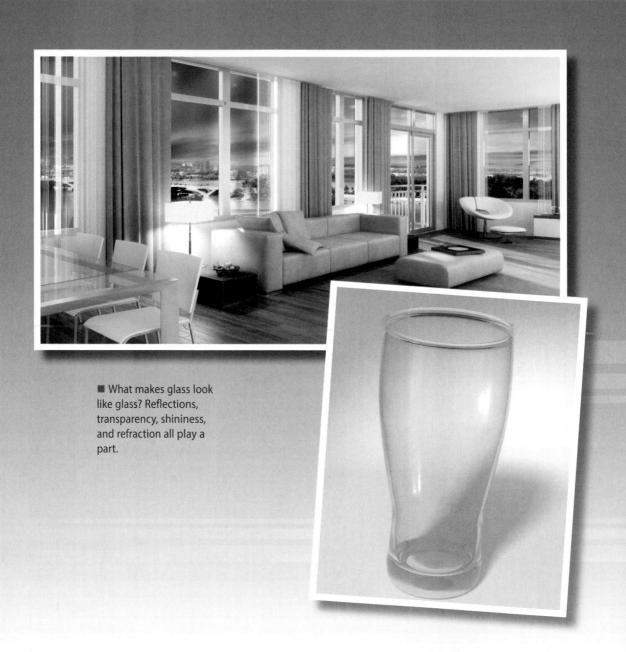

8 Glass

GLASS CAN SEEM TO BE awfully complicated. Plain old transparency with a bit of shine doesn't do the trick. You search in vain for the Instant Glass button, but somehow the developers of 3ds Max left it out of the user interface.

The key is to use reference images to find the look you want, and then consider which maps and parameters will create a material that simulates that look.

Exterior daytime windows

LASS WINDOWS ON A SUNNY DAY make a pretty architectural rendering. Using photos for reference, you can create a realistic rendition of windows seen from the outside, as with this rendering from Neoscape, Inc.

You can use a photo as a basis for a texture and map it onto the windows. This will give you a realistic look, but only if the light is coming from the same angle as in the photo. For a still image, this is a viable option. With an animated camera, the lack of a changing reflection will become obvious as soon as the camera moves.

From photos, you can see that exterior windows in daylight aren't really transparent. Depending on the lighting, you might be able to see partway into the building, or you only see a reflection of the environment.

To reflect the sky and also show shadows from the scene's light source, apply a Matte/Shadow material to the windowpanes. Be sure to turn on Receive Shadows and Additive Reflection for the material. If using Mental Ray, use the Matte/Shadow/Reflection (mi) material. Here, a large plane creates the panes for all the windows at once, and mullions are modeled separately to sit above the plane.

Interior daytime windows

HE APPEARANCE OF WINDOWS can make or break an interior rendering. Nicely done windows indicate a space with air and light. The appearance of the exterior environment through the windows coupled with the play of light on the floor will do most of the work for you.

Being able to see the environment outside indicates less direct light or a lower exposure for your virtual photograph. Here, there's no distinct light shape on the floor, but rather a blown-out highlight, indicating indirect light. This effect is created with a spot light that shines only on the floors and nearby walls, with a large difference between its Hotspot and Falloff angles. A hint of reflection in the windowpanes is appropriate for this type of setup.

A higher exposure for your virtual photo almost completely whites out the environment in the windows. A sharp light shape on the floor indicates direct light coming through the window. Create this effect by whiting out the background and making the windows nearly opaque.

Nighttime and dusk

INDOWS AT NIGHTTIME are perhaps the easiest to do. For exterior scenes, they're just clear panes showing the scene lit within. For interiors, the scene outside is dark, perhaps showing a brightly lit cityscape but not much else.

For exterior scenes at dusk, the appearance of windows varies according to the direction of the sun and also whether anyone has bothered to turn on the lights. The reference images shown above help show the various ways windows can look at these different times of day.

In late afternoon or at dusk, windows are dark if the lights aren't on and bright if they are. The direction of the sun is also a factor.

Nighttime windows are brightly lit from inside, and the interior is visible.

Interior windows at night are dark, not allowing much of an exterior view. In the picture at right, at bit of the cityscape is visible.

For nighttime exteriors, you'll need to put something inside the building for the viewer to see through the window. Often, a few items mapped onto planes will do the trick.

Pint glass

LASS IS SHINY and transparent, so to make curved glass, all you have to do is turn up the shine and lower the opacity on the material, right?

Not exactly. Curved glass is refractive, meaning light bends as it passes through it. Refraction is one of the properties that distinguishes glass from plastic and other materials.

To make convincing glass, you actually don't mess with the opacity at all. Instead, you get refraction to do all the work for you. This means you have to have some sort of interesting environment to refract. A basic lathed studio setup, detailed scene, or environment map will help. You can use the same technique to create drinking glasses, vases, and any kind of curved glass object.

Let's take a look at a few reference photos. The cut-glass vase refracts light aplenty, creating an irregular pattern of black and white reflections. In fact, there's so much refraction you can hardly see through it at all. Even a simple drinking glass refracts light.

To save rendering time, you can get decent glass for a background object with a Standard material. Start by setting up a streaky map as the Reflection map and giving the material high Specular Level and Glossiness values.

To make convincing glass, model both the inside and outside of the object using a lathed spline. Set the segments high enough to have a smooth result.

To get refractions, add a Raytrace map as the Refraction map. Lower the Reflection map percent to 10 or 20. Because the Refraction map creates the illusion of transparency, you won't need to adjust Opacity at all.

If you have plenty of time for rendering, you can use a Mental Ray material. Change the renderer to Mental Ray, choose the Arch & Design material, and choose the Glass (Physical) template. This material works right out of the box but takes longer to render than a Standard material.

Change the Index of Refraction in the Extended
Parameters rollout to get different effects. Here, I've set
the Index of Refraction to 2.5 and Reflection map percent to
just 10.

ScanlineGlass.max MRGlass.max

HOT TIP

In 3ds Max, the appearance of a glass material changes in different kinds of light. Set up your lighting first before spending a lot of time getting the glass to look right.

INTERLUDE

Fun with physics

BEHOLD THE HUMBLE drinking glass. You've seen a glass like this a hundred times, so you know what it should look like, right? Unfortunately, so does everyone else. This means you can't get away with a cheesy rendering of a transparent tube. A little physics is required to get a realistic rendering.

To study the properties of curved glass, I placed a pencil into an ordinary drinking glass. As light passes through the glass, it bends, bounces around a bit, and eventually makes it into your eyes (or in this case, the camera lens). The picture at the far left shows the actual photograph, where the pencil inside the glass appears bent.

Modeling the glass, pencil, and tabletop in 3ds Max was a pretty simple exercise. I used Bevel on each of the polygons in the middle portion of the glass to simulate the indentations in the glass I photographed, and I made a custom texture to simulate the spots on the glass.

Next up was the material for the glass. In life, some transparent media, such as glass and water, bend light to some degree. In physics, this degree is expressed as a number called the Index of Refraction. Clear air, which doesn't bend light at all, has an Index of Refraction of 1.0. Numbers greater and lesser than 1.0 indicate bending of light. The farther you get from 1.0, the more the light bends. Numbers less than 1.0, such as 0.8 and 0.9, bend the light one way, while

■ The first image shows a photo of a pencil in a glass. The rest of the images are renderings, with an IOR of 0.8, 0.9, 1.1, and 1.2 respectively, and then a last rendering with an IOR that varies over the surface of the glass. The variable IOR was created with a pair of Gradient Ramp maps in the IOR channel of an Arch & Design (mi) material. When a map is used to set the IOR, white represents 1.0, and darker colors descend to lower IOR values.

DrinkingGlass.max

HOT TIP

The 3ds Max file contains numerous lights. many of which illuminate just one or two objects. This makes it easier to control the highlights and brightness of individual objects in the rendering so the reference photo could be matched as closely as possible. In addition, Exposure Control was used on the image with Render> Environment> **Exposure Control** rollout.

numbers such as 1.1 and 1.2 bend it in the other direction.

For many materials, 3ds Max provides a parameter to set the Index of Refraction for transparent/refractive objects. You can find the Index of Refraction parameter in the Extended Parameters rollout for Standard materials and the IOR parameter in the Main Material Parameters rollout for Arch & Design (mi) materials.

There are numerous websites where you can find the real-life IOR for everyday items like glass, plastic, water, and gemstones. However, getting a realistic rendering isn't as simple as setting the IOR to the specified number. The IOR for glass clocks in at about 1.5, but the outside of a drinking glass might have a different IOR than the inside, and the glass might have imperfections. In other words, the physics-based IOR is just a guide. If the rendering looks good, the IOR is right; if it doesn't, it isn't.

Physics tells us that the IOR for all known substances is above 1.0. But the second and last renderings shown above, both of which use IORs under 1.0, are actually truer to the reference photo than those with IORs above 1.0.

So when you need to simulate refraction, go with what your eyes tell you, not with what the physics book says. A realistic rendering is always more "correct" than a technically accurate one.

Learning a few animation tricks of the trade will make it possible for you to animate scenes quickly and effectively.

9 Animation

ANIMATION IS WHERE the real fun comes in with 3ds Max. You can fly through or around your model or make objects whiz by. You can even animate materials and modifiers.

In this chapter, you'll learn how to utilize 3ds Max's powerful animation toolset to animate your scene in a minimum of time.

Dummy objects, non-rendering objects used to control other objects, are particularly useful in setting up animation.

Animation

Animation 101

EYFRAME ANIMATION is the easiest type to do with 3ds Max. Use this primer to learn the basic tools and start animating your scene right away.

A keyframe is a major point that the animation passes through. You don't animate every frame in 3ds Max; you just place the object at key points along the way, and 3ds Max figures out what to do in between.

While the time line shows you the keyframes for the currently selected object, you can see a full representation of all keys in Graph Editors > Track View - Dope Sheet. In Dope Sheet mode, Track View shows a track for each axis of each transform.

Curve Editor mode shows how the frames between keys are interpolated. To open this window, you can use the Mode menu on an open Dope Sheet or choose Graph Editors > Track View - Curve Editor. In Curve Editor mode, you can also move keys around to change timing, either in Track View or on the time line. Learning to use Track View and the time line effectively means you can create the animation you envision.

To create keyframes, turn on Auto Key at the bottom of the screen. Pull the time slider to go to a frame later than 0, and move or rotate the object. This sets a key at that frame and also at frame 0 if a key is not already present.

On the time line, right-click the key to see which parameters are animated at that frame. You can change the key value or frame number in the dialog that appears.

You can set the total number of frames and the speed of the animation by clicking Time Configuration at the lower right of the screen.

Move to other frames and transform the object again to set more keyframes. You can instantly see the results of your keyframing by pressing Play Animation at the lower right of the screen. Press the same button to stop playback.

You can also animate any numeric parameter or color in 3ds Max by changing it with Auto Key turned on. Doing so creates a keyframe on the time line and in Track View.

HOT TIP

To determine rough timing for your animation, play it in your head while counting the seconds. This might sound silly, but it works. You can also use a stopwatch.

9

Spinning your gears

HEELS, GEARS, and other spinning objects often need to rotate over the length of the entire animation. With a few keyframes and a bit of math, you can get your wheels and gears in motion.

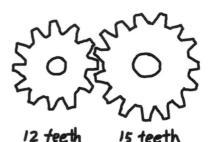

Draw a diagram to figure out how many teeth each gear will have. Numbers that divide evenly into 360 are easiest to work with. My gears will have 12 and 15 teeth.

On the NGon, select two adjacent vertices, skip two vertices, select the next two, skip the next two, continuing in this fashion all the way around the NGon.

Scale the selected vertices outward to form the gear teeth. Create the additional gears in the same way, selecting every other set of two vertices to form the teeth.

Turn on Auto Key. On a frame later than 0, such as frame 10, rotate each gear by the number of degrees equal to one tooth, which is 360 (the number of degrees in a circle) divided by the number of teeth. After rotation, the teeth will be aligned again. Scrub the animation to test it.

To make the gears turn infinitely, select one of the gears and open the Curve Editor. Select the Rotation track with the curve, and then on the Edit menu choose Controller > Out-of-Range Types. Click the right button under Relative Repeat, and close the dialog.

In 3ds Max, create an NGon shape for the first gear with four times as many sides as the number of teeth. Collapse the shape to an Editable Spline.

Select all vertices and right-click them to change them all to the Corner type. This will make it easier to form the teeth.

Gears.max

HOT TIP

To rotate by exactly a specified number of degrees, type the value into the entry area at the bottom of the screen. If you're not sure which axis is correct, try each one. If you pick the wrong one, type in 0 to reset the rotation on that axis, and try again.

The additional gears should be proportional in size. For example, since the second gear has 20% more teeth (15 as opposed to 12), it should be 20% larger.

Prepare for animation by rotating and moving one of the gears so its teeth fit with the other gear.

When you play the animation, you'll see a slight hesitation on each turn. Open the Curve Editor, select the points at each end of the animation curve, and click Set Tangents to Linear. When you play the animation again, the gear will turn smoothly.

Repeat the process for each gear, and play the animation to test it. Extrude the gears and shape them, and add additional elements as necessary to complete your scene.

Animated pivot point

IVOT POINTS are critical to animation and especially rotational animation in 3ds Max. Once you start working a lot with pivot points, you will want to animate them. The ability to animate a pivot point is a bit of a hidden gem in 3ds Max, a side effect of the animated pivot feature that came with the CAT rigging system introduced in 3ds Max 2011. A number of controllers were introduced with CAT and the CATHDPivotTrans is one of them. It allows us to have an animated pivot point on any 3ds Max object including custom rigs.

With your object selected, go to the Motion panel and select the Transform track from the controller list. Click Assign Controller and choose CATHDPivotTrans from the list.

With this controller you have the standard Position, Rotation, and Scale transform tracks as well as a new Pivot: Bezier Position track. There is a new Sub-Object option in the Motion panel where you will edit the animatable pivot.

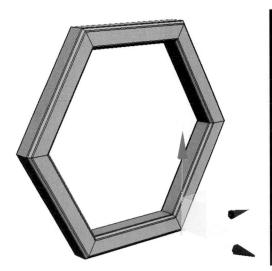

AnimPivotStart.max AnimPivotEnd.max

With your object selected, click the Sub-Object button in the Motion panel. Now you can move the pivot point to its starting place, such as the corner of your object. When you step back out of Sub-Object mode, the new pivot point is used instead of the default 3ds Max pivot.

With Auto Key on, rotate the object so it rotates forward to its next edge. Make sure you are not in Sub-Object mode for this part.

HOT TIP

Use hold keyframes to set your pivot point animation to change over one frame. You might have to set a few more keys, but you will not have to change your key interpolation type.

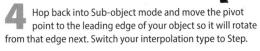

Get out of Sub-Object mode and set the interpolation back to Smooth. Now rotate the object forward again and it will rotate over the leading edge.

9 Animation

Following a path

NSTEAD OF MANUALLY setting keyframes to animate an object, you can use a constraint. A constraint automatically animates an object according to specific parameters.

In this example, you'll use a Path Constraint to make an object follow a path shape over a series of frames. This technique is particularly useful for making a camera follow a path to create a fly-around or fly-through of your scene.

Create a camera in the scene at around the same spot you want it to be when the animation starts. Create a shape for the camera to follow, and move the shape so it starts roughly at the same spot where the camera currently sits. Here, I've created an Arc shape.

Scrub the time slider to see the animation. In the Motion panel, you can see that the % Along Path parameter in the Path Parameters rollout has been animated from 0 to 100 over the course of the total number of frames in your animation. If you want the object to start at the other end, you can turn on Auto Key and change the % Along Path parameter to start at 100 and end at 0.

Select the camera and choose Animation > Constraints > Path Constraint. A dotted line appears, waiting for you to select a path. Click the shape to complete the assignment of the constraint. The camera jumps to the start of the path.

To change the path, you can convert the shape to an Editable Spline and move the vertices. The constrained object will move along the path in its new shape.

PathStart.max PathFinish.max

HOT TIP

If moving the vertices causes the path to take a strange shape, change all vertices to the Smooth type on the rightclick quad menu.

Look a-here

HE LOOKAT constraint is a rotation controller that forces an object to always be rotated to "look at" another object. In practice, this means that one axis of an object will always point toward another object.

The LookAt Constraint is particularly useful for controlling a pair of eyes. Instead of rotating the eyeballs manually to look this way and that, you can use a LookAt Constraint with a Dummy object to control the eyeball rotation.

Set up a couple of eyeballs to control. Here, we can make a cat look this way and that with the LookAt Constraint.

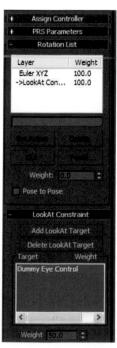

It's not unusual for the LookAt Constraint to deliver up the wrong LookAt Axis by default. Try different axes in the Select LookAt Axis group in the Motion panel to see which one works best. Here, the Y axis gives me the right result.

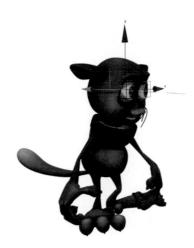

Select one of the eyeballs and choose Animation menu > Constraints > LookAt Constraint. Move the cursor to pick the object that you want the selected object to look at.

Its a good idea to link your eyeball assembly to a Point helper or Dummy object first and then use these for the LookAt Constraint. Having the extra level of hierarchy will give you flexibility in your rig down the road.

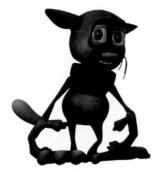

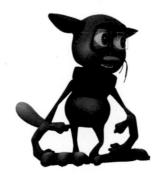

9

Jumping beans

HE NOISE CONTROLLER animates an object randomly. This type of controller is useful for giving life to an object, making it sway or vibrate in a subtle way that will register as real to your audience. You can assign a Noise Controller to animate the position, rotation, or scale of an object, and adjust each one separately for that transform.

The animation produced by the Noise Controller appears to be random, but is actually calculated to appear that way. At the heart of the calculation is a Seed number that produces a motion graph. By using the same Seed for two Noise Controllers, you can produce exactly the same "random" effect today that you did yesterday. On the other hand, using a different Seed for two different objects gives you the same flavor of motion without an exact match in speed and direction.

Making the Seed values different is important; making them wildly different is not. Two consecutive Seed numbers produce completely different motion, so making the Seed 0 for one object and 1 for another will give you as much variation as using 57 and 2398 for the two values.

Select the object that you want to make jump around randomly. Choose Animation menu > Position Controllers > Noise. Scrub the time slider to see the object jump around.

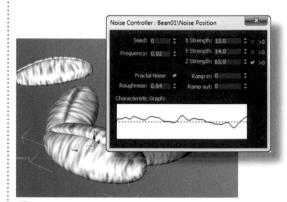

Reduce the Frequency to make the object move slower. You will see the Characteristic Graph change to reflect the new frequency. Turn on the >0 checkbox for the Z Strength parameter to keep the object from moving below the surface it's sitting on. Adjust any other parameters as you like, and scrub the time slider to test the effect.

The Noise Controller takes over the definition of the object's position so you can't move it manually in the viewport. If you want to move the object to another location, select the Position XYZ layer in the Position List rollout, then click the Set Active button to give control back to the default transform controller. Now you can move the object in the usual way.

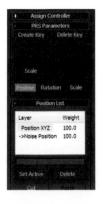

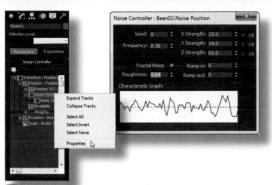

On the Motion panel, expand the hierarchy in the Assign Controller rollout to see the Transform > Position > Noise Position entry. Highlight Noise Position, and right-click to choose Properties from the menu.

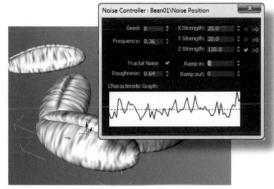

Repeat the process of assigning a Noise Controller to animate each object's position. Change the Seed parameter to change the graph pattern while retaining the same overall parameters. You can also assign a Noise Controller to an object's position with Animation menu > Rotation Controllers > Noise.

Add some motion blur by changing the object properties. Select all objects, right-click to choose Object Properties from the quad menu, and turn on the Image type of motion blur. After rendering a test, adjust the Multiplier value to give you the right amount of blur in the rendering.

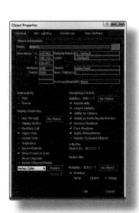

Beans.max JumpingBeans.max

HOT TIP

Close the Noise Controller dialog before selecting another object. If you don't close the dialog and select another object, the dialog will still show the earlier object's parameters and not those of the currently selected object, making it too easy to accidentally change the earlier object and not the current one.

INKING OBJECTS
TOGETHER with Select
and Link can help you
control your animation without
having to animate each object
individually. Linking works with a
parent—child relationship, where
you link the child to the parent
and the child does what the
parent does thereafter.

Dummy objects can assist greatly with linked animation. A Dummy object is a non-rendering Helper object that works as an intermediary between linked objects, allowing you to pass only movement and not rotation, or vice versa.

The advantage of linking to Dummy objects is that you can

In this topic, I've created low-poly models of icons of India to rotate around a traditional Indian carving.

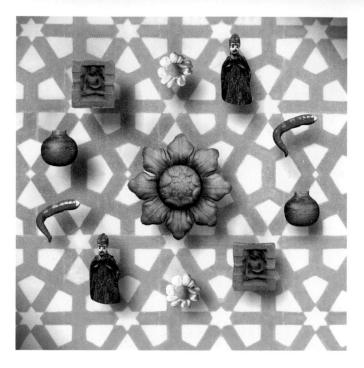

Now you can rotate the center Dummy object to rotate the outside objects without rotating the center object.

To prevent the outside objects from rotating, select an outside Dummy and go to the Hierarchy panel. On the Link Info tab, under Inherit, turn off the Rotate checkboxes for X, Y, and Z. Repeat for each outside Dummy object.

CONS CREATED WITH PHOTOS BY WARREN APEL

Use Select and Link to link all the outside objects to the one in the center, and rotate the center object. All the outside objects rotate around the center object and turn as they do so. If this is what you want, then you're done.

Use Create panel > Helpers > Dummy to create a Dummy around the center object and around each outside object. Link each outside object to its Dummy.

More likely, you'll want the outside objects to keep their original upright orientations as they rotate, and you won't necessarily want the center object to rotate. You can achieve this effect with Dummy objects.

Link all outside Dummy objects to the center Dummy. You can do this by selecting all the Dummy objects and linking them to the center Dummy at the same time.

IndiaLinks.max IndiaDummies.max

HOT TIP

When linking, take care to drag the cursor to an area of the screen that contains only the parent to avoid linking to the wrong object. Click Select Objects to end the linking process and avoid linking additional objects by accident. You can also link by name by pressing the H key to select the parent object.

Now you can make the outer objects orbit the inner one without rotating.

To complete the controls, create another Dummy object around the center object, and link both the object and the first center Dummy to it. This will allow you to move or rotate both the center object and the entire assembly.

Animation

Linking to multiple objects

INKING IS A USEFUL TOOL for many types of scenes, but it limits an object to having one parent throughout the entire animation. For times when you want an object to follow one parent for a while and then another, use the Link Constraint.

In this example, the object follows two different parents, but in practice you could make an object follow numerous different parents over the course of the animation.

Animate the object changing position at the transition point. In this case, the nail jumps to the magnet when the magnet gets close.

MagnetStart.max MagnetFinish.max

Select the object to be animated or the Dummy object that the object is linked to. Choose Animation menu > Transform Controllers > Link Constraint, and then click a stationary object in the scene. This will keep the selected object still until you want it to follow another object.

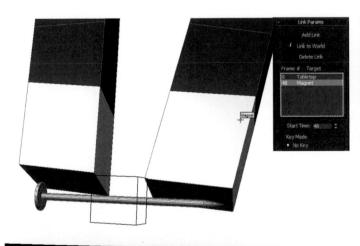

9 Animation Chains

DS MAX INCLUDES a Bones system, a series of non-rendering objects that are already linked together. While Bones were primarily intended to create a skeletal system for a character, they are useful for animating a series of solid objects that need to stay together but move separately.

A series of linked objects is called a *chain*. Like a metal chain, each link can rotate on its own, but only as long as it stays connected to its adjacent chain members.

Any linked chain can be controlled by an IK solver. IK stands for inverse kinematics, a technical term meaning an individual link in the chain can be affected by links on either side of it. This is the opposite of forward kinematics, where a link can be affected by one end of the chain only.

Here, we'll use a short chain of five objects to illustrate the concept. In practice, you can use Bones and IK chains on as long a chain as you like.

On a historical note, the implementation of inverse kinematics in mainstream 3D software in the 1990's was a breakthrough that made all kinds of animation possible. A character animator, for example, could finally animate a leg by working with either the hip or the foot. Inverse kinematics is one of the reasons 3D animation has taken off so much in the past decade.

Create the chain as a series of objects laid out straight. While it isn't strictly necessary to have the objects lined up, it will make your work much easier if they are.

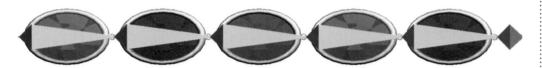

Choose Create panel > Systems > Bones to create a series of bones through the objects. Click at each joint in the chain to create a bone for that joint. Creating the bones at a slight angle to one another will determine the bend angle after you apply the IK solver. When you get to the end, right-click to create a nub at the end. Don't delete the nub.

Move the bones so they go through the objects, with each bone end coinciding with a "joint." In this case, the joints lie between the jewels. Use Select and Link on the toolbar to link each jewel to its bone. When you're done, click the Select Objects button or right-click the screen to close the linking process and avoid accidental linking when doing the next steps.

Now you'll apply an IK solver, a gizmo that allows you to use IK with your object. Select the first bone you created, choose Animation menu > IK Solvers > HI Solver, and click the nub at the end of the bone chain. This creates a new object, an IK Chain helper, between the nub and its previous bone.

You can move the IK Chain helper to change the shape of the chain, and can even animate it. To make this easier, you might want to place a Dummy object at each end of the chain, and link the first bone to one Dummy and the IK Chain object to the other. The object might flip onto its side when you do this, but you can simply rotate it back into place. If you want to change the angle of rotation of the chain, you can select the IK Chain object, and on the Motion panel, change the Swivel Angle parameter.

Jewell inks max

HOT TIP

If the bones appear too skinny in your viewport, you can make them fatter by increasing the Width and Height values in the Bone Parameters rollout on the Modify panel. To change the parameters of multiple bones at once, go to Animation menu > Bone Tools and press Bone Edit Mode. Then you can change the parameters for several bones at once.

9 Animation

INTERLUDE

Super-duper tools

AS FASHIONS CHANGE, so do trends in 3D graphics tools. There are a number of features that came into fashion, had their heyday, and then faded into obscurity. Not entirely though, because they retain their positions on the menu release after release.

Old tools are never retired, because to remove them from the system would cause older files to cease working. Every production company that's been around for a few years has a library of these old files, and they are some of Autodesk's best customers.

This can confuse a new user. You want to become better at using 3ds Max, so you start perusing all the available tools. You read about them in the Help, and scratch your head. You try in vain to find someone who knows how it works. The problem is, those of us who lived through the tool's heyday discarded it from our personal toolset long ago, and we can't remember much about it except that it was replaced by something else.

The following tools are not worth learning about, except for historical purposes. I'm not saying you should never learn them, but if you're trying to get up to speed quickly on useful tools, you should skip over these features.

Video Post. Back in the old days, this tool was great for compositing scenes. With the widespread use of Photoshop, After Effects and Premiere, it's pretty antiquated. Still, you'll run into the occasional old file that uses it. Use the new Composite tool instead.

HD Solver. HD stands for history-dependent, meaning every time you update something it has to run through the entire animation to figure out what it's doing. This type of solver is good for mechanical animation that requires IK, but not for other applications. Use the HI Solver instead.

Spline IK Solver. This tool uses a spline to control a chain of objects. When it was first released, everyone got very excited about it. Then we discovered that if you curl the spline a certain way (as you're very likely to do in any animation of substance), the spline flips around erratically. Every 3D package with a similar tool has the same problem; it's rooted in the way IK works, and isn't likely to be solved anytime soon.

Scatter. Replaced by particle systems where you can pick the emitter

Scene States. Have been used to setup render passes and for scene management. These always tended to be buggy and you never

knew what had been saved in a state. Scene States is now a much better and more robust tool for doing both scene management and render passes.

Boolean. Replaced by ProBoolean.

NURBS. An alternative to polygon modeling, NURBS makes smoothly curved surfaces from splines. NURBS is useful for making curtains and tablecloths, and that's about it. Some industries use it almost exclusively, but if you're not in one of them (and you'll know if you are), learning NURBS is not the best use of your time.

Lens Effects. These are effects like Glow, Star and Streak right inside 3ds Max. While it is cool to have them directly in 3ds max they are fairly limiting. In many cases you're better off doing some compositing in Composite or After Effects.

Physique modifier. Before the Skin modifier, it was all we had. Physique hasn't been updated in several releases, and the Skin modifier is now light years beyond it. If you need to update an old scene that uses Physique, your first order of business should be to replace Physique with Skin.

I'm sure that some people still use these tools, in fact I expect to get angry letters from the three people who are still using Video Post. I'm not questioning anyone's right to use them. I'm just recommending that you learn the most useful tools first.

So then, you might ask, what tools should you learn? Why, the ones in this book, of course.

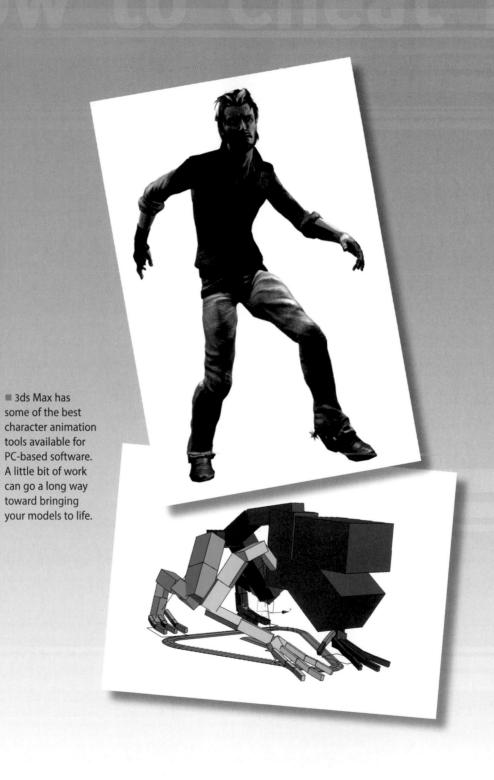

10 Character Animation

ANIMATION OF CHARACTERS is one of the primary uses for 3ds Max in the fields of games and broadcast. While this primer won't teach you everything you need to know to be a character animator, it can get you started with the main tools: CAT and Biped.

CAT is short for Character Animation Tools. CAT is a complete and easy-to-use animation system for creatures of all shapes and sizes.

Biped, an animation system designed for two-legged characters, is an older and less robust tool, but is still used by many animators.

Character Animation

Character animation workflow

O YOU'VE HEARD about CAT and Biped and what they can do. How do you get started? The overview here will give you the basic workflow, and then you can use the topics that follow to kick-start your own project.

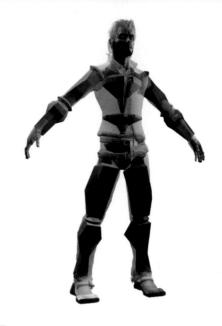

Start with a character model created with the usual modeling tools. Create a CAT or Biped skeleton and pose it to fit inside the character model.

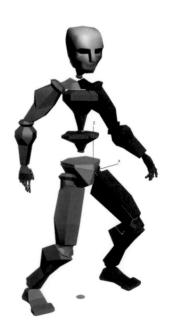

Once the skinning is complete, animate the skeleton performing the final animation.

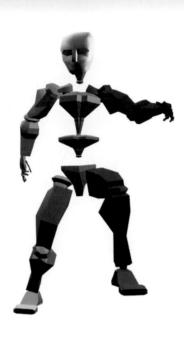

2 Create a short test animation for the skeleton, moving it through the poses it's likely to make over the course of your animation.

Use the Skin modifier to associate the skeleton with the character model, and adjust the influence of each bone over the vertices around it.

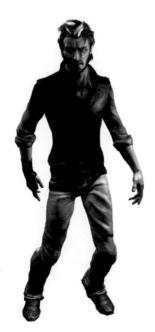

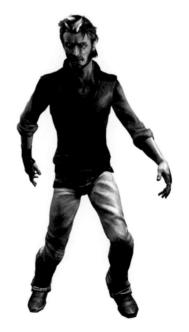

 $\label{the:eq:hide} \mbox{Hide the skeleton and check the animation.} \mbox{ Adjust skinning as necessary, and render the final animation.}$

10 Character Animation

CAT 101

HE CAT ANIMATION system was introduced in 3ds Max 2011. It provides a number of features including a wider variety of default skeletons and

Before you start animating, click the Setup/ Animation Mode Toggle button in the Layer Manager rollout to change it to Animation mode (green). This tells CAT that you're done posing the skeleton and you're ready to start animating.

Turn on Auto Key go to a frame later than 0, and start animating the skeleton. You can move or rotate just about any bone in the skeleton.

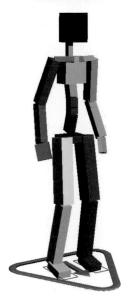

To create a CAT skeleton, use Create panel > Helpers > CAT Objects > CATParent. Choose a template in the CATRig Load Save rollout, then drag in a viewport to create the skeleton.

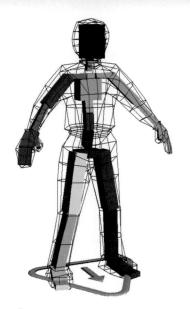

Fit the skeleton to the mesh, and skin the mesh. See the Skeleton Fitting topic for details on how to do this.

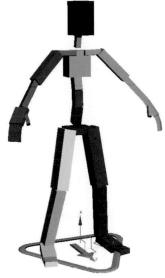

Select any part of the CAT rig, and go to Motion panel. In the Layer Manager rollout, click and hold the Add Layer button to display layer types, and choose Abs to add an Absolute Animation Layer.

To move an entire foot, select the helper object underneath the foot and move the helper to move the whole foot.

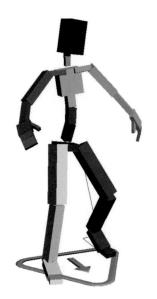

To create a walk cycle, add a CATMotion Layer. This creates a default walk cycle that you can customize as you like.

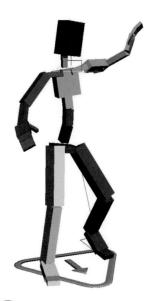

To remove a layer's influence on a body part, select the part and lower the Local Weight value for that layer.

1 Character Animation

Biped 101

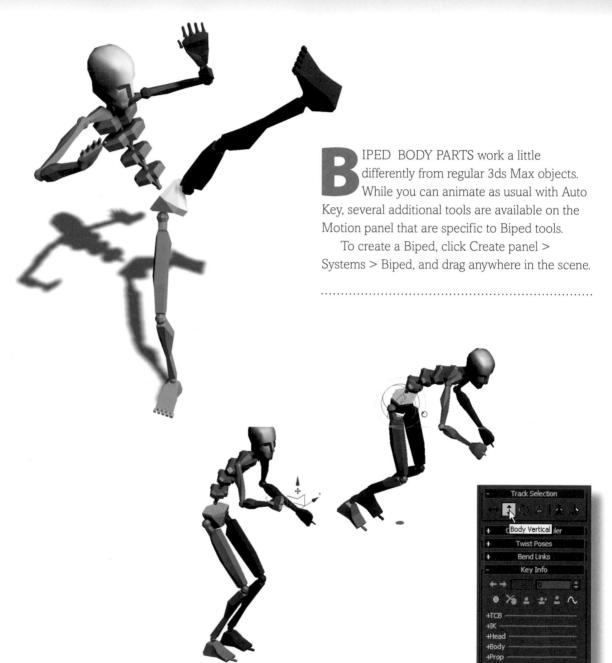

Now you can turn on Auto Key, move to a frame other than 0, and start moving and rotating Biped parts. Don't animate the pose at frame 0. If you want the Biped to start off in a different pose, animate its parts into the pose on a later frame, such as 10. When you render, you can simply render from that frame forward.

To animate the entire Biped, move or rotate the COM (center of mass) object. You can select this object easily by clicking one of the first three selection buttons in the Selection Track rollout. The COM works a little differently from other 3ds Max objects, where it has a separate track for horizontal movement, vertical movement, and rotation.

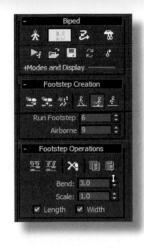

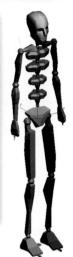

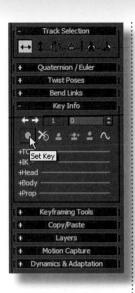

One of the easiest ways to get an animation going with the Biped is to create footsteps for it. See the Walking in your Footsteps topic for details.

To prepare the Biped for a non-footstep-based animation (called Free Form in Biped parlance), you'll need to put a key at frame 0 for all Biped parts. Select all Biped parts, go to the Motion panel, and click the Set Key button in the Key Info dialog. You will also need to click each of the three COM selection buttons (the first three buttons in the Track Selection rollout) and click Set Key for each one.

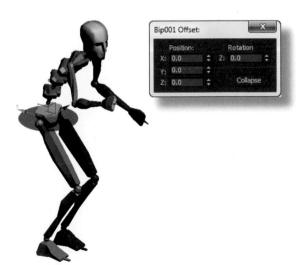

To move the entire animation, use Move All Mode in the Biped rollout. This causes a disk to appear around the COM, indicating that you can move or rotate the Biped to shift the entire animation. An Offset dialog appears where you can type in numerical values rather than manually moving or rotating the Biped. Be sure to turn off Move All Mode when you're finished with this tool.

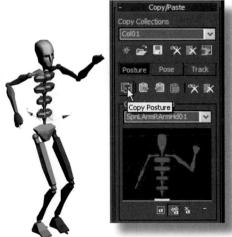

To reuse a pose, copy and paste postures in the Copy/Paste rollout. First you will need to click the Create Collection button, and then select the Biped parts you want to copy and click Copy Posture. Then you can go to another frame, and with Auto Key turned on, paste the posture to the selected parts.

HOT TIP

In Track View, tracks for Biped parts are different from regular 3 ds Max objects. There is one track for each entire leg/ foot and one track for each arm/ hand.

The COM object is named Bip01 by default. It's the root of the entire linked Biped hierarchy.

1 Character Animation

Skeleton fitting

HE FIRST STEP in associating a skeleton with a character is posing the skeleton to fit the character. A skeleton that fits the character well will animate the character well. Conversely, it's nearly impossible to get a decent animation from a poorly fitted skeleton.

When you fit a Biped, you turn on Figure Mode in the Motion panel to indicate that you're posing the Biped and not animating it. With a CAT skeleton, you make sure the Setup/Animation Mode Toggle button is set to Setup (red) in the Motion panel. In general, you want the skeleton to fit inside the character model with its bones sized to about 1/2 to 3/4 the volume of the model.

While working with a specific part of the skeleton, it's important to put on blinders and work with just that part to get it posed correctly before moving on to the next. The skeleton will

the very end, when it all comes together in a perfect pose.

look very strange until

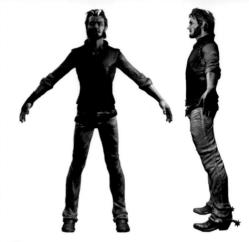

Your character model should be posed with its arms out at its sides and palms facing down, and with its feet a shoulder's width apart. It can also help to bend the arms and legs slightly.

Rotate and scale the skeleton's legs to fit the character's legs. If a CAT skeleton's legs don't go down the center of the character's legs, you can move the thighs to make them line up. For a Biped, you'll need to scale the Pelvis object horizontally until the legs fit. Be sure to match up the knees and ankles in all views, and rotate the legs slightly to match the bent legs.

Position the character on the ground plane grid. If you've applied a TurboSmooth modifier to the body, remove it. Make all the body parts see-through, and freeze them.

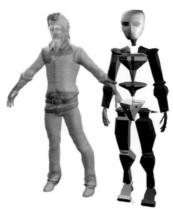

Create a CAT or Biped skeleton about the same height as the model. Set the skeleton parameters as necessary to match the type of character.

Line up the skeleton with the character body, especially the hips. For a CAT skeleton, move the parent object and then the pelvis. For a Biped, go to the Motion panel and turn on Figure Mode, then move the COM (center of mass object) to the center of the character's hips.

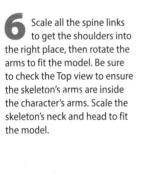

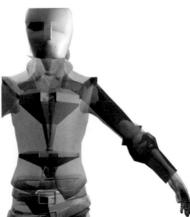

Scale and adjust the feet and toes, making sure the skeleton's ankles fall at the model's ankles. If the character is wearing shoes or boots, the skeleton's feet should fill out the entire shoe area. Scale a single toe link to represent the entire toe of the shoe.

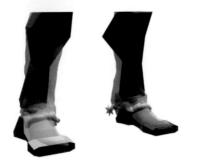

Fingers usually take the longest to pose. Scale the palm to fit the character, and move and rotate each base finger link to get it going in the right direction before scaling the finger links. The hand is easiest to pose in an angled view while simultaneously checking your work in an orthographic view. After you've done one hand, copy and paste the pose to the other side of the body.

HOT TIP

For the best results with skeletal fitting and animation, the character body model should be all one piece. While it's possible to use CAT or Biped with a multipiece model, the seams might be exposed when you animate the model. However, it's usually okay to leave the head and hair as separate objects.

10

Skinning

KINNING IS THE PROCESS of associating a character model with a skeleton. When you apply the Skin modifier to a model, it uses the bones you specify to determine how the model will deform when the skeleton is animated.

Skinning works by associating each bone with specific vertices on the model. If a vertex is affected by more than one bone, then the bone's influence on that vertex is determined by a weight value. All the weights for a vertex add up to 1.0, and a weight of 1.0 means the bone has complete influence over the vertex. Weights are set with the Abs. Effect parameter and the Weight Table.

Hide the character model, and take the skeleton out of pose mode (for Biped, turn off Figure Mode; for CAT, add an Abs Layer and set the Setup/ Animation Mode Toggle to Animation mode). With the skeleton, create a simple animation to test the skinning, such as bending the arms and legs. You should also create a Selection Set for the skeleton to make the skinning process easier.

Hide the skeleton. Pull the time slider to see if the character model deforms correctly. Chances are, it won't. The easiest areas to fix are the legs and arms. Let's use the left calf as an example.

Another area that's fairly easy to clean up initially is the torso. Select 2–3 rows of vertices and the nearest spine bone, and set Abs. Effect to 1.0. You can also scrub to a later frame to find and select vertices that aren't behaving correctly. Here, the vertices that make up the third button need to be affected by the second spine bone. At frame 10, they're easy to select and adjust.

Put the skeleton back into its pose mode (turn on Figure Mode for Biped, or set Setup/Animation Mode Toggle to Setup mode for CAT). Unhide just the character body. Remove any TurboSmooth or MeshSmooth modifier from the character, and collapse any modifiers still on the stack.

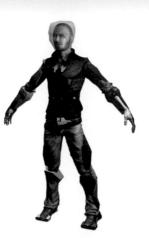

Apply the Skin modifier to the head and body model. Click the Add button next to Bones in the Parameters rollout, and choose all the skeleton parts.

Gunslinger.max

Select the body model. In the Parameters rollout, click Edit Envelopes. In the Select group, turn on the Vertices option. Select all vertices that should be affected by the left calf bone only. In the Parameters rollout, choose the right calf bone. In the Weight Properties group, change Abs. Effect to 1.0.

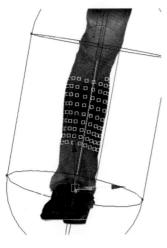

Scrub the time slider to a later frame, and check the right calf. Select individual vertices, and for each one, adjust the Abs. Effect parameter for the left calf and left thigh bones until the leg looks good. If you like, you can apply a TurboSmooth modifier above the Skin modifier to see how it's coming along.

HOT TIP

With straight skinning, as we've done here. elbows and knees don't retain their bony appearance when bent to extremes, giving you"spaghetti" or"noodle"arms and legs. To fix this problem, use the Skin Morph modifier to set custom volumes at extreme poses.

Once you've done a general cleanup, some areas, such as underarms and hips, will need additional work. Select a few vertices and open the Weight Table. Choose Selected Vertices at the bottom left of the dialog, and from the Options menu, choose Show Affected Bones. In the table, drag a weight value left or right to change the weight values. The vertex changes position as you change the values.

Work on the vertex weights until the entire body looks good in the test animation. Unhide the skeleton and the other body parts. Put the skeleton in pose mode again, and link any facial parts such as eyes, hair, and teeth to the skeleton head. Go into animation mode, remove the test animation keys from the skeleton, and your skinned model is ready for animation.

10

Walking in your footsteps

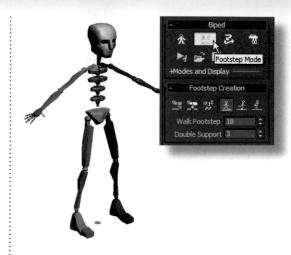

NE OF THE BIPED'S key features is its footstep tool, which lays down footstep icons for the Biped to step through. This unique feature uses a complex set of calculations to set keys for the entire Biped skeleton, including the spine and arms.

In order to use footsteps to animate the Biped, you must not have set any keys for Biped parts. If you animate one or more of the Biped body parts manually, the Footstep Mode button will be disabled, making it impossible to use footsteps. If this happens, you can delete the keys to make Footstep Mode become available.

Select any part of the Biped. On the Motion panel, turn on Footstep Mode in the Biped rollout.

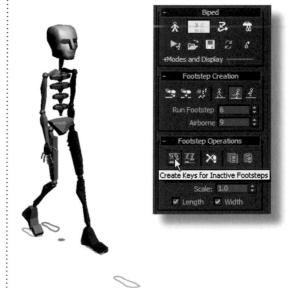

Click Create Keys for Inactive Footsteps in the Footstep Operations rollout to create the keys. Play the animation to see the Biped move through the footsteps. If more frames are needed to create your animation, the length of the animation is extended automatically.

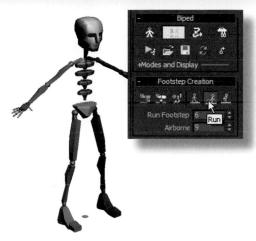

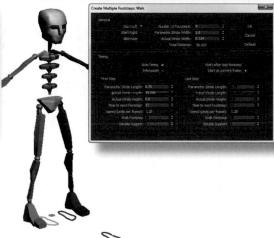

In the Footstep Creation rollout, choose a gait: Walk, Run, or Jump. The gait determines the overall footstep pattern that will be created. Click Create Multiple Footsteps. In the dialog that appears, set the Number of Footsteps and other parameters as desired. Click OK to create the footstep icons in the scene. If you play the the animation, you won't see any action as the keys haven't been created yet.

HOT TIP

If moving, rotating, scaling, or bending footsteps causes the Biped's legs to behave strangely (unexpected stomping, kicking, etc.), you can reset the body keys. Select the footsteps and click Deactivate Footsteps in the Footstep Operations rollout to remove the keys, then click Create Keys for Inactive Footsteps to reset them. While this will fix the leg animation, it will also remove any upper body animation, so copy the upper body animation to a track first and paste it back on afterward if necessary.

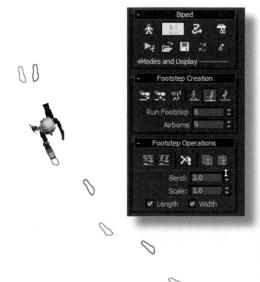

You can move and rotate the footsteps themselves, and the Biped's feet will follow them automatically. You can also use the Bend and Scale parameters in the Footstep Operations rollout to change selected footsteps.

To change footstep timing, open Track View – Dope Sheet while still in Footstep Mode, and expand the Bip01 Footsteps track. Each colored box corresponds to a footstep. Drag one end of a footstep key to change its length, or select and drag an entire key to move the entire footstep in time.

The alternative skeleton

KELETONS COME in all shapes and sizes. The CAT system comes with a variety of default skeletons such as a centipede and alien. And while the Biped system is intended for two-legged creatures, you can use it to animate just about anything, including a quadruped.

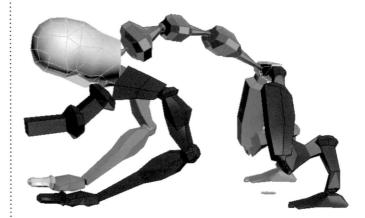

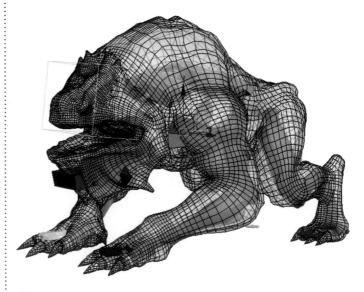

You can turn Biped into a quadruped by bending its spine links over during the posing stage.

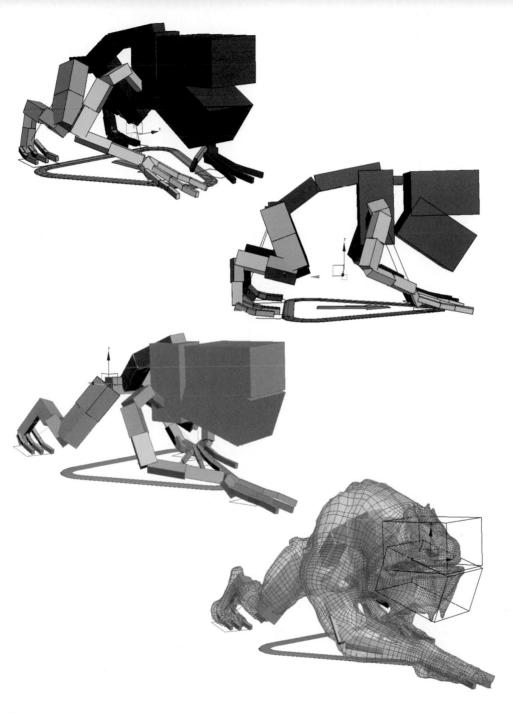

2 CAT is flexible enought to create a multi legged and armed creatures as well as bipedal ones. When creating a quadruped CAT or a custom rig is your best bet.

10

Biped foot control

IPED HAS its own method of doing IK/FK blending using Plant and Free keyframes. These keyframe types when set on a foot or hand will set the Biped's IK blend mode to IK or FK. Many animators like to have some sort of control object and just have the Biped's legs in IK mode most of the time.

Creating a controller object for the Biped's feet is easy. Biped already has the option to control its feet and hands with an external object. Usually this is used for animation scenarios where you need to stick the biped's feet or hands to an animated object.

Create a control object around the Biped's foot that you will use to animate with. A spline object is usually a good choice.

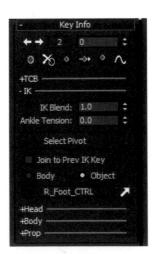

In order for the Biped foot to follow the control object we need to make a keyframe on the foot and set the key to use IK and follow the object. Create a keyframe and set the IK blend to 1.0 and select the Object option.

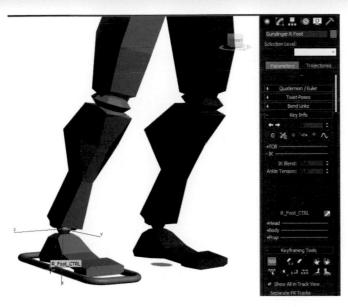

With the Biped's foot selected go to the Key Info rollout in the Motion Panel. Here under the IK section you will find Select IK Object. Pick your spline control object in the scene.

Now you can set up control objects for both feet and interact with your Biped more like a standard IK setup, setting keys on the control object for animation.

HOT TIP

If you're working with spline controllers like this you can also link the Biped COM object to a controller for easier selection and control.

CAT gizmos

AT COMES WITH a set of tools to help control its rigs. Some of these additional tools can be found in the CAT context sensitive quad menu. One of these tools is the CAT gizmo. CAT gizmos create fast controllers for your CAT bones. This can make your rig a little more customized without you having to do any heavy scripting or controller work.

If you right-click on a CAT limb bone, the bottom left quad will show some CAT specific tools like Extra Bones, Extra Controllers, and Gizmos.

One cool thing about these gizmos is that you can add your own custom shapes or objects to the list easily. You will find a Gizmos.max file in the plugcfg_ln\CAT\Gizmos folder off your root 3ds Max folder. This is the file that our CAT Gizmos are created from.

Choosing Add Gizmo brings up a dialog where the type of gizmo can be chosen. Choose a gizmo type and it will be added to the CAT rig. Most of these gizmos are parametric 3ds Max objects so you can adjust their size and properties like Render Enabled in Viewport.

Adding other gizmos to parts of the rig will give you quick control objects for the CAT rig.

Save the Gizmos.max file and go back to the CAT rig.
As the Gizmos.max file is likely on your C: drive you will
need to make sure you have proper permissions to save over it.
Be sure to make a backup copy of the original file just in case.
Now you can add your own custom Gizmos to the CAT rig.

HOT TIP

To use these CAT Gizmos with your other custom bone rigs, take a look at the CAT Gizmos for Custom Rigs topic in the MAXScript chapter.

When creating new gizmos pay attention to the pivot point position and orientation so your gizmo aligns the way you want on the rig. If you're creating a more custom object you may want to add a Xform modifier so you can adjust the size without affecting object level scale.

INTERLUDE

CAT vs. Biped

IN THE BEGINNING, 3ds Max had no built-in character animation systems. From 1990 to 1995, character animators using 3ds Max had to fend for themselves with Bones, morphing, and fairly primitive IK systems. While a few brave souls managed to get some good work done, the process took a long time and required an extensive knowledge of skeletal animation, not to mention 3ds Max itself.

Then, in 1996, a breakthrough. Unreal Pictures, an independent software developer, released the Character Studio plug-in for 3ds Max with its signature Biped skeleton. Although the first release was nowhere near as sophisticated as it is now, it did include those magic footsteps. Character animation suddenly became available to anyone willing to purchase the plug-in, and subsequent versions went from strength to strength. Character Studio, now known as Biped, was eventually included with 3ds Max when version 7.0 was released in 2004.

The same year, Character Animation Technologies introduced the Character Animation Toolkit (CAT) as a 3ds Max plug-in. CAT, with its superior toolset, was quickly adopted by production studios that specialize in advanced character animation.

Now that CAT is included with 3ds Max, you can expect that most new character animation projects will use CAT rather than Biped. However, there's still a long legacy of Biped animation out there, and chances are you'll have to deal with a Biped sooner or later.

The Skin modifier continues to be the tool of choice for skinning, but the original version of Biped included a modifier called Physique to perform this task. In its day, Physique was quite the slick tool, and it remains available in 3ds Max so old files that reference it will still open and function. However, Physique hasn't been updated in several versions, and the Skin modifier has long since surpassed it in ease of use, functionality, and reliability. From time to time I run into someone

who genuinely prefers Physique, but the vast majority of artists use the Skin modifier instead.

The same is likely to be true for Biped for many years to come. Artists who are very comfortable with Biped, and who find it meets their needs, will continue to use it for a long while.

If you're just now learning character animation, I advise you to go with CAT to keep your skills current, at least until the next big breakthrough comes along.

11 MAXScript

MAXSCRIPT IS 3ds Max's scripting language which is very powerful and pretty simple to use. With MAXScript you can automate tasks, create new tools, and extend 3ds Max's functionality greatly.

There are also a large amount of free and commercial scripts out there in the community if you are not a scripter yourself.

At Scriptspot.com, you can search and download a huge amount of useful scripts. In this chapter we will look at a few scripts that I find useful in many of the projects I work on.

INTERLUDE

A world of MAXScripts

IT'S HARD TO IMAGINE the world of 3ds Max without the ScriptSpot website. A vast community of MAXScripters contribute to and utililize this website on a daily basis.

What's even more amazing is that they do it all for free! That's right, just about all the MAXScripts listed at ScriptSpot can be downloaded free of charge. This might seem too good to be true, but MAXScripters seem to enjoy sharing and exchanging the scripts they've written for themselves. There's even free training on the site for learning how to write MAXScripts.

Before you get into a downloading frenzy, you need to know that MAXScripts come in a few different forms. The ScriptSpot website has a great article that explains how the different types work as well as how to install them:

http://www.scriptspot.com/3ds-max/tutorials/script-installation-in-3ds-max

Here is a brief summary of the file types and how to install and run them. There are a few different types of MAXScripts that you will run into when you download scripts from Scriptspot or other places. The most common file types are .MS and .MCR, and you will also sometimes encounter .MSE and .MZP files.

- The .MS file is the original type of maxscript and should be run by using the Run Script command under the MAXScript menu.
- The .MCR is a newer style of maxscript called a Macroscript. Macroscripts are run by loading them as you do with .MS files, but then you must assign them as an action in the Customize UI dialog. You can assign them to a toolbar or quad menu, or as a standard menu item.
- An MSE file is an encrypted maxscript. These files are encrypted for security to protect the author's code. Usually, these are commercial scripts (meaning, they cost money).
- Finally, the .MZP extension is a Zip format that allows you to more easily install the script. With these files you can install them by dragging them into the 3ds Max viewport or by using the Run Script command.

An important note on MAXScripts is that they aren't the same as plugins. While some plugins

started out as MAXScripts, plugins generally come with an .EXE file for installation, and you can't see the code. With a MAXScript file in .MS or .MCR file, the code is stored as plain text. You can look inside and see how it was written, and even customize it for your own needs.

Use any text editor such as Notepad to edit MAXScript files. You can also download the free Notepad++ program, which numbers the lines of code for easier editing.

Never done any programming? Afraid to try? To get familiar with MAXScript commands, open the MAXScript Listener from the MAXScript menu, choose Macrorecorder > Enable, and watch the commands pop up as you execute them in the user interface. This is a great way to learn the MAXScript equivalents of 3ds Max tools you use every day.

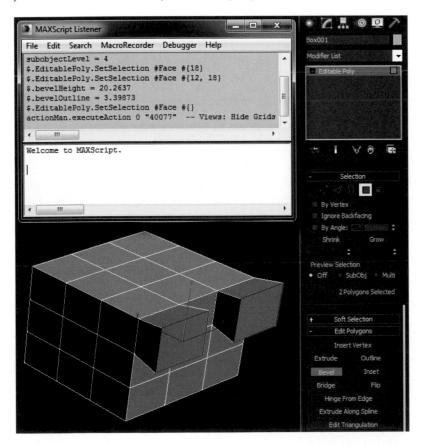

Voronoi stone wall

racture Voronoi is a script that fractures objects based on a fractal voronoi type pattern. This pattern emulates how objects like stone might crack or break apart with age. This script is very useful when doing destruction sequences or creating rubble of some kind.

At Scriptspot.com, search for: Fracture Voronoi

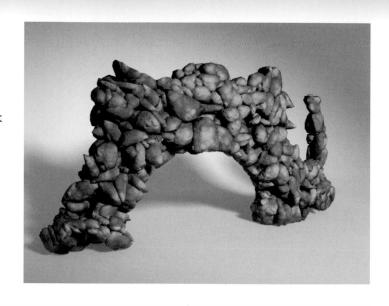

Set the Nb Parts and Iterations so you get the desired amount of pieces. Watch the Break button at the bottom which will tell you how many pieces you will ultimately get. Don't go too crazy or 3ds Max might take a long time to respond after you click Break.

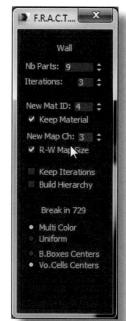

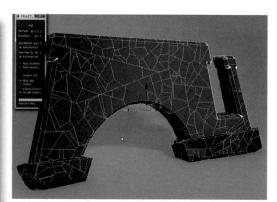

Break your object into pieces by clicking Break in. Once it's done you will have an object fractured into many chunks.

Select all the pieces of the wall and add a Push modifier to them. The Push modifier will make up for the volume lost when we apply TurboSmooth in the next step.

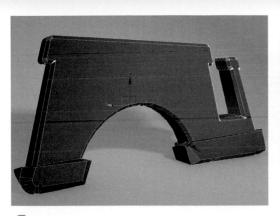

Create the shape of an object you want to destroy or break into pieces.

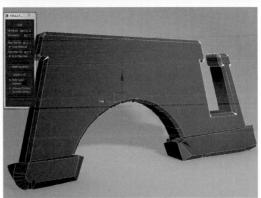

Run the Fracture Voronoi script and pick the object with the Pick button at the top of the dialog.

FractWallStart.max FractWallEnd.max

HOT TIP

In the Special Effects chapter, we look at how to use this tool to destroy objects.

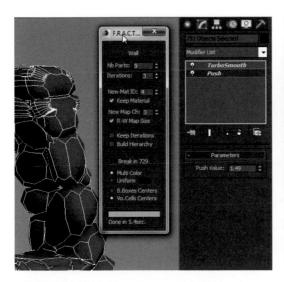

Add Turbosmooth and adjust the Push and Turbosmooth modifiers so your wall looks like a freeform stone wall.

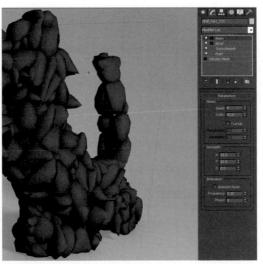

Lastly you can add a Noise or Bend modifier to all the objects to vary the shape of the wall, and remove a few of the rocks to make it look like an old stone wall.

11 MAXScript

Gizmo control

IZMO CONTROL is a nice little script that allows for control of a modifier or object gizmo via a control object like a point helper. Here, we'll look at how to use this script to create a helper that controls a Slice modifier's gizmo.

Gizmo Control is a MacroScript, so you will need to set it up ahead of time to run from a toolbar or quad menu. The action is under the MB Tools Category in Customize UI. You can also drag it to the 3ds Max Extras toolbar if you prefer.

At Scriptspot.com, search for: gizmoControl

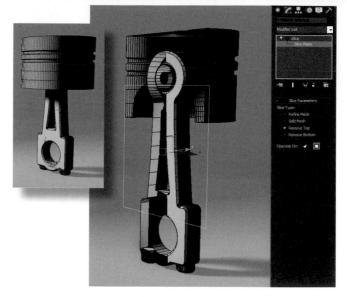

Select one or a number of objects and apply a Slice modifier. Choose Remove Top from the Slice Parameters and adjust the slice gizmo so its at the desired angle to give a good cross section of your object.

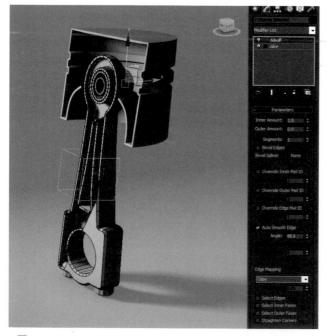

The Slice gizmo will jump to the position and orientation of the helper object but now you can control the gizmo with that control object. Select the point helper and align it so you have a nice-looking cutaway. A Shell modifier can be added with an Inner Amount to give your object thickness.

Create a Helper object such as a Point helper to control the slice gizmo, and run the Gizmo Control script from the toolbar or quad menu. Click Pick modifier object and choose the object with the Slice modifier on it.

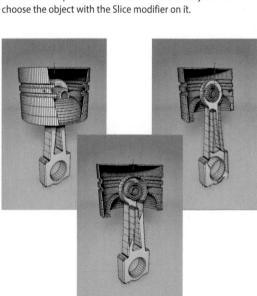

Animate the control object to create an animated cross section of your object that reveals the details inside.

Now you can add an animation controller to the control object such as a Path Constraint for complex cutaway animations.

A dialog will pop up asking which modifier's gizmo you want to control. Choose Slice and click Ok. Click Pick control object and pick your point helper. To associate the two together, click Link gizmo to node transform.

For the look of a technical illustration, you can apply different materials to the inside, outside, and edges with a Multi/Sub-Object material by setting the Shell Overrides to create a different material ID for each part.

GizmoStart.max GizmoEnd.max

HOT TIP

The Gizmo Control script can make an object work similar to the way the Linked Xform modifier works. Another common use would be to use it to animate a UVW gizmo.

CAT gizmos for custom rigs

N THE Character Animation chapter we looked at creating gizmos for a CAT rig. Wouldn't it be cool if we could use those gizmos for any 3ds Max rig or object? With a couple of edits to the scripts that are used in 3ds Max, we can.

There are two scripts that control the the CAT gizmos:

- CATRiggingRCM.ms in the 3ds Max\stdplugs\stdscripts\CATScripts folder
- Macro_CAT.mcr in the 3ds Max\ MacroScripts folder

You can use any text editor to edit these files. Before saving the changes, be sure to store a backup copy of the original files.

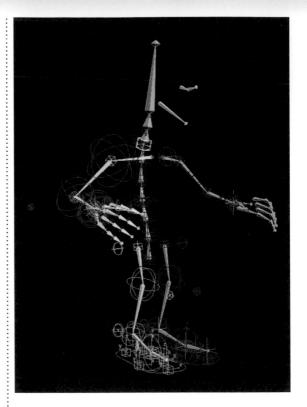

Open the Macro_CAT.mcr script and go to line 258. Comment out the "on is Visible do" section by adding a /* to the beginning of line 258 and a */ at the end of line 261. This will allow the Add Gizmo option in the quad to always be present so these gizmos can be added to any object. Save the script.

```
52
                   gizmo = selection[1];
 53
                   catbone.layer.addnode gizmo;
 54
                   gizmo.wirecolor = catbone.wirecolor;
                   gizmo.name = (catbone.name + ~GIZMO_NAME~);
 55
                   gizmo.transform.controller = CATGizmoTransform();
 56
 57
                   gizmo[3].TargetNode = catbone;
                   catbone[3].AddExtraRigNodes #(gizmo);
 58
                   if catbone[3].catparent.lengthaxis == "X" then gizmo.objectOffsetRot = (quat 0 -0.707107 0 0.707107)
 59
 60
                   select gizmo;
                   MessageBox ~MSGBOX_ERROR_CREATING_GIZMO2~
 61
 62
                   if gizmo != undefined then delete gizmo;
 63
                   gizmo = undefined;
51
               try(
52
                  qizmo = selection[1];
53
                  catbone.layer.addnode gizmo;
54
                  gizmo.wirecolor = catbone.wirecolor;
55
                  gizmo.name = (catbone.name + ~GIZMO_NAME~);
56
                  gizmo.transform.controller = CATGizmoTransform();
57
                  gizmo[3].TargetNode = catbone;
58
                  Try(catbone[3].AddExtraRigNodes #(gizmo);
59
                      atbone[3].catparent.lengthaxis == "X" then gizmo.objectOffsetRot = (quat 0 -0.707107 0 0.707107)
60
61
                  catch( if catbone.BoneEnable do gizmo.objectOffsetRot = (quat 0 -0.707107 0 0.707107))
62
                )catch(
63
                  MessageBox ~MSGBOX_ERROR_CREATING_GIZMO2~
64
                  If gizmo != undefined then delete gizmo;
65
                  gizmo = undefined;
```

Open the CATRiggingRCM.ms script in the text editor of your choice, and locate line 58. Replace lines 58 through 60 with the code shown in the second image above. This new code allows you to set a gizmo for other objects as well as CAT objects. It aligns the gizmo to the correct axis of a bone object, like the original code does for a CAT object. Save the script with the same filename in the same folder.

66

in 3ds Max, right-click on the bone setup and add your

3ds Max from now on.

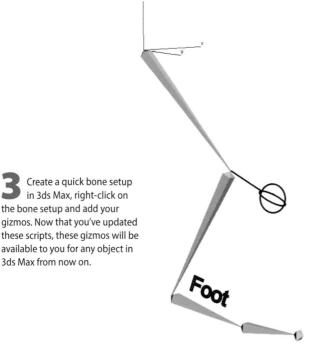

HOT TIP

This can be a very useful trick, but be sure you know what you're doing before you use something like this in production.

MAXScript

Getting a little tense

HE TENSION MODIFIER is more of a plugin than a script. But unlike the plugins in the plugin chapter, this one is free for educational and non-commercial use.

As with scripts, there are a great deal of free or inexpensive plugins that can help produce better results or get the job done faster.

Grant Adam's Tension Modifier:

http://www.rpmanager.com/plugins/TensionMod.htm

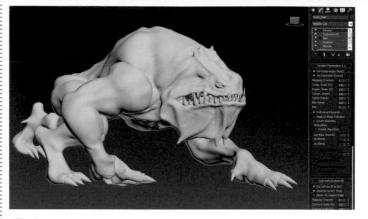

The Tension modifier allows you to visualize areas of a mesh that have tension or compression. This can be useful for animation and skinning. With a deforming character selected add the Tension modifier to it.

Scrub the timeline to see the character deform. The vertex colors change to show the tension and compression or squash and stretch of the mesh. This is useful for tuning your skinning or blending in textures in these areas.

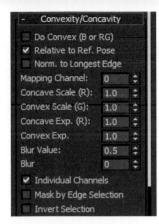

Uncheck Do Convex (B or RG) for now. We will use this in another lesson in materials.

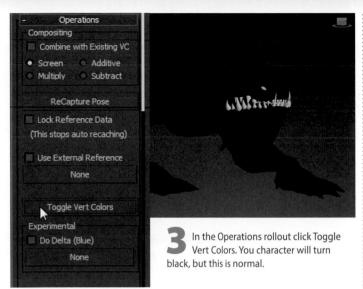

TensionStart.max TensionEnd.max

Adjust the Blur value as well as the Comp. Scale and Expan. Scale to get a smoother result, or push up either the tension or compression.

PF Spliner

F SPLINER is a great little script that generates splines from particles. This can produce some interesting motion graphics effects as well as effects for creating trails behind objects. There are options for making the paths animate as well as attaching them all together into one object.

A special thanks goes out to John Rand for updating the script for 3ds Max 2014 for me and the rest of the community.

At Scriptspot.com, search for: PF Spliner

Select some particles with interesting movement to them like the ones created in the swirly particles topict in the Effects chapter. Run the PF Spliner script and your particles will already be active in the particle source section.

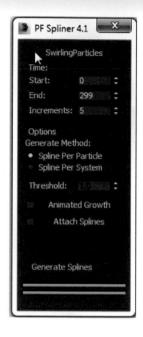

Another nice function is the Animate Splines Growth option. Click Delete Old Splines and check the Animated Growth option. Generate Splines again.

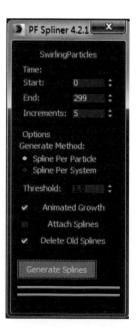

Click Generate
Splines and the
script will run through the
timeline twice. Once to
track the particles and once
to build the splines. In the
end you will have a bunch
of cool swirly splines.

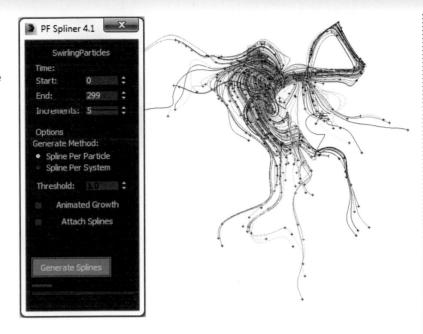

PFSplinerStart.max PFSplinerEnd.max

HOT TIP

Be careful of large particle counts when using this script. It can generate a lot of data and cause 3ds Max to become unresponsive for some time.

The splines are now animated over time, creating a captivating flow or trail from the particles.

12 Rendering

RENDERING IS THE EASIEST task in 3ds Max, in most cases just a matter of a few clicks. In this chapter, we'll look at ways to enhance your rendering experience while keeping the process fast and easy.

Rendering basics

HE RENDER SETUP DIALOG is your main resource for rendering settings. Choose Rendering menu > Render Setup to open the dialog.

While this dialog contains numerous parameters, there are a few that are crucial to creating the type of rendering you want.

To prepare for rendering, your first stop is the Time Output group in the Render Setup dialog. To render an animated sequence, choose Active Time Segment or enter a range of frames next to Range.

Your next stop is the Output Size group. Choose from resolution presets, or enter a custom Width and Height.

If you're rendering an animated sequence, be sure to click Files in the Render Output group and enter a file name. Otherwise, your animation will get rendered to nowhere.

HOT TIP

To render an image for print at the right resolution, you can use the Print Size Wizard to calculate resolution and render quickly. Go to the Rendering Menu and choose Print Size Assistant.

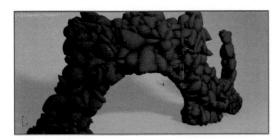

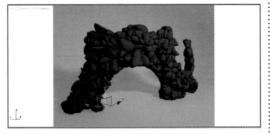

To accurately show what portion of a viewport will get rendered, click the viewport name and turn on the Show Safe Frames option.

Mental ray rendering

HE DEFAULT RENDERER for 3ds Max is called the Default Scanline Renderer. You will find many uses for the mental ray renderer, which creates images with a higher degree of realism than the Default Scanline renderer.

This topic gives you a quick guide to using mental ray. More information is available in the Materials chapter and the Lighting chapter.

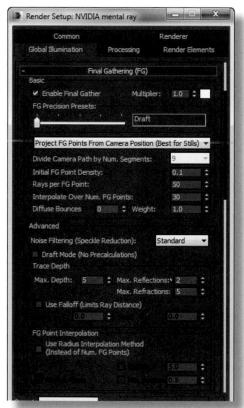

Under the Global Illumination tab, in the Final Gathering rollout, make sure Enable Final Gather is checked, and the FG Precision Presets are set to Draft.

To get the most from mental ray, change your materials to mental ray materials. See the Materials and Mapping chapter for specifics on how to do this.

To change the renderer to the mental ray renderer, click the pick button in the Assign Renderer rollout of the Render Setup dialog, and choose NVIDIA mental ray Renderer from the dialog that appears.

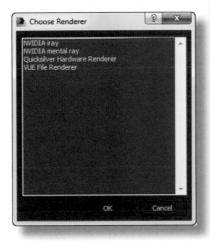

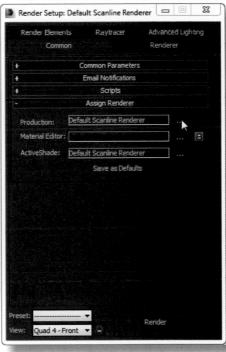

HOT TIP

When you switch to the mental ray renderer, its a good idea to use the mrphotographic Exposure Control

Mental ray renders one rectangular chunk (called a bucket) of the image at a time. The first pass is for advanced lighting calculations, and the second is for the final rendering.

INTERLUDE

What is mental ray, anyway?

IN REAL LIFE, light bounces all around all the time. The light bouncing off any surface, such as your desk, and then into your eyes (so you can see it) might have bounced thousands of times before it got to you. Each time it bounces, it loses some of its energy (brightness).

To understand the effect this bounced light has on what you see in everyday life, take a look under your desk. You can clearly make out the carpet or floor below even though no light reaches this area directly. Light from a window or from overhead has bounced several times off the floor and the underside of the desk to illuminate this area enough for you to see it.

The mental ray renderer calculates an approximation of this bounced light. It isn't feasible for your humble computer system to calculate light rays bouncing as many times as they do in real life, so mental ray cheats a bit and uses just a handful of bounces. The reasoning is that by the time light has bounced a few times it's lost most of its brightness anyway, so you only need so many bounces to get a decent result.

Mental ray renders by bouncing light around the scene a specific number of times. Compare with the Default Scanline Renderer, which does no such thing. The default renderer sends light rays out one time from each light source, and that's it.

In addition to lighting areas that don't receive direct light, bounced light also picks up a bit of color from each object it touches. For example, a brightly colored object near a plain wall will leave a subtle spray of color on the wall. This effect, called *radiosity*, makes the difference between a so-so rendering and a magnificent one. Viewers, without knowing anything about radiosity, will intuitively find a scene with this effect warmer and more inviting, not to mention more realistic. The mental ray renderer, when used with mental ray materials, produces this effect. To enhance the radiosity effect, increase the number of Diffuse Bounces in the Final Gather rollout to 1 or 2.

Mental ray includes two methods for bouncing light around a scene, Global Illumination (GI) and Final Gather. While the rays used for GI are narrower and give a more accurate result, Final Gather sends out big clumpy rays to light an entire blob of the rendering in one shot. Originally, Final Gather was intended to be used in addition to GI to lighten up dark corners and other areas that somehow didn't get their share of GI rays. But then artists discovered that you could get pretty good results with Final Gather alone, and that it was much faster to use than GI. The use of Final Gather alone has now become popular as a rendering workflow.

When using Final Gather, start with the Draft setting and make changes only as necessary. The Max Trace Depth value (Render Setup dialog > Renderer > Rendering Algorithms rollout > Reflections/Refractions group) determines how many bounces occur. By default this value is 5, and a rendering often looks pretty close to real with just 5 bounces. You can increase realism by increasing this value, but you'll also increase rendering time.

All this light-bouncing is done with an intense series of calculations on virtual rays rather than real rays. Thus the name mental ray.

12 Rendering

Nitrous viewport

HE LATEST releases of 3ds Max have implemented a much more realistic viewport rendering system called Nitrous.

Nitrous is on by default, but there are a few options to consider for getting the best realistic viewport results or fastest interactive performance. Nitrous also includes a few new viewport shading modes that can be useful for specific workflows.

There are some interesting overlay effects that can be useful for previsualization. Try Ink Lines or Colored Pencil to give your scene the look of a sketch, which can help you avoid questions from clients about texturing and lighting when you're not at that stage yet. These effects make it clear that what's being shown is for preview only.

Realistic mode is great for tuning lighting and

can slow down scenes that are very large or have huge

textures to deal with.

getting good previews of your model. However, it

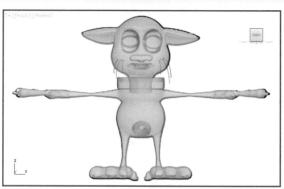

When modeling with reference planes in the background and using the see-through property on your model, it's good to turn off the Ambient Occlusion option as it makes a mess and continually updates. You can also just use the Shaded option.

HOT TIP

Turn off adaptive degradation if your navigation gets slow on simple scenes. Its supposed to make it easier to navigate heavy scenes but sometimes it can do the opposite for basic ones.

The clay shader is useful for modeling in 3ds Max. It's similar to shaders in other sculpting applications that can help you visualize your model's topology in a better way.

17 Rendering

Quicksilver rendering

O RENDER the results you see in the viewport, the Quicksilver renderer has been introduced. With Quicksilver you can produce a higher quality preview render for pre-vizualization and in some cases final output.

Change the renderer to Quicksilver so you can output the Nitrous results. There are options to let the renderer increase the quality for a certain number of iterations.

Use it for a super fast AO (ambient occlusion) pass. Quicksilver does screen space AO that is really fast. If this is good enough for your production, render an AO pass out of Quicksilver.

The option of time per frame is great. I will set this pretty often when I know how much time I have and need a good preview animation in 20 minutes. Just set the time per frame and you will get the best quality possible for that amount of time.

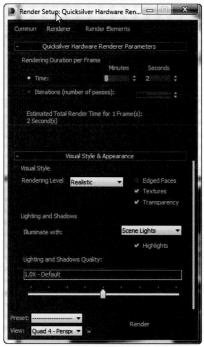

Render Elements Alohe Moheral ID Object ID 2 Depth OK Cancel

Quicksilver also has a few render elements it can output. In many cases it can be the quickest way to get Zdepth or Material IDs.

HOT TIP

For the AO pass add a white 100% self-illuminated material to all your objects in the scene.

Render passes with state sets

TATE SETS can be used to create complex render passes for your scene so you can more effectively composite and update your renders in post-production. Render passes can isolate objects via mattes or IDs. You can also create separate ink line or Ambient Occlusion passes. Previously you would need to save many different versions of your scene to do this which can become cumbersome.

State Sets work like a layered system to your base 3ds Max scene. Every State you add can change something in that base scene like materials, lights, renderers, and modifiers.

Create a new State and name it Logo_Grey. Click Record and hide everything in the scene but the Logo object. Open the Material Editor and assign a new grey material to the logo. This pass can be rendered with the logo itself with a flat grey material that could be useful in composite.

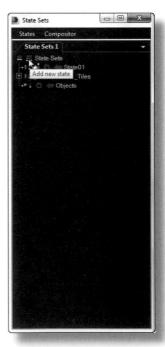

Launch State Sets and click Record on State 01. Hide the Logo and Background objects and click the Record button again to stop recording. Press the arrow button to toggle on or off the effect of that State. Turning on the state now hides these two objects so you can render only the midground tiles. Rename the state to Mid_Tiles by slow double clicking on its name.

0

PassesStart.max PassesEnd.max

HOT TIP

Using State Sets ability to use different renderers in each State can work well if you need to render things like fluids or hair in Scanline or other renderers.

State Sets can switch to different renderers for different passes. To create a fast AO pass create a new State named AO and click Record. Switch the renderer to QuickSilver and assign all the objects in the scene a white 100% self-illuminated material. Set the QuickSilver AO radius to 30.

Managing your scene

TATE SETS is a great tool for scene management and setup. Besides controlling display properties of objects, states can control viewport properties and materials. By setting up a few states you can optimize your work environment for animating, rigging, or skinning a character among other things.

Launch State Sets and start recording State 01. Hide the Controllers layer and unhide the environment layer. Stop the recording by clicking Record again, and rename the state to Display.

Create one more state and click Record. In this State apply a simple grey material to the character so it's fast to update without the textures. Unhide the Biped layer and select all objects on the Biped layer. Set those objects to Display as Box. Name the state Animate.

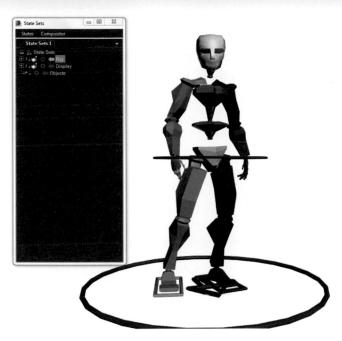

Create a new state and click Record. Hide the Character Mesh layer and unhide Biped. Set the view to be Shaded instead of Realistic so it will be faster for animation. Select all the objects on the Biped Layer and set them to renderable. This way if you see the biped's movement in a rendering. Stop Recording, then Name the state Rig.

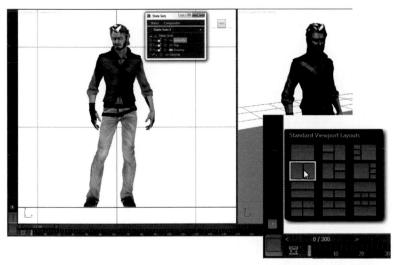

If you want to go back into any state and record some new option you can at any time. Create a new viewport tab with two views, and set them to Front and Perspective. Set your view preferences for each view to Consistent Colors for the Front with no AO or Shadows, and Realistic for the Perspective view. Go back to the main View Tab and click record on the Display State. Switch Viewport Tabs to the newly created one and stop recording. Now that State will switch to this layout for you as well.

Gunslinger.max

HOT TIP

If setting up another Realistic View is too taxing on your system and video card, try setting the Perspective view to Shaded.

INTERLUDE

Tipping the attenuation scales

WHILE ADVANCED rendering engines such as mental ray and VRay are certainly the most appropriate and accurate when it comes to photorealistic interior lighting and rendering, at certain times you might find yourself in need of a quicker and easier scanline solution.

For this interlude I will focus on an interior scene that is lit almost entirely from exterior light sources; specifically the sun (direct illumination) and the sky and bounce light (indirect illumination). One of the most difficult lighting effects to achieve without the help of global illumination or Final Gather is the correct mix of direct and indirect sources and mimicking how light would bounce around a room. For instance, it is deceiving how much variation in light color and intensity there is within a single interior space.

Play close attention to the corners of any interior space and, in particular, the quality of light as compared to the other parts of the room. The corners are often darker than the center of the

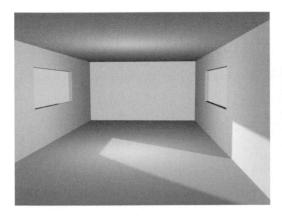

room, setting them back in the overall visual mix. To achieve this look without the use of an advanced rendering engine, you can take advantage of an underutilized light function within 3ds Max: scaling the attenuation settings of a particular light source.

Attenuation refers to the distance a given light's rays are able to travel through 3D space in your scene. If attenuation is not used, the rays will travel forever. If you choose to use this function, your light's rays will attenuate or diminish over the specified distance. When using an Omni light, this distance is represented by a wireframe sphere that will grow away from the light's center as you increase the attenuation.

What you might not realize is that this spherical representation of the light's attenuation can be scaled to better match a particular space. To put this into practical use, I've created a simple interior scene and placed an Omni light in the center of the room. Without any attenuation, the room looks quite flat and unrealistic.

To achieve more photorealistic results, check both the Use and Show radio buttons in the Intensity/Color/Attenuation rollout and do a quick non-uniform scale on the Omni light. Also, it is important to turn off both the Diffuse and Specular light and check the Ambient Only radio button in the Advanced Effects options of the Omni light.

Jason Donati Department Chair, Media Arts The New England Institute of Art

13 Plugins

ONE OF 3DS MAX's strongest suits is its active third-party plugin development community. In some cases these tools become the basis for a 3ds Max pipeline. Because of this I wanted to highlight some of the plugins I could not do without in 3ds Max. Some of these tools I have helped to design, and some are crucial to my workflow.

It's important to know what tools are out there and which developers produce well-crafted tools that can help you get your job done. Like scripts, each plugin has a website for downloads and updates.

When a new version of 3ds Max is released, plugins usually have to be recompiled for that version, which is why there's a specific version of a plugin for each version of 3ds Max. www.maxplugins.de is one of the best resources around for 3ds Max plugins, partly because the owner of the site, David Baker, takes his own valuable time to recompile many plugins for the latest versions of 3ds Max. Depending on the scope of the 3ds Max update, adjusting and recompiling a plugin can take a while, causing a delay in your favorite plugins becoming compatible with the latest release.

13 Plugins V-Ray

HAOS GROUP's V-Ray Renderer is the raytrace renderer of choice for 3ds Max. It has all the bells and whistles of an advanced rendering system including Global Illumination, Caustics, Advanced Materials, as well as the ability to handle huge amounts of geometry and output a comprehensive set of render passes.

One feature I find useful for really tuning renders in post is the LightSelect Render Element. LightSelect is a V-Ray Render Element that allows you to select each light in the scene and output its contribution as a render element. If you have a render with many lights sources as well as global illumination you can render out using LightSelect and then tune your renders to a great degree in post.

2 Save your files out as .exr or a format that supports 32 bit pixel depth. This way you will be able to adjust the Exposure effectively in the post application.

In Photoshop arrange your render elements in your preferred order, and set their blend modes to Add. This combines them together, adding each light contribution to the overall look.

After you render with all your lights selected in render elements you will get many light outputs in the Vray VFB.

Adjust the Exposure and Hue/ Saturation of each layer to achieve the look you're after. You can brighten and darken lights, and set the tone of each by adjusting its color.

Having this much flexibility real-time in a post application is very nice because you can really tweak the final render without long 3ds Max render times on every edit.

13 Plugins Phoenix FD

HOENIX FD is Chaos Group's fluid dynamics simulator. With it you can create realistic smoke, flames, explosions and liquid effects. Fluid simulations are a fairly technical area but if you want to achieve realism it's the way to go.

A couple of reasons I use Phoenix for my fluids work are that it does liquids right inside of 3ds Max as well as smoke and fire, and it has great integration with V-Ray since it's from the same developer.

Setting up multiple grids to ignite at different times can make your simulation more dynamic and can even save time. Using the Burning options, some sources are set to emit only fuel that is ignited by one of the other simulators.

When using a grid-based fluid system like Phoenix FD it's important to tune your grld and cell size to get the best detail and speed. I find using multiple grids can be helpful for this as well as using the adaptive grid option. Here an adaptive grid is set up on the windmill blade so it does not have have a large grid that would encompass the entire blade rotation.

The GPU preview can give you a good idea of what your final render will look like without costly full-frame renders

13 Plugins Ornatrix

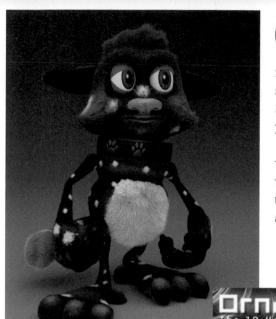

RNATRIX IS a hair solution for 3ds Max for grooming, animation, and rendering. Its styling tools are very intuitive and it uses a modifier stack-based system. The modifier system lets you apply an individual curl or brushed style per modifier. This leverages one of the core strengths of 3ds Max and allows you to come up with flexible solutions for your production.

Ornatrix has its own raytrace renderer that is capable of very fast, soft, and fluffy hair. It also has very tight integration with V-Ray, allowing for renderings of large amounts of hair using V-Ray's hair shader with global illumination, reflections, and other V-Ray rendering features.

In the Surface Comb modifier Sub-Object mode you can set Sinks to control the direction of the comb. These are drag and drop pointers that influence the hair. A few quick clicks should get you a nice base to work with.

When setting up a furry character with Ornatrix the Surface Comb modifier is a quick way to get a base groom.

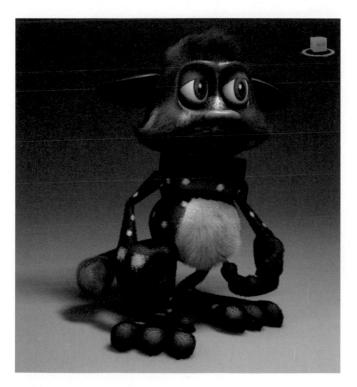

Adding a Mesh from the Strands and Render modifier that are enabled only in the viewport can give you great viewport rendering quality. With the latest Nitrous viewport a really nice preview can be achieved for Ornatrix hair right in the viewport.

13 Plugins

Zookeeper

OOKEEPER IS a scene management tool for 3ds Max that allows for a fully node-based workflow as well as advanced outliner tools like object management and nested layers. On a daily basis I use it for quick selection of objects and managing layers more effectively than the 3ds Max layer manager. For more complex scenes Zookeeper is great for managing materials and scene objects in a node based environment.

2 Creating a new tab for object management and using the top filters can give you quick access to only lights or helpers in a tab.

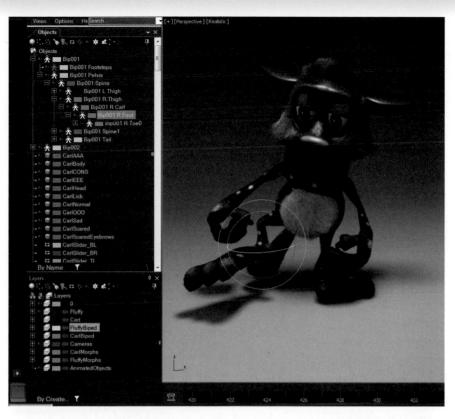

With Zookeeper docked in the 3ds Max UI you can quickly select objects and layers as well as drag and drop between the two. Selected objects have their layer highlighted so you can know which layer they are on.

Having a full node-based control over not only materials but all objects, controllers, modifiers and everything in 3ds Max is good to have for complex scenes or setups. You can directly wire controllers, expressions, and materials together and easily see their relationships.

Automate your animation with parameter wiring, and animate multiple objects by changing just one parameter.

14

Parameter Wiring

TO SIMPLIFY the animation process, you can set up custom parameters that pertain to just the values you want to animate, and put all the new parameters in one central location. Then you can wire (connect) these custom parameters to real parameters to create a useful interface for your animation needs.

While programming experience and math skills are helpful for doing parameter wiring, they're not essential to take advantage of this powerful tool.

Wiring 101

O ILLUSTRATE THE concepts of parameter wiring, I've used a simple animation of a bead on a wire. In this example, you'll create a custom manipulator right on the screen, and then use it to control the bead's animation.

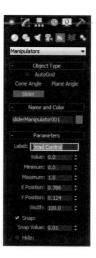

Now we'll create a custom manipulator to control the bead. On the Create panel, choose Helpers > Manipulators, and click Slider. Enter a name for the manipulator in the Label field, and click in the Front view to create the slider. Set Maximum to 1.0, and adjust the X Position and Y Position so you can see the slider on the screen.

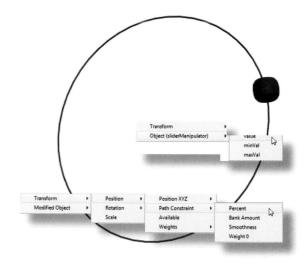

Next, we'll wire the manipulator's Value parameter to the Percent parameter for the bead. Right-click the slider and choose Wire Parameters. From the pop-up menu that appears, choose Object (Slider) > Value. Click the bead, and from the pop-up menu, choose Transform > Position > Path Constraint > Percent.

Load the file BeadStart.max, and select the bead. Choose Animation menu > Constraints > Path Constraint, and click the wire to put the bead on the path.

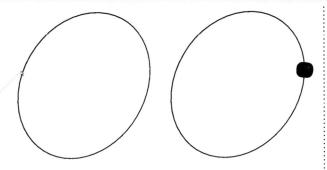

BeadStart.max BeadFinish.max

Pull the time slider to see the animation. The bead goes around the path but doesn't turn with it. In the Motion panel, turn on Follow, and try different Axis settings until the bead goes around the wire correctly.

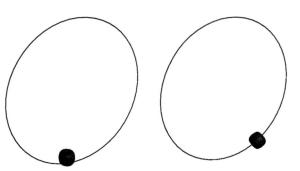

The Parameter Wiring dialog appears. Click the right arrow, and then click Connect to connect the two parameters together, with the slider controlling the bead's Percent parameter. Minimize the dialog.

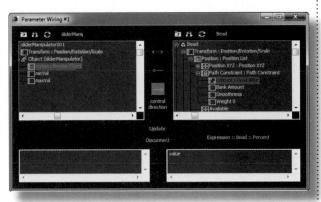

HOT TIP

The reason we made the slider Value go from 0 to 1, rather than 0 to 100, is that 3ds Max internally stores the Percent parameter for the Path Constraint as a number between 0 and 1.

On the toolbar, click Select and Manipulate. Pull the slider handle to make the bead go around the wire. To animate the bead moving around a wire, simply turn on Auto Key and animate the slider value.

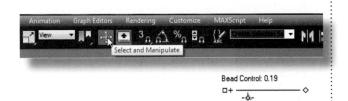

Follow me

NE BEAD is very nice, but what about multiple beads? We can't wire them all directly to the manipulator value or they'll all end up on top of one another. What we want is for each successive bead to follow the first, but with an offset so they'll follow in order.

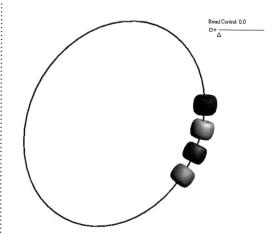

Load the file BeadsSeq.max. The first bead is wired to the manipulator, and is currently at the 0 position on the path. Select each of the other beads, and note their % Along Path values on the Motion panel. Each bead's percent differs from the previous one's by -4.0. This will translate to -0.04 with parameter wiring.

Click Manipulator Mode on the main toolbar, then when you pull the slider handle, the second bead follows the first, always keeping a distance equivalent to 4% of the path length.

Wire the third bead to the second, and the fourth to the third, each time with an offset of -0.04. When you pull the manipulator handle, all the beads will follow along.

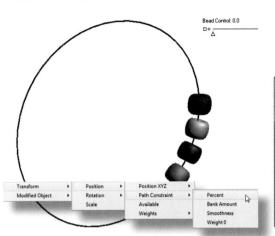

Select the first bead. Right-click it to choose Wire Parameters, and choose Transform > Position > Path Constraint > Percent. Click the second bead, and choose the same sequence of parameters.

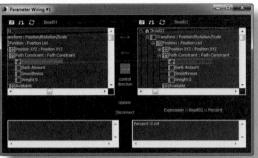

In the Parameter Wiring dialog, the first bead appears on the left, and the second bead on the right. In the entry area at the bottom right of the dialog, change the entry to Percent –0.04 as shown in the image. Click the right arrow and Connect to make the connection.

BeadsSeq.max BeadsFollow.max

HOT TIP

A manipulator is a special kind of helper that creates an in-viewport parameter control. Like every manipulator, you'll need to click Select and Manipulate on the toolbar before using it.

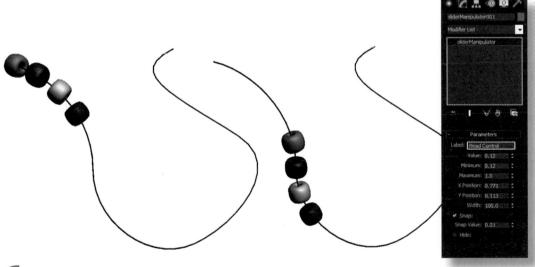

This type of setup works with any kind of path, even an open one. Here, I've converted the circle to an Editable Spline and used Break to break one of the vertices. Then I was able to fashion the spline into a necklace shape. When the first bead is at 0, the other beads will jump to the end of the path, as 3ds Max interprets a negative Percent value as 100 minus the value. For example, -4% is interpreted as 96%. To avoid this problem, you can adjust the slider's Minimum value to 0.12 to force the first bead to start far enough down the path to accommodate all the beads.

Parameter Wiring

Telling time

OU COULD SET THE TIME manually, but why bother when you can use wiring? Setting up wiring for rotation requires a smidgen of math and the use of a special function to convert the numbers to angular degrees that 3ds Max can interpret.

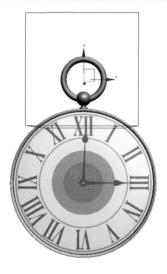

Load the file TimeStart.max, and select the Dummy object at the top of the watch. This is the object that will hold our new custom parameters.

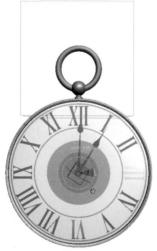

Rotate the hour hand Dummy with the Local coordinate system, and you can see that it rotates on the negative Z axis. You will use this axis when wiring it to the Hours parameter.

Select the Watch vcontrol Dummy, and wire its Object (Dummy) > Custom Attributes > Hours parameter to the hour hand Dummy's Transform > Rotation > Keyframe XYZ > Z Rotation parameter.

Since the watch face has 360 degrees and 12 hours, each hour is 30 degrees along the watch face. At the lower right of the Parameter Wiring dialog, type in –Hours * 30 (with the minus sign for the negative rotation), and click the right arrow and Connect.

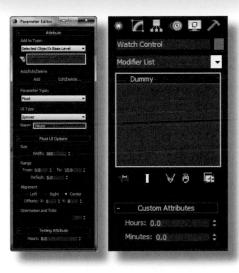

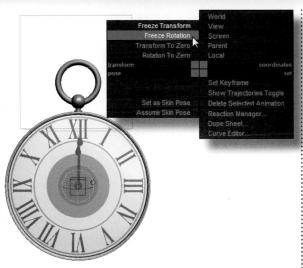

TimeStart.max TimeFinish.max

Choose Animation menu > Parameter Editor.
Create a new parameter of the Float type
called Hours, with a Range from 1 to 12. After you
click Add, the parameter appears on the Modify
panel. Create a second parameter called Minutes
with a Range from 1 to 60.

We'll wire the hour hand first. But before we do that, we need to tell 3ds Max where the 0 position is. Select the hour hand Dummy and rotate the hour hand to point to the 12. Then use ALT-right-click to display the animation quad menu, and choose Freeze Rotation. This resets the current rotation to 0 internally, so any rotation coming from wiring will start from that point as the 0 point.

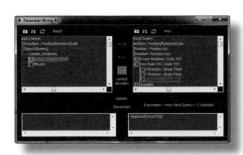

When you adjust the Hours spinner, the hour hand goes wild. This happens because internally 3ds Max expresses degrees as radians, an angular measure equal to about 57 degrees. You'll need to convert the degrees to radians with the degtorad function in the Parameter Wiring dialog. At the lower right of the dialog, change the entry to —degtorad(Hours * 30) and click Update. Adjust the Hours spinner to see the hour hand move smoothly from hour to hour.

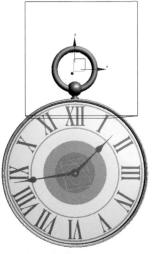

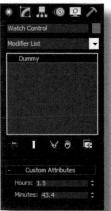

Wire the Minutes value in the same way. Freeze the minute hand Dummy at the 12 mark on the watch face, check for the correct rotation axis, and use –degtorad(Minutes * 6) to wire the Minutes parameter to the minute hand Dummy's rotation parameter. Now you can animate the Hours and Minutes parameters as you like to set the time on the watch.

INTERLUDE

Spinning wheels

REMEMBER WHEN YOU dozed off in geometry class, wondering when you would ever use the stuff you were learning? That day has arrived.

In your animation travels, sooner or later you'll need to make something spin. Of course you can keyframe the rotation, but that can be tricky. If you rotate an object three full times, for example, 3ds Max will sometimes think the object just has to go the shortest distance between the start and end rotation, which is essentially zero. So keyframing rotations of more than 360 degrees can be troublesome.

Instead, look at wiring as an option. For example, suppose you need to animate a toy car moving along a road. You know how far the car is going to travel, so you can easily figure out the number of wheel rotations.

If you know a bit of geometry, that is. Let's revisit that musty old classroom and grab a useful equation or two.

A circle has 360 degrees, and a wheel turns 360 degrees to make one turn. So far, so good.

Every circular object has a radius, the distance from the center to the edge of the circle. If you know the radius you can figure out all kinds of things, like how much road a wheel covers when it turns one time.

Suppose you put a chalk mark on your car's tire, then roll it forward just far enough so the chalk mark goes around once and comes right back to where it started. You have just traveled a distance equal to the outside edge of your tire.

The measurement of this outside edge is called the circumference. To measure the circumference of a wheel, you can get out your tape measure and wrap it around the wheel. Or you can do it the easy way: measure the radius and make a calculation.

The circumference of any circle is the same as 2 times the radius times pi, a magic number equal to 3.14 something and a bit. Pi is sometimes represented as the Greek symbol π . You don't even have to know exactly what pi is to do your calculations. 3ds Max knows what it is, and that's all that matters.

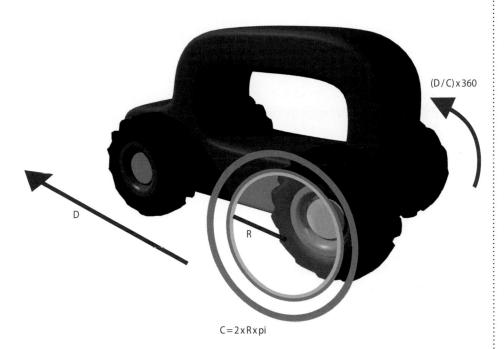

Say the car travels 300 units on the Y axis, and the radius of the wheel is 23. To figure out how many times the wheel turns, you need to divide the distance traveled (300) by the circumference of the wheel ($2 \times 23 \times pi$).

So that gives us the number of full turns. To get the number of degrees it has turned at any given time, just multiply the whole thing by 360, stick a degtorad in front of it, and you have wheels-a-turning. If you want to see this equation in action, I've included a toy car file with all four wheels wired in this way.

Granted, this technique isn't for the faint of heart. But if you like the idea of automated animation, parameter wiring can't be beat. If that's the case, dust off that old geometry book and revisit those equations. All of them still work.

Parameter Wiring

Feeling exposed

XPOSE TRANSFORM is a tool that riggers use to get info from objects or controllers in their rig in order to set values on other objects in respect to that. Being able to get to this data allows you to drive other objects with that information. The Expose Transform helper can also be used to create some interesting motion graphics effects by driving an object's properties based on its distance from another object in the scene.

Select the Expose Transform helper and pick POS_Object as the Expose Node. Uncheck Parent under that and pick POS_CTRL as the Local Reference Node. This will set the Expose Transform helper to expose the distance from these two objects.

If you move the POS_CTRL object the Tile will rotate based on its distance from the control object.

To get started we have a few objects. First the mesh object (Tile) which will be our flipping tile in the scene. Second, a point helper (POS_Object) for the position of the Tile. Third is a Circle (POS_CTRL) that will be moved around the scene controlling the flipping. And lastly, the Expose Transform help, (ExTrans) to expose the distance between POS_CTRL and POS_Object.

So all these pieces move together Link ExTrans to Tile, and Tile to POS_Object. Now to move the assembly you can just move the POS_Object.

TileExposeTStart.max TileExposeTEnd.max

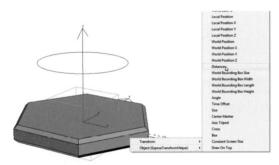

Right-click on Tile and select Wire Parameters. Choose Transform/Rotation/Rotation X then pick EXTrans and wire Object/Distance.

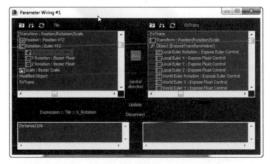

In the Wire Dialog click the arrow pointing to the left to connect in that direction and then in the bottom left field add a /100 after Distance to slow the rotation a bit. Make sure you choose Connect or Update in the bottom center of the dialog.

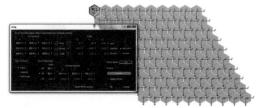

Select all objects but POS_CTRL and go to Array. Set up a 2D array with 10 copies in each. Offset in X and Y in the first set and only in Y in the second. Make sure you choose Copy as Type of object.

As you move the POS_CTRL circle around the tiles will flip and create a progressing rotational animation.

INTERLUDE

To code or not to code

I HAVE WORKED in the 3D industry for 20 years and for most of that time I have been a technical director and coder doing a variety of jobs: building tools, animating, rigging, modeling, and everything in between for companies such as Walt Disney, 2K, Red Rover, Lockheed Martin Areospace and many more. I am also a professor and currently work at the largest college in Canada teaching 3D.

In that time I have been asked many questions but there's one that must come up at least once a month: "What do I need to do to become an excellent technical director?" This is always a very hard question to answer as there are many things that need to be learned. First and foremost is we all need to be artists and understand what is needed by artists. We also need to have the desire to solve problems as that is what much of the job of technical artist or director entails.

But, the one main thing that is always needed by any one in the 3D business is a work ethic and the ability to be able to finish what one has started. This of course sounds very similar to what all of our parents kept telling us for years and what most of us ignored until we either spent a life failing at what we wanted to do or succeeded at doing what we set our minds to.

As a technical director I'm usually asked to solve problems for which there is little or no guidance. The ability to solve problems is a very difficult skill to teach someone. It is about having the desire to not accept failure in producing a desired result, and finding creative ways to solve the issues that are slowing or stopping production.

I'm also often asked if a technical director needs to learn to program. The answer to this is Yes. There are some companies that have positions for "riggers" who only rig characters using available software tools, and these positions are not required to know how to code. However, these are very low-level positions; if you want to be efficient at rigging it is best to know at least the built-in language of the software you are working with. The ability to solve problems that don't have built in solutions will make you are far better technical director and worth more to the companies that hire you.

Learning math, programming languages and best practices is the easy part; learning to rig complex characters just takes time. It is the desire and work ethic to not give up trying to understand the tools and methods that is the hard part.

Paul Neale
PEN Productions
http://penproductions.ca

15 Special Effects

ON ANY GIVEN DAY at the movie theater you can enjoy a variety of special effects from rain, snow, and smoke to entire forests and landscapes.

While big-budget film effects might not be in your schedule, there are a few effects you can add to your scenes with a minimum of work.

Logo polishing

N THE REFLECTIONS chapter we worked with a logo for a motion graphics spot. Here we will add some nice shadows and a glow to polish it up.

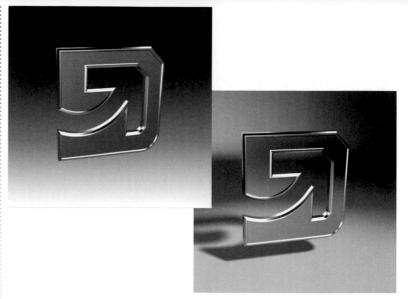

It's common in logo animations and motion graphics to set objects up on an infinite plane. To cast shadows on that plane and see through to the background environment, apply a Matte/Shadow/Reflection material to the plane.

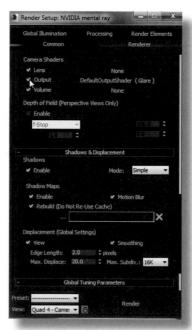

Adding a bit of glow or glare to the highlights is easy. In the Render Settings Dialog under the Renderer tab, check the Output option under Camera Shaders. This will apply the Glare camera shader to the scene. Wherever there are hot highlights or reflections in the scene a glare effect will be produced.

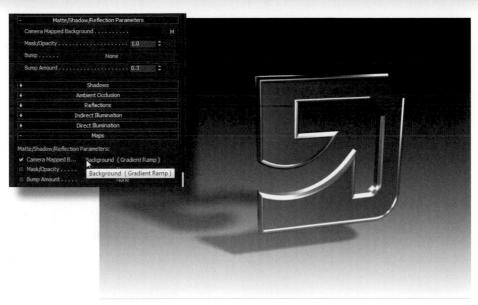

0

LogoPolishStart.max LogoPolishEnd.max

Set the Camera Mapped Background map to use the gradient map that is currently in the Environment background slot. The scene will now render with the objects shadow over the backdrop. This is also a good way to get reflections over the environment if needed.

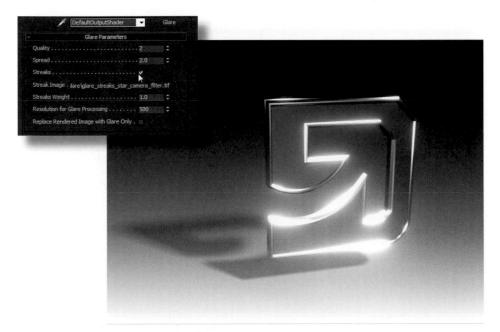

The Glare shader can be dragged into the material editor to tune its Spread, Quality and other settings. You can even set the Streaks option to get some more interesting results.

15

MassFX destruction

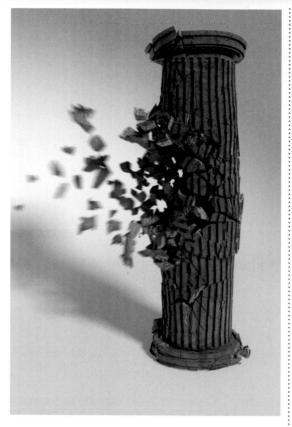

Run the Fracture Voronoi script and select the Pillar object to fracture.

ASSFX WAS INTRODUCED as the de facto simulation engine in 3ds Max 2012. MassFX replaced Reactor as a simulation engine. While it did not cover all the areas that Reactor did it is a pretty fast rigid body simulator.

Here we will set up a simple destruction sequence making use of the Fracture Voronoi script from the MAXScript chapter.

On the MassFX Toolbar, click Reset simulation (back button). Then with all the pillar objects selected click the MassFX Tools button and go to the Multi-Object Editor tab. Here set Start in Sleep Mode for all the objects. This means they will hold their position until something collides with them.

In the Fracture Voronoi dialog set your Nb Parts to 11 and Iterations to 3. Parts will create 11 large chunks and Iterations will then subdivide those further. Set the option for Vo.Cells Centers, which will set the pivot of each object to the center of the cell.

Break the pillar object and with all the pieces selected bring up the MassFX toolbar. Here you can set all the pieces to Dynamic Rigid Bodies.

Simulate by pressing the Play button in the MassFX toolbar and the pillar will crumble to the ground. We want the pillar to stay standing until an object hits it, so we will set the Start in Sleep Mode property for all the pillar

objects.

PillarStart.max PillarEnd.max

Select the sphere in the scene and set it to be a Kinematic Rigid Body. This will allow the object to keep its animation and collide with other objects in the scene.

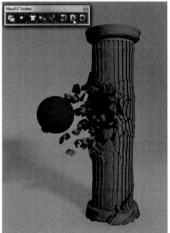

Simulate the scene and the pillar will stand until the sphere object crashes into it, causing the pillar to crumble to the ground.

Bake out the animation and by using the Bake All option in the MassFX Tools dialog and render out the animation.

HOT TIP

Fracture Voronoi can set up material ID's for the inside of the fractured objects. This way the insides of the destroyed pillar can look slightly different with a Multi/Sub-Object material applied.

Raindrops

ATURAL PHENOMENA can be intimidating, especially water. All that transparency and refraction! But In reality, falling rain looks like a blur. Water droplets, when viewed en masse, are just reflective blobs.

To create an animation of raindrops falling on a window pane, you need rain outside the window, droplets falling on a window pane, and a few drips for good measure.

Dreary lighting, a dark exterior, a reflective window pane, and dappled shadows on the window frame add to the gloom.

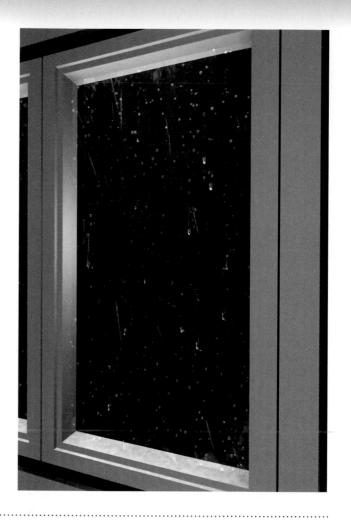

Create a material for the raindrops to make them look like water. No need to go overboard—a simple material with a Reflection map, lowered Opacity, and high shininess will do the job. Render a few frames late in the animation to see how the raindrops look with the material.

Сору the first raindrop to create two more raindrops. These will be your drips. Alter one of them to look like a long, dripping raindrop when viewed in the Top viewport. Select the round drip, and use the Morpher modifier to morph it into the long drip over 120-150 frames.

Set up the scene for rainy day lighting. Here, I've set up a dim direct light coming in through the window, and medium lighting in the room itself. A second direct light makes dappled shadows on the window frame.

Create a Spray particle system to spray particles outside the window. Turn on Object Motion Blur for the Spray in the Object Properties dialog. Adjust the particle Speed until the raindrops look like a fast blur in the rendering.

Create a raindrop object to spread over the window pane. A sphere will do, but you'll catch more highlights with a flattened sphere. At the Vertex sub-object level, rotate the sphere so its flat end points down in the Front viewport. This will ensure the drops are oriented correctly when used with the PCloud particle system.

Create a plane over both window panes. Create a PCloud particle system, and choose the plane as the emitter. In the Particle Type rollout, choose Instanced Geometry, and pick the raindrop as the reference. Hide the plane, and set particle size and quantity values to get a nice spread of raindrops over the course of the animation.

If you don't like the distribution of raindrops, you can get a new arrangement by clicking New under Uniqueness. This grabs a new Seed value for random calculations, redistributing the particles in a new configuration.

Create a second PCloud system for the drips, with the round drip as the instanced particle. The number of particles should be about 5% of the total number of raindrops. Under Animation Offset Keying, choose Birth to cause the drips to morph as soon as they appear.

Create a copy of the raindrop material, and add a Raytrace map in the Refraction slot for the drips. Because the drips are larger, you can detect the refraction in the rendering. There aren't a lot of drips, so the Raytrace map shouldn't cause a significant increase in render time..

INTERLUDE

Morphing

MORPHING CAN BE A useful tool for special effects. It turns one object into another over a series of frames. Morphing is accomplished by assigning the Morpher modifier to an object and picking target objects.

Morphing works by taking the vertices of one object and moving them to the locations of the other object's vertices. Under the hood, 3ds Max numbers the vertices of every object. When you morph one object to another, vertex #1 of the original object travels to the position of vertex #1 of the target object, vertex #2 in the original object travels to vertex #2 position of the target object, etc. The distance and direction in which the vertices travel are relative to the object's pivot point.

Morph targets have to have the same number of vertices as the original object, or the Morpher modifier won't let you use them. The best way to create morph targets is to make a copy of the original object and alter the copies to make targets. Then each target will have the same vertex configuration, with its pivot point in the same relative position to the final object.

Even with carefully made morph targets, things can go awry. Suppose you modify a morph target in such a way that the pivot point isn't really in the right spot. You can just move the pivot point, right? Wrong. Morphing uses the *original* pivot point location, no matter where you move the visible pivot point after the fact.

■ Raindrop drips from Raindrops topic: round drop, long drip, and partial morph from round to long. The morph grows upward at the top due to the pivot point alignment. Moving the long drip downward at the vertex sub-object level would put the pivot point at the right spot for a correct morph.

The only solution is to move the entire object at the sub-object level to orient it to the original pivot point. This can get tricky, since the original pivot point is essentially invisible. The best approach is to align a helper with the pivot so you can see it when moving the object at the sub-object level.

Once you've created morph targets, there's no going back to the original object and collapsing vertices or adding edges. Such operations will cause a mismatch between the number of vertices in the original object and the morph targets. And you can't correct the problem by adding a vertex here and there. Doing so causes a change to the object's vertex numbering pattern. Remember that vertex #236 on the original object will travel to the location of vertex #236 on the target object. Adding vertices on one object changes its vertex configuration relative to other objects. This means that when you morph, you'll end up with a big mess, with the object turning inside out and most likely looking like a wadded-up tissue along the way.

The most common uses for morphing are lip synch and facial animation. Create a series of morph targets representing vocal sounds and facial expressions, morph between them in time with the sound track, and you've got yourself a live, talking character. Just be sure to have the original object in perfect condition, with the exact number of polygons needed and all the vertices welded appropriately. Then you won't have the need to add or remove vertices after you've created the morph targets.

Morph targets for facial expressions. For a full set of lip synch and facial expression targets, each major vowel and consonant sound is represented, as well as common facial expressions like blinking, smiling, and frowning.

Special Effects

Cracks in a surface

NIMATED CRACKS appearing in a landmass make a powerful visual statement. The ProBoolean tool with an animated loft makes quick work of it and allows you to determine where the crack appears and how fast it grows.

Next you'll animate the loft scale to make the loft grow along the path. Go to the Modify panel, and on the Deformations rollout, click Scale. In the Scale Deformation window, click Insert Corner Point, and add two points on the line. Click Move Control Point and arrange the graph as shown in the diagram. Use the value entries at the bottom of the window to enter the value 0 for the two rightmost points.

Scale Deformation(X)

100 1-0

100 1-0

100 1-0

100 1-0

100 1-0

100 1-0

100 1-0

100 1-0

100 1-0

100 1-0

100 1-0

100 1-0

100 1-0

100 1-0

100 1-0

100 1-0

100 1-0

100 1-0

100 1-0

100 1-0

100 1-0

100 1-0

100 1-0

100 1-0

100 1-0

100 1-0

100 1-0

100 1-0

100 1-0

100 1-0

100 1-0

100 1-0

100 1-0

100 1-0

100 1-0

100 1-0

100 1-0

100 1-0

100 1-0

100 1-0

100 1-0

100 1-0

100 1-0

100 1-0

100 1-0

100 1-0

100 1-0

100 1-0

100 1-0

100 1-0

100 1-0

100 1-0

100 1-0

100 1-0

100 1-0

100 1-0

100 1-0

100 1-0

100 1-0

100 1-0

100 1-0

100 1-0

100 1-0

100 1-0

100 1-0

100 1-0

100 1-0

100 1-0

100 1-0

100 1-0

100 1-0

100 1-0

100 1-0

100 1-0

100 1-0

100 1-0

100 1-0

100 1-0

100 1-0

100 1-0

100 1-0

100 1-0

100 1-0

100 1-0

100 1-0

100 1-0

100 1-0

100 1-0

100 1-0

100 1-0

100 1-0

100 1-0

100 1-0

100 1-0

100 1-0

100 1-0

100 1-0

100 1-0

100 1-0

100 1-0

100 1-0

100 1-0

100 1-0

100 1-0

100 1-0

100 1-0

100 1-0

100 1-0

100 1-0

100 1-0

100 1-0

100 1-0

100 1-0

100 1-0

100 1-0

100 1-0

100 1-0

100 1-0

100 1-0

100 1-0

100 1-0

100 1-0

100 1-0

100 1-0

100 1-0

100 1-0

100 1-0

100 1-0

100 1-0

100 1-0

100 1-0

100 1-0

100 1-0

100 1-0

100 1-0

100 1-0

100 1-0

100 1-0

100 1-0

100 1-0

100 1-0

100 1-0

100 1-0

100 1-0

100 1-0

100 1-0

100 1-0

100 1-0

100 1-0

100 1-0

100 1-0

100 1-0

100 1-0

100 1-0

100 1-0

100 1-0

100 1-0

100 1-0

100 1-0

100 1-0

100 1-0

100 1-0

100 1-0

100 1-0

100 1-0

100 1-0

100 1-0

100 1-0

100 1-0

100 1-0

100 1-0

100 1-0

100 1-0

100 1-0

100 1-0

100 1-0

100 1-0

100 1-0

100 1-0

100 1-0

100 1-0

100 1-0

100 1-0

100 1-0

100 1-0

100 1-0

100 1-0

100 1-0

100 1-0

100 1-0

100 1-0

100 1-0

100 1-0

100 1-0

100 1-0

100 1-0

100 1-0

100 1-0

100 1-0

100 1-0

100 1-0

100 1-0

100 1-0

100 1-0

100 1-0

100 1-0

100 1-0

100 1-0

100 1-0

100 1-0

100 1-0

100 1-0

100 1-0

100 1-0

100 1-0

100 1-0

100 1-0

100 1-0

100 1-0

100 1-0

100 1-0

100 1-0

100 1-0

100 1-0

100 1-0

Go to the last frame of the animation, turn on Auto Key, and move the two middle points on the graph to arrange it as shown in the picture. Take care not to make the points pass by each other, as this could confuse 3ds Max and make it do unexpected things.

CrackStart.max CrackFinish.max

Create a terrain with some thickness, and draw a line in the shape of the crack. Use Snaps Toggle with the Face option turned on. Create a line in the Top viewport starting outside the terrain, then zigzag it across the terrain to form the crack. Place three or four vertices between each twist and turn so the line stays on the surface the whole time. Be sure to turn off Snaps Toggle when you're done.

Create a tall, thin ellipse and loft it along the line. The resulting loft will be used to cut the crack. Make sure the Creation Method is set to Instance, and turn off Banking in the Skin Parameters rollout. Set Shape Steps to 2 or 3 and Path Steps to 0 for faster computation. If it looks like the cut won't be the right width or depth, change the ellipse parameters.

Select the terrain, and use the ProBoolean compound object to subtract the loft object. Hide the loft and scrub the animation. If you want to change the crack's path anywhere along the way, just move the vertices of the original line used to make the loft.

HOT TIP

To make the crack automatically have a material different from the surface, assign different material IDs to the surface and the loft before performing the boolean operation. You can do this quickly by applying a Material modifier with a different ID number to each object.

15 Special Effects

INTERLUDE

What's in the box?

Particle Flow was introduced in 3ds Max 6 quite some time ago. Its a very powerful system and throughout the years the original developer, Orbaz, has continued to improve and add functionality with plugin releases. Each of these extensions to PFlow was called a Box and there has been a release for Box #1, Box #2, and Box #3. At this point all of these additional Boxes have been integrated in the main 3ds Max package.

Box #1 was integrated early on and introduced some important speed improvements as well as cool operators like Lock Bond. Box #2 and Box #3 have just been integrated in 3ds Max 2014.

Box #2's main focus is dynamics and allowing particles to collide with each other in a dynamic way. It uses the MassFX technology and has been dubbed MParticles in 3ds Max. Most of the operators associated with MParticles will have an mP in there name.

Box #3 allows you to create your own operators using math nodes and other conditions. Its a very powerful set of tools accessed from the Data Operator and it has its own Data View to create operators in.

See, not as scary as you thought.

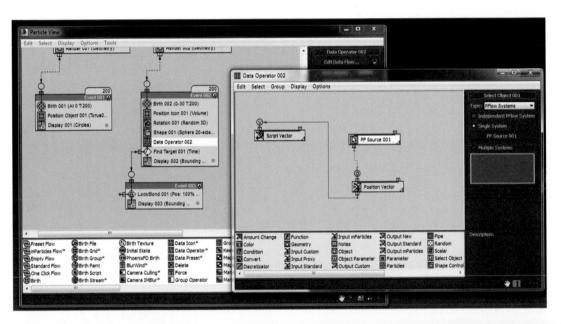

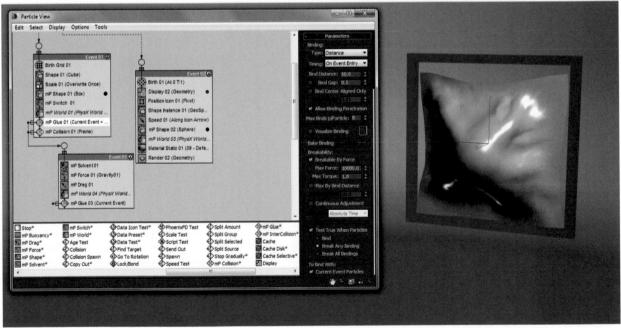

Particle flow basics

ARTICLE FLOW, also known as PFlow, is the core, node-based particle system in 3ds Max. There is still room for the simple legacy particle systems for quick and dirty things but I recommend using PFlow for most of your particle needs.

Most of the work in PFlow is done in the Particle View. Particle flow has all the base particle attributes your're used to, but presents them in a more modular way. Parameters like Birth, Speed, Rotation, and Display are all present in PFlow.

Drag out a PF Source in the Perspective view and press play. PFlow gives you a default set of particles so you have moving particles right from the start, and you can start playing with settings.

To link Events or pass particles from one to another you will need a Test action. Dragging a Age Test into the original Event will allow you to define an age at which particles go into the next Event.

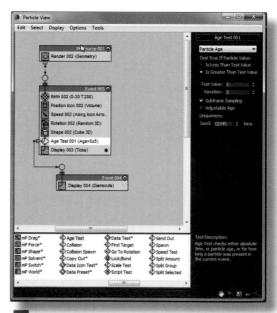

Adjust actions in the Parameters Panel. Select the second Display action you created and set the Type to Diamonds. Select the Age Test and set the Test Value to 5. Now at frame 5 you can see the particles are passed to the second event.

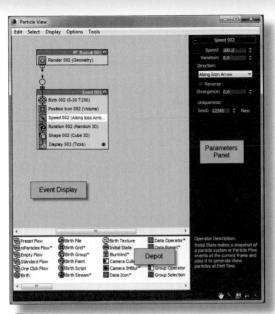

Open up the Particle View and you will see a few sections. The Event Display is where most of the action happens. Pflow is event based and particles get passed from event to event through some sort of condition or test.

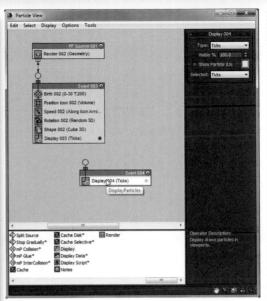

Pflow actions or operators are at the bottom in the Depot. You can drag actions like Speed, Age Test, or Display into an existing event or into the Event Display directly to create a new event.

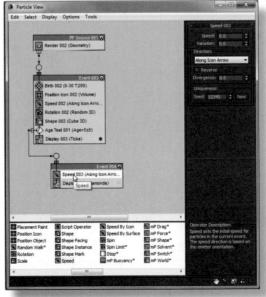

Any action you add into the new event you created will only affect particles over 5 frames old. Drag a Speed action into that event and set the Speed to 0. The particles will now stop after 5 frames and hang in space.

Special Effects

Swirly particles

ANY BROADCAST, film, and game effects shots have these swirly particles with fluid movement. This type of movement can be generated by a turbulent field with some sort of drag that reduces the particles' speed over time or distance. Lets look at setting up a simple swirly particle animation.

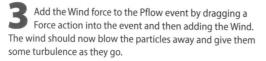

To get the swirling effect more clearly and slow our particles down some add a Drag force to the system. Set the Damping to be 25% in X,Y, and Z. Set the Time off to be the end of the frame range too.

SwirlyStart.max SwirlyEnd.max

Start with a Pflow source to that emits about 10,000 particles over 300 frames. Set the particle speed to 0 as we will be creating the particle movement with wind.

2 Create a Wind force and set its Strength to 0.2, Turbulence to 1.5 and Scale to 0.01. This will blow the particles slighting and with a little turbidity. HOT TIP

The Scale in Wind is a bit backwards from how you might expect it to work. A small value like 0.01 produces a large wavy turbulent field and a larger value like 1.0 produes a tight pattern that will make your particles jitter around.

Increase the particle count and tune the wind turbulence and drag damping to get interesting swirling particle effects.

Special Effects mParticles

PARTICLES ALLOW YOU to have particle meshes collide with one another, and let you add joints to particles and skin particles in a cloth-like fashion.

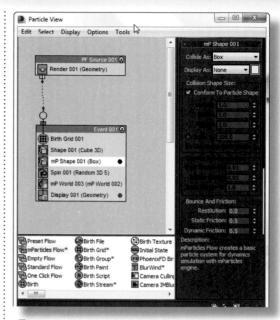

Create a Pflow system and in the Particle View remove all the events and drag in a mParticles Flow. This will set up a preset flow with all the basics needed for a mParticles simulation. You should see an mP Shape action as well as a mP World. The mP world is the MassFX simulation engine integrated into particle flow to do shape collisions.

Set the Birth Grid to Non-Uniform Grid and reduce the Grid height % to get more coins stacked up. Press play to watch them drop into place and collide with the ground.

mParticlesEnd.max

Play back the animation to see a grid of boxes that drop to the ground and collide with the ground plane as well as each other.

Create a Chamfer Cylinder that is about the size of a coin and replace the standard Shape action with a Shape Instance. Pick the cylinder as the instanced shape. Adjust the Scale of the shape so they don't overlap. If the objects are interpenetrating the collisions will fail and they will go flying off into space.

Play with the Restitution value in mP Shape to get the desired bounce out of your simulation.

The coins collide a bit unnaturally because their mP Shape is set to box. Set the mP Shape Collide As field to Convex Hull to better approximate the actual shape of the coins and press play again. Now they collide better.

To collide with a scene object use an mP Collision Test below mP World. In order to pick the scene object to collide with add the Pflow Collision Shape (WSM) modifier to it. Make sure you press the Activate button in the modifier so it will participate in the simulation.

Data flow operators

ATA FLOW OPERATORS (or PFlow Box 3) allow you to dig deep into particles and create your own operators that normally would not be a part of PFlow. It's a bit technical by nature but here is a simple example of the type of thing you can do with it.

Start out with a particle system that places a few hundred particles on the surface of an object using the Position Object action. We will create a second particle system that emits particles, and then finds the particles in the first system and moves to their positions.

Add a Data Operator to the second event above Find Target and Edit Data Flow. In the Data Flow window add a Select Object, Input Proxy, and Output Standard and wire them together. In Select Object set the Type to Pflow System and choose the first Pflow system by clicking on the none button and picking that system. This will be the system we grab our info from.

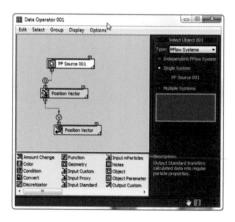

In the Output Standard action choose Script and select
Vector from the dropdown list and close the Edit Data Flow view. This may disconnect your Position Vector. Be sure to reconnect it. Now the particles will emit and after a short time find their target particle on the other system.

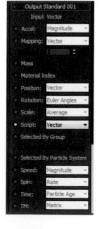

Drag out a Standard Flow to the Event Display to create another system and set the Birth of amount of the second system so that you have the same amount of particles emitting as the first system. Set the Speed to be 100 and Random 3D for Direction.

In the second event add a Find Target Test and send those particles to a new event with a new Display action. In Find Target set it to Control by Time with a Time of 120 and Variation of 60. This will cause the

The first first of the first of

DataFlowStart.max DataFlowEnd.max

particles to find their targets over 120 frames with a little variation. In the Target section set Point to Script Vector. We don't have script vector yet for it to find but that is what we will build with the Data Operator.

Right-click on the Input Proxy and choose Show Data. If you scrub the timeline this will show you the position data for all the particles in the Pflow System that was picked. By feeding that info into the Output Standard action as a Script Vector, Find Target will be able to access that data.

Right now the particles find the target and just keep flying around after that. To have them stay once they find the particle we can use the Lock Bond action. Add Lock Bond to the third and final event and pick the Torus as the Lock On Object. Set the Lock To Surface and Snap To Surface options. Now the particles will find their target and stick to the surface afterward.

Appendix

HERE IN THE BACK, I've included some goodies to aid you on your journey to becoming a better and faster artist with 3ds Max.

These challenges will give you practice in the techniques described in this book.

Appendix

Challenges

FTER GOING THROUGH the topics in this book, you're probably eager to start putting the techniques to use. The challenges here are intended to inspire you to explore 3ds Max and create your own original works.

Use the images and guidelines provided here to practice the techniques in this book, or start with your own reference material.

Remote.jpg

Take a straight-on photo of a household object, such as a remote control or cell phone. Using the techniques described in the Modeling chapter, remove the perspective from the photo in Photoshop, and use the map both as a guide for modeling and as a texture. Make your own custom texture from a photograph, or use the reference image included on the CD.

GrayBuilding.jpg

Start with a straight-on photo of a building. Flatten it out in Photoshop, and paint out items that hide the facade, such as trees and street elements. Use the photo to model a 15-minute building like the one in the Modeling chapter. Take a photo of a building in your environment, or use the image provided on the CD. Then light the building's windows for both day and night as described in the Glass chapter.

Spots3.jpg

To get a handle on the techniques of making curved glass, try your hand at making this well-used pitcher. Feel free to use the spots texture from the Glass chapter.

Reference material is important for animation, too. Videotape a friend walking, getting as close to a straight side view as you can. Then animate the Biped walking the same way. The crazier your friend walks, the more fun you'll have.

Appendix

Challenges

REFERENCE IMAGES AND MODEL: JAMES MALLARD

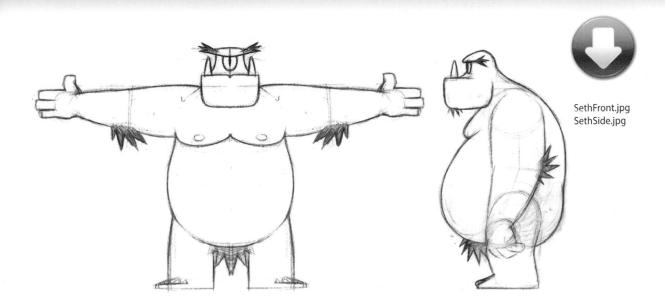

What's more fun than modeling characters? Nothing, I say. That's why I've included these reference images so you can make your own. These models were created by Michele Bousquet's students in her Low Polygon Character Modeling class at CGSociety.org. They have graciously allowed their reference images to be included with the book so you can enjoy the same pleasure. Use the techniques described in the Character Modeling chapter to create the body and head, then rig and animate with the Character Animation chapter.

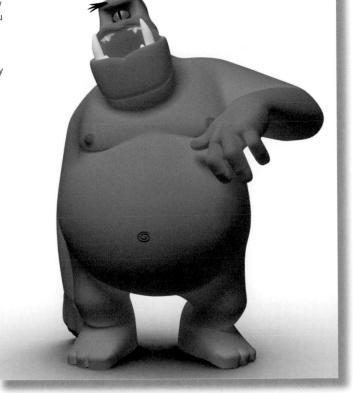

REFERENCE IMAGES: NICOLAS ZARZA AND PABLO MORENO MODEL: NICOLAS ZARZA

Index

Index

A

alpha channel, PSD file 80 animation Auto Key 147 Curve Editor 148-149 Dummy objects 158-159 facial 253 IK solver 162 Link Constraint 160-161 loft 254-255 LookAt Constraint 154-155 Noise Controller 156-157 Path Constraint 152–153 pivot point 150-151 random effect 156-157 scene workflow 18 trackbar 147 Track View 146 Arch & Design material 98-99, 100-101 Attach Editable Mesh/Poly 27-28 attenuation 115 Auto Key 147

B

Backface Cull 120
balcony 42–43
Bevel 48–49
Bias 106
Biped
copy and paste postures 173
Figure Mode 175
fitting skeleton 174
footsteps 178–179
IK/FK 182
move without animating 173
skinning 168–169
Bones 162–163
Boolean 165

C

CAT animation system fitting skeleton 174 Gizmos 184, 196-197 pivot point controller 150 skinning 174 CATHDPivotTrans 150 CheckMate Pro standard 52-53 circumference calculation 238-239 clone object 33 collapse modifier stack 82 COM, selecting 172 Connect 39-40, 41, 69 controller CATHDPivotTrans 150 copy object 33 Curve Editor 146, 148-149 set tangents 149 custom menu 4-5 Cut 39-40 cycling viewports 6

D

Daylight system 116–117 decal map 83 degtorad 237 dirt shader 92 Dope Sheet 146 Dummy objects 26, 154–155, 158–163 in parameter wiring 236–237

Ε

edge loops 62
Edge sub-object 41
Editable Poly
Attach 27–28
Convert to 38
Preserve UVs 40–41
Edit UVWs dialog 88–89
Enhanced Menus 8–9
Expose Transform helper 240–241
Exposure Control 4
Extrude 48–49

F	lighting
face structure 48–49 facial animation 253 Fastskin 95 Flat Mirror map 131 fluid dynamics simulation 224–225 Fracture Voronoi script 192–193 Free keys (Biped) 182 freeze 23, 28	attenuation , 115 bounced 208–209 colors 114 intensity 104, 112 mr sun 117 negative Multiplier 115 scene workflow 19 Skylight 117 Spot vs. Direct 107
G	sun 108–109 three-point 104–105
gemstones 126–127 glass pint 140–141 refraction 142–143 windows 134–139 glow 110–111 Gradient Ramp map 84–85 Group 26	volume light 115 Light Lister 4 Light Lister dialog 104, 119 Link Constraint 160–161 linking 158–159, 160–161 lip synch 253 lock selection 17, 28 loft 254–255 logo treatment 128–129, 246–247
Н	LookAt Constraint 154–155
hair 226–227 HD Solver 164 helper Expose Transform 240–241 hide 23	manipulator 232–233 mapping building 40–45 scene workflow 19
I i	maps decal 83
IK Chain 163 IK/FK blending 182 IK solver 162–163 index of refraction 142–143 Instance 33 inverse kinematics 182	Flat Mirror 131 Gradient Ramp 84–85 mr physical sky 117 Noise 84–85 Normal 90–91 Raytrace 125, 251
L	Reflect/Refract 124, 131 tileable 79
Lathe modifier 32, 49 Lattice modifier 120 layers Layer Manager 22	Vertex Color 87 materials Matte/Shadow 120, 135 Mental Ray 125 Raytrace 126–127 scene workflow 19 Matte/Shadow material 120, 135 Maximize Viewport Toggle 20

MAXScripts	N
CAT gizmos 196–197	
for getting a job 242–243	NGon 148–149
Fracture Voronoi 192–193	Nitrous viewport 210–211
Gizmo Control 194–195	Noise Controller 156–157
PF Spliner 200	Noise map 84–85
Tension modifier 198–199	Size 85
Maya	normal
emulating 10–11	definition 91
Mental Ray 206–207, 208–209	mapping 90–91
Arch & Design material 98–99, 100–101	NURBS 165
radiosity 208–209	P
Mental Ray material 125	P
middle mouse wheel 21-22	Parameter Editor 237
modeling	Parameter Wiring dialog 233–237
spline 36–37	particle systems
modifiers	PCloud 251
Lathe 32, 37, 49	Spray 251
Lattice 120	Path Constraint 152–153
MeshSmooth 66	PCloud 251
Morpher 252–253, 256–257	PFlow
Physique 165	about 256-257
Projection 91	Box 3 264-265
Push 121	PF Spliner script 200
Shell 48, 51	Photoshop
Skin 165, 176–177	cleaning up reference images 34–35
Sweep 32, 49	Physique modifier 165
Symmetry 39	pi 238-239
Tension 198–199	pivot point 150–151
TurboSmooth 39, 66, 48–49	for morphing 252-253
Unwrap UVW 77, 88–89, 96–97	Place Highlight tool 131
UVW Map 41, 76–77	Plant keys 182
VertexPaint 86–87	plugins
Morpher modifier 252–253, 256–257	Tension 92
motion blur	polygon structure 48
rain 251–252	Polygon sub-object 41
mr physical sky map 117	Preserve UVs 40–45
mr sun light 117	primitives 32–33
	scene workflow 19
	ProBoolean 165, 254–255
	Projection modifier 91
	PSD file
	alpha channel 80

Push modifier 121

Index

Q	shadows
quadruped 180 Quicksilver renderer 212–213	Bias 106 ray traced vs. shadow map 80, 109 Shadow Map Size 107
R	troubleshooting 118–121 Shell modifier 48, 51
radiosity 208–209	Show Standard Map in Viewport 83
random animation 156–157	skeleton fitting 174
Raytrace map 125, 251 Raytrace material 126–127	quadruped 180
reference images 18–19	skin
use in virtual studio 38–39	material 94–95
reflection	Skin modifier 165 skinning 168–169
troubleshooting 130–131	procedure 176–177
Reflect/Refract map 124, 131 refraction 142–143	Weight Table 177
Rename Objects 23	Skylight light 117
renderer	Spline IK Solver 164
mental ray 206–209	spline modeling 36–37 splines 32
Quicksilver 212–213	how to draw 44–45
V-Ray 222–223 Render Scene dialog 204–205	splines to particles 200–201
Render to Texture 90–91	Spray 251
rigid body simulation 248–249	standards for 3D modeling 52
S	state sets 214–215, 216–217 subdivision 66–67, 71
3	sub-object
scale transform 25	Edge 41
Scatter 165	Polygon 41
scene workflow 18–19	selection 17, 19
ScriptSpot.com	Vertex 38, 40 subsurface scattering 94–95
about 190–191	Sweep modifier 32, 49
scripts 192-195, 200-201	Symmetry modifier 39
Search Bar 6–7	_
Select by Name 16, 29 selection 16–17, 18–19	т
lock 17, 28	technical director job 242–243
multiple objects 16–17	Tension plugin 92–93
sub-object 17, 28	three-point lighting 104–105
unlock 17	tileable map 79 Time Configuration 147
Selection Filter 29 Selection Set 23, 26	trackbar 147
500000011 500 25, 20	Track View 146
	TurboSmooth modifier 39, 66–67 not working well 48–49
	TurboSquid 52

U

Unwrap UVW modifier 77, 88–89, 96–97 UVW Map modifier 41, 76–77 fitting options 82–83

V

Vertex Color map 87 vertex painting 86–87 Vertex sub-object 38, 40 Video Post 164 viewports cycling 6 Nitrous 210–211 virtual studio 69 volume light 115

W

water droplets 250–251 Website files 277 Window/Crossing toggle 17, 19 windows 134–139 Workspace 4–5, 8, 12, 228–229

Website files

OR THOSE WHO LIKE to surf the website for interesting files and find them in the book, here is an alphabetical list of all the files referenced in topics.

AnimPivotEnd max 151 AnimPivotStart.max 151 BalconyMap.ipg 43 Balcony.max 43 BeadFinish.max 233 BeadsFollow.max 235 BeadsSeg.max 235 BeadStart.max 233 Beans, max 157 Bracelet.max 127, 129 Candles.jpg 45 CandyDish.max 125 Carving.max 101 CarvingMR.max 101 CatFront.jpg 57, 69 CatSide.jpg 57, 69 ConcavityEnd.max 93 ConcavityStart.max 93 CrackFinish.max 255 CrackStart.max 255 CurtainFinal.max 47 CurtainStart.max 47 DataFlowEnd.max 265 DataFlowStart.max 265 DrinkingGlass.max 143 ExteriorLit.max 109 Exterior.max 109 ExteriorMR.max 113 ExtWindows.max 135 Fake3SEnd.max 95 Fake3SStart.max 95 FireAlarm.max 35 FireAlarm.tga 35 FractWallEnd.max 193 FractWallStart.max 193 Gears.max 149

GizmoEnd.max 195 GizmoStart.max 195 GlassBottle.max 141 GrayBuilding.jpg 268 GunMap.jpg 51 Gun.max 51 Gunslinger.max 177, 217 IndiaDummies.max 159 IndiaLinks.max 159 InteriorDay.max 111 JewelLinks.max 163 JumpingBeans.max 157 LogoPolishEnd.max 247 LogoPolishStart.max 247 LogoReflEnd.max 129 LogoReflStart.max 129 MagnetFinish.max 161 MagnetStart.max 161 MailboxLit.max 105 Mailbox.max 105 MailFinish.max 83 MailStart.max 83 MeterMap.jpg 39 Meter.max 39 MeterPole.jpg 39 MeterRef.jpg 39 MountStart.max 89 MountUVW.max 89 mParticlesEnd.max 263 MRGlass.max 141 OgreFront.jpg 57, 270 OgreSide.jpg 57, 270 PassesEnd.max 215 PassesStart.max 215 PathFinish.max 153 PathStart.max 153 PeopleTrees.max 81 PFSplinerEnd.max 201 PFSplinerStart.max 201 PillarEnd.max 249 PillarStart.max 249 RainFinish.max 251 RainStart.max 251 Remote.jpg 268 RoomAtten.max 115 RoomMR.max 113

RoomNeg.max 115 RoomVolume.max 115 ScaleLightEnd.max 219 ScaleLightStart.max 219 ScanlineGlass.max 141 SethFront.jpg 57, 271 SethSide.ipg 57, 271 ShaderBallRef.max 125 SoccerBall.max 91 SpaceFlare.max 115 Spots3.jpg 269 SwirlyEnd.max 261 SwirlyStart.max 261 TensionEnd.max 199 TensionStart.max 199 TerrainMix.max 87 TerrainStart.max 87 TileExposeTEnd.max 241 TileExposeTStart.max 241 TimeFinish.max 237 TimeStart.max 237 TovCar.max 239 USMail.jpg 83 USPS_Logo.psd 83 WheelFinal.max 37 WheelStart.max 37 WhtBldgMap.jpg 41, 43 WhtBldg.max 41

cheat_N 3ds/Max 2014

You are a creator.

Whatever your form of expression — photography, filmmaking, animation, games, audio, media communication, web design, or theatre — you simply want to create without limitation. Bound by nothing except your own creativity and determination.

Focal Press can help.

For over 75 years Focal has published books that support your creative goals. Our founder, Andor Kraszna-Krausz, established Focal in 1938 so you could have access to leading-edge expert knowledge, techniques, and tools that allow you to create without constraint. We strive to create exceptional, engaging, and practical content that helps you master your passion.

Focal Press and you.

Bound to create.

We'd love to hear how we've helped you create. Share your experience: www.focalpress.com/boundtocreate

Focal Press
Taylor & Francis Group